Photographing Washington, D.C.

Digital Field Guide

Photographing Washington, D.C.
Digital Field Guide

John Healey

WILEY

Wiley Publishing, Inc.

Photographing Washington, D.C. Digital Field Guide

Published by
Wiley Publishing, Inc.
10475 Crosspoint Boulevard

Indianapolis, IN 46256
www.wiley.com

Copyright © 2010 by Wiley Publishing, Inc., Indianapolis, Indiana

Published simultaneously in Canada

ISBN: 978-0-470-58687-7

Manufactured in the United States of America

10 9 8 7 6 5 4 3 2 1

For general information on our other products and services or to obtain technical support, please contact our Customer Care Department within the U.S. at (877) 762-2974, outside the U.S. at (317) 572-3993 or fax (317) 572-4002.

Wiley also publishes its books in a variety of electronic formats. Some content that appears in print may not be available in electronic books.

Library of Congress Control Number: 2010920657

WILEY

About the Author

John Healey is a professional photographer who lives in Washington, D.C. He has worked in many genres of the profession, from small-town newspapers practicing the lost art of deadline-developing and printing, to shooting for international wire services, creating portraits for magazines, to working for companies big and small — there's little he hasn't been involved with in the profession.

In addition, John has worked around the world as a technical assistant for photographers on assignment in such diverse genres as sports, automotive, underwater, interior, and portrait photography.

Credits

Senior Acquisitions Editor
Stephanie McComb

Project Editor
Chris Wolfgang

Technical Editor
Mike Hagen

Copy Editor
Beth Taylor

Editorial Director
Robyn Siesky

Editorial Manager
Cricket Krengel

Business Manager
Amy Knies

Senior Marketing Manager
Sandy Smith

Vice President and Executive Group Publisher
Richard Swadley

Vice President and Executive Publisher
Barry Pruett

Project Coordinator
Patrick Redmond

Graphics and Production Specialists
Lissa Auciello-Brogan
Ana Carrillo
Andrea Hornberger
Jennifer Mayberry
Jill A. Proll

Quality Control Technician
John Greenough

Proofreading
Penny Stuart

Indexing
Broccoli Information Management

In remembrance of those Americans who have given their lives so that others may be free.

Acknowledgments

The best work always comes from a collaboration of talented people. Thanks to Stephanie McComb, Chris Wolfgang, and the other editors at Wiley for their hard work of hammering, straightening, and polishing this book into what you see today. The National Park Service and other personnel at the sites mentioned in this book also deserve much credit: Over the years that I have explored these areas, I have come away impressed by their upbeat attitudes, knowledgeable guidance, and tireless patience. Thanks to the team at Any Chance Productions for their assistance and friendship, Abigail T. for being a great photography assistant, and to Fizzle for your patience and sage advice.

Contents

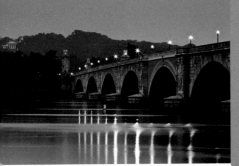

Arlington Memorial Bridge

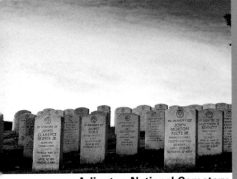

Arlington National Cemetery

Ford's Theatre

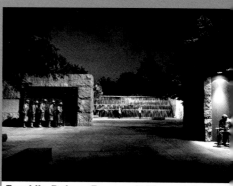

Franklin Delano Roosevelt Memorial

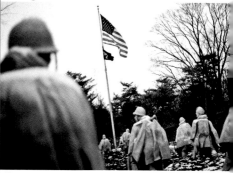

Georgetown

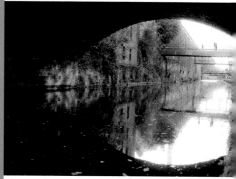

Korean War Veterans Memorial

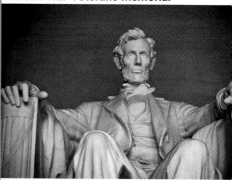

Lincoln Memorial

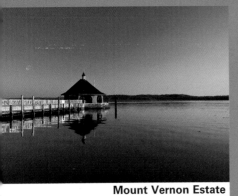

Mount Vernon Estate

National Air and Space Museum

National Archives

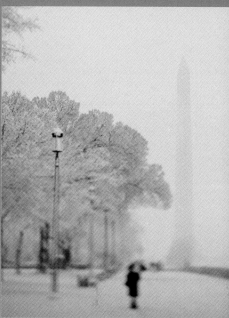

The National Mall

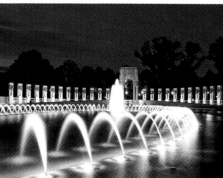

National World War II Memorial

The National Zoo

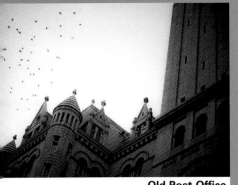
Old Post Office

The Pentagon Memorial

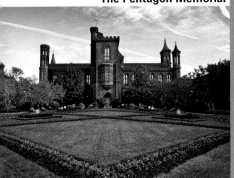
Smithsonian Institution Castle

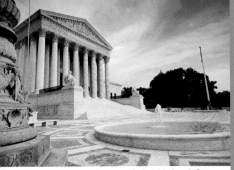
The Supreme Court of the United States

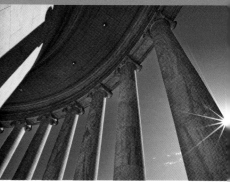
Thomas Jefferson Memorial

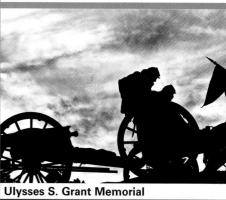
Ulysses S. Grant Memorial

United States Air Force Memorial

United States Botanic Garden

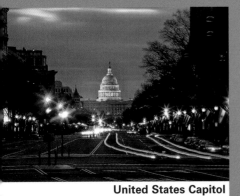
United States Capitol

The United States Library of Congress

The United States Marine Corps War Memorial

United States National Arboretum

Vietnam Veterans National Memorial

The Washington Monument

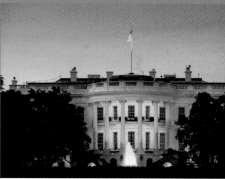

The White House and President's Park

Introduction

Photography is a great way to see and experience the world in a more in-depth manner, and there's probably no where in the United States that offers as many historic photo opportunities in such concentration as Washington, D.C. If you want to put your photography skills to the test and learn new ones, Washington, D.C., is a great place to do so.

Who the Book Is For

This photography guide is meant to serve as both inspiration to get out there and take some incredible photos, as well as to get you started on where some of the classic and lesser-known vantage points are. Photography is all about individuality and being creative, so begin at these locations and then see what you find. With all there is to photograph in and around Washington, D.C., there's much to discover.

Along the way, this book provides tips that will help you use your camera to its best and help you make the most of situations that might arise. There is useful information about where you specifically can bring tripods (and more importantly, where you cannot), how to pack for certain locations where security checks are necessary, what lenses you may want to use, and some suggested settings for your camera.

Photographers are usually an inquisitive breed, so there is also information about a location's significance. As any professional photographer knows, it's important to know a lot about your subject, and while this guide certainly won't replace a good guide book, its aim is to provide some interesting insights along the way.

A note about copyright: A relatively unknown fact about some landmarks in the Washington, D.C., area is that they are copyrighted by the artists and/or the foundations that made them possible. Many do so to protect the memorial or monument against unregulated commercial use. Reproducing copyrighted works is against the law and could result in a lawsuit. This does not generally apply to personal use — making a print of a copyrighted work for, say, your living room wall would not attract any attention. But posting the photos online for sale is an entirely different matter.

Examples of memorials that are covered by copyright include the Korean War Veterans Memorial, the sculptures at the Vietnam Veterans National Memorial and the artwork within the Franklin Delano Roosevelt Memorial.

The ease of sharing and publishing photos due to digital photography and the Internet have meant that being educated about copyright is more important than ever. For more information, see the United States Copyright Office at copyright.gov.

Tripods in Washington, D.C.

A small, table-top tripod is a great idea when traveling, but if you wish to use a full-size tripod note the following:

▶ According to the District of Columbia Office of Motion Picture and Television Development as well as the National Park Service, use of tripods by photo enthusiasts for personal use does not require a permit so long as you are not in areas where there are specific regulations against using them. For more information, see DC Film and TV, www.film.dc.gov and The National Park Service, www.nps.gov/nama.

▶ Note that rules may change at anytime, and often do, to provide additional security for special events. Specific institutions may have their own procedures and rules as well.

▶ Washington, D.C. code regulates the issuing of permits to those who occupy or otherwise use public rights of way, public space, and public structures. These laws can prevent tripod use in those areas no matter the purpose. Therefore, while it's generally okay to use one in areas that allow them, if an official tells you that you cannot use one, understand that there are more rules potentially limiting their use than allowing their use.

▶ Tripods are rarely allowed to be used indoors.

▶ If you are near any security-intensive buildings, expect more scrutiny.

▶ Popular areas where tripods are not allowed without a permit include the U.S. Capitol Grounds, the White House, the Washington Monument, the Lincoln Memorial, the Thomas Jefferson Memorial, the Franklin Delano Roosevelt Memorial, and the Vietnam Veterans National Memorial. Please see the individual chapters covering these areas for more information.

How the Book Is Organized

Whether you are traveling to or live at one of the destinations covered by the Digital Field Guides, time is usually a limiting factor. So these guides have been organized by the editors in a way that will allow you to quickly understand the locations, get an overview of where you should go, and determine what gear you should bring, and how well your gear will work at a location.

Each chapter begins with an overview of the subject and quickly moves on to where the best locations are and provides images illustrating what's possible

there. The equipment section explains what will help you capture these images, while the settings section offers tips and guidance specific to each area. If you are new to photography you may want to mostly use the locations and let your camera do the rest. If you are an expert, the tips will help you get up to speed quickly and make your own unique images.

The best advice for any aspiring photographer is simple: Get out and shoot more. Thus this guide is designed to get you out the door as quickly as possible with the information you need to make the best photos you can.

All focal lengths in this book are given as standard 35mm (full-frame) equivalent focal lengths. Digital cameras have varying crop factors that change the focal length of a lens. Be sure to know your camera's specific crop factor if you want to determine precisely what lens you may need for a photograph.

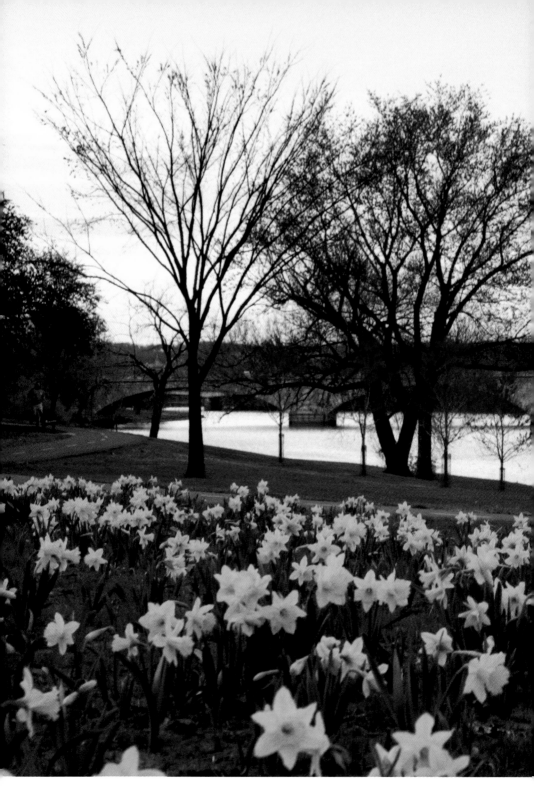

Arlington Memorial Bridge photographed from along the west bank of the Potomac River in Lady Bird Johnson Park. Taken at ISO 200, f/9, 1/40 second with a 75mm lens.

1 Arlington Memorial Bridge

Why It's Worth a Photograph

Of the many bridges that span the Potomac River near Washington, D.C., Arlington Memorial Bridge is often considered the most beautiful. It's a symbolic link that draws together the Union's Lincoln Memorial and the Confederacy's Robert E. Lee Memorial across the Potomac, the Civil War-era water boundary between the North and the South.

Where Can I Get the Best Shot?

There are at least three ways to get great shots of Arlington Memorial Bridge: from next to the bridge's east end, from the west end of the bridge, and from the western banks of the Potomac River.

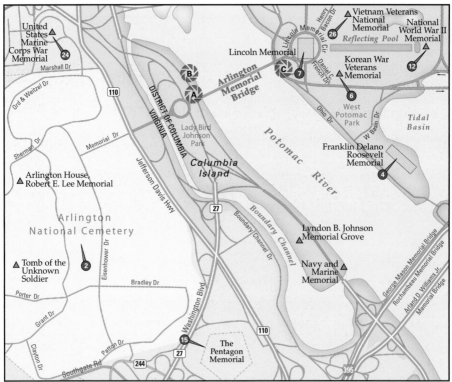

The best locations from which to photograph Arlington Memorial Bridge: (A) the west end, north side of the bridge, (B) the west bank of the Potomac River, north of the bridge, and (C) the east end, south side of the bridge. Nearby photo ops: (2) Arlington National Cemetery, (4) Franklin Delano Roosevelt Memorial, (6) Korean War Veterans Memorial, (7) Lincoln Memorial, (12) National World War II Memorial, (15) Pentagon Memorial, (24) United States Marine Corps War Memorial, and (26) the Vietnam Veterans National Memorial.

The west end, north side of the bridge

The view from the bridge's west end and on its north side lets you line up the Lincoln Memorial with the bridge (see figure 1.1). One way to get to this point is to walk from the Lincoln Memorial across the north sidewalk of the bridge and then follow a dirt path down and around to its north side, immediately after the end of the bridge. Another option is to park at Arlington National Cemetery, but you will have to work around its parking hours to do so.

The west bank of the Potomac River, north of the bridge

You can also shoot from the banks of the Potomac and get a wider shot with Arlington Memorial Bridge, the Lincoln Memorial, and the Washington Monument all in the same image (see figure 1.2). One way to get to this spot is from Arlington

1.1 Arlington Memorial Bridge photographed from the Virginia side at dusk (see A on the map). Taken at ISO 100, f/16, 30 seconds with a 150mm lens mounted on a tripod.

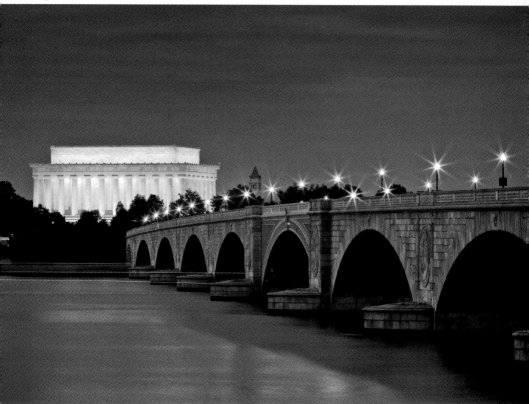

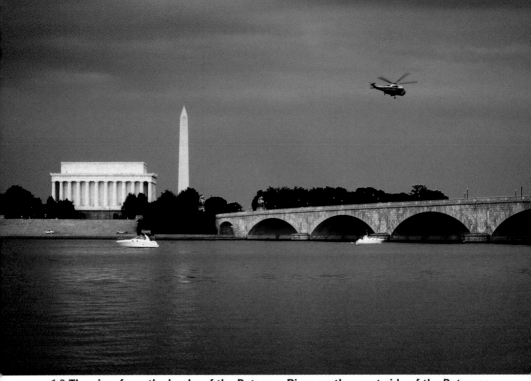

1.2 The view from the banks of the Potomac River on the west side of the Potomac River on a summer evening (see B on the map). Taken at ISO 640, f/5, 1/100 second with a 90mm lens mounted on a tripod.

National Cemetery. Take the sidewalk on the south side of Memorial Drive and follow it toward the Potomac.

Turn right where it tees and follow it to the Mt. Vernon Trail, where you'll head north. One other option is to park at Theodore Roosevelt Island's parking lot along the Potomac (north of the bridge) and walk about 3/4 of a mile southeast on the paved trail.

The east end, south side of the bridge

On the east end of Arlington Memorial Bridge, you can shoot from the south side of the bridge (see figure 1.3). A grassy hill overlooks the river, making a nice spot to photograph the bridge with the Arlington House in the background. Getting to this spot is easiest from the Lincoln Memorial area using the crosswalk from its south side.

You can also access it by walking from the parking lot at Arlington National Cemetery and then across the south span of the bridge.

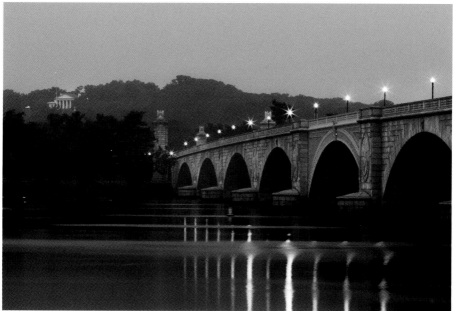

1.3 Looking west across the Potomac River toward the Arlington House on a cloudy, early morning (see C on the map). Taken at ISO 100, f/32, 15 seconds with a 180mm lens and a tripod.

How Can I Get the Best Shot?

These photos require a little bit of hiking and finding places to shoot that are off the beaten path. It's a good idea to pack lightly, wear some good shoes, and bring some water. Although the locations are close together, you will have to do some walking because access is limited.

Equipment

All of these locations require moderate to longer telephoto lenses. Flashes and wide-angle lenses can stay at home. If it could rain, bring something to protect you and your gear as well.

Lenses

For both shots looking across the spans of the bridge (refer to figures 1.1 and 1.3), lenses of between 135-200mm are appropriate, depending on how you choose to compose the shot. From the banks of the Potomac (refer to figure 1.2), something around 65-100mm, depending on where you are standing, lets you get the Lincoln, Washington, and Arlington Memorial Bridge in the photograph.

Filters

A polarizing filter can add some drama to a blue, daylight sky, and a graduated neutral density filter can even out the exposure of the sky depending on the time of day you are shooting.

Extras

A tripod is helpful to do an early morning or dusk shot at any of these locations, but you could shoot them handheld if you feel your hands are steady enough. (Shooting below 1/30 second hand held is usually not recommended.)

 If you are using a tripod and long exposures, use your camera's self timer to trip the shutter to avoid hand-shake.

Camera settings

Camera settings vary widely depending on the time of day that you shoot. However, a few things are constant. If you are shooting in the warm morning or evening sun, set your camera's white balance to its Sun mode to render the light best. Higher apertures allow you to get the entire bridge in focus but also mean slower shutter speeds and/or higher ISO settings.

If you're not using a tripod, focus on the most distant subject and set a lower aperture value, since having the bridge in complete focus isn't absolutely critical depending on your composition. Doing so allows you to hand hold your camera rather than use a tripod.

Exposure

The best images of the bridge are made morning or evening, but during the day can also work as well.

Ideal time to shoot

For the shots from the north side of the bridge (refer to figures 1.1 and 1.2), evening is your best bet. The sun fills up the spans of the bridge and creates an orange-yellow aura within them, while the Lincoln Memorial and Washington Monument glow under its light.

For the shot from the east (refer to figure 1.3), the morning sun will light the bridge and Arlington House.

Working around the weather

These photographs are all of outdoor areas that offer no protection in case of rain. While the classic images are summertime, sunlit shots, shooting in other conditions such as overcast skies, snow, and fog can be equally powerful. Overcast skies offer soft light that make for good black-and-white photos, for example. Make the best of what you are given with the time you have and remember that surprises can be the best part of photography.

Low-light and night options

These shots work best while some ambient light is in the sky. At night, you may need a full moon to help get some light under the spans of the bridge so that you can tell what the structure is.

Getting creative

The spans of the Arlington Memorial Bridge positively glow when the early morning and evening sunlight are upon them, and the picture possibilities here are great. Also, keep an eye out for rowers, kayakers, and other boats. They can give the bridge an awesome sense of scale. Consider photographing all the architectural details and statues at either end of the bridge as well (see figure 1.4).

1.4 Just north of the eastern end of the bridge are two sculptures by James Earl Fraser. Shown here is "Arts of Peace (Music and Harvest)." Taken at ISO 320, f/4, 1/400 second with a 230mm lens.

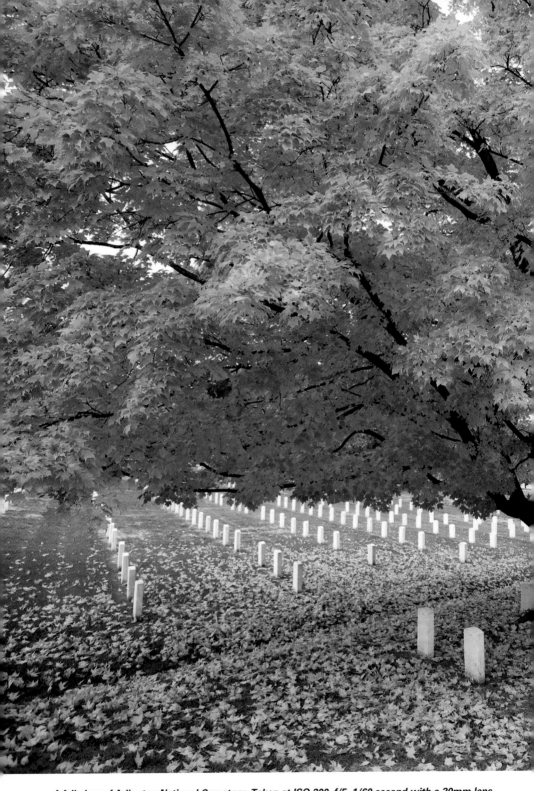

A fall view of Arlington National Cemetery. Taken at ISO 200, f/5, 1/60 second with a 20mm lens.

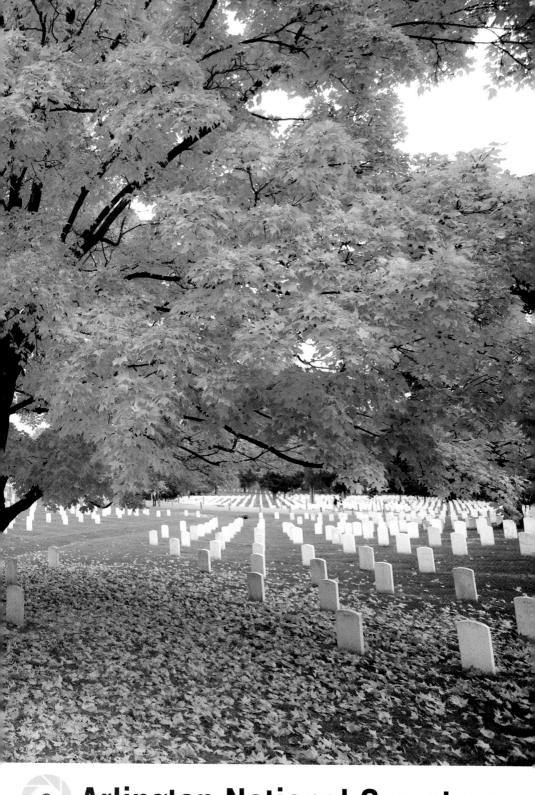

② Arlington National Cemetery

Why It's Worth a Photograph

Arlington National Cemetery is the United States' national military cemetery, as well as a shrine honoring the men and women who served in the United States Armed Forces. Veterans are buried here from all of the wars the United States has engaged in, from the American Revolution to the wars in Iraq and Afghanistan. In addition to those who served in the Armed Forces, two former presidents (William H. Taft and John F. Kennedy) are buried here. Several other monuments and memorials are also significant features of Arlington Cemetery.

Where Can I Get the Best Shot?

Both iconic and creative photos can be made at the Tomb of the Unknown Soldier, along Memorial Drive, and at the gravesite of architect Pierre L'Enfant.

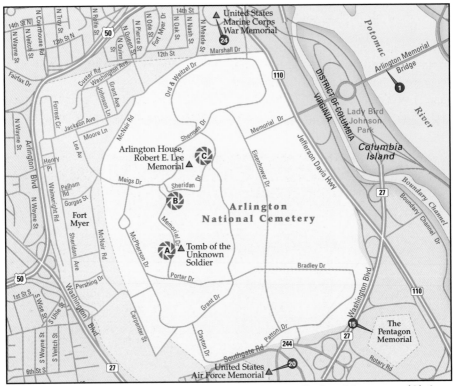

The best locations from which to photograph Arlington National Cemetery: (A) the Tomb of the Unknown Soldier, (B) Memorial Drive, and (C) the gravesite of Pierre L'Enfant. Nearby photo ops: (1) Arlington Memorial Bridge, (15) Pentagon Memorial, and (24) United States Marine Corps War Memorial.

The Tomb of the Unknown Soldier

Also known as the Tomb of the Unknowns at Arlington National Cemetery, this sarcophagus overlooks Washington, D.C., and was originally a tomb to the Unknown Soldier of World War I. Today it represents the unknown soldiers who have all died serving in the United States Military.

The Tomb is guarded 24 hours a day, 365 days a year by specially selected volunteers of the 3rd U.S. Infantry (The Old Guard). These Tomb Guard sentinels are considered to be the most elite soldiers of the 3rd U.S. Infantry (see figure 2.1).

The Tomb Guards change in an elaborate, historical ritual that is open to the public during the hours Arlington Cemetery is

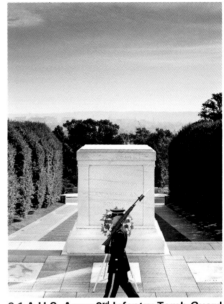

2.1 A U.S. Army 3rd Infantry Tomb Guard at the Tomb of the Unknown Soldier (see A on the map). Taken at ISO 400, f/7.1, 1/800 second with a 90mm lens.

open (see figure 2.2). From October 1 to March 31, the ceremony is repeated every hour. From April 1 to September 30, the ceremony is repeated every 30 minutes.

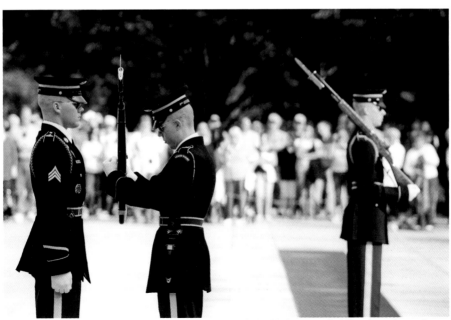

2.2 The Changing of the Guard at the Tomb of the Unknown Soldier (see A on the map). Taken at ISO 500, f/4, 1/1250 second with a 215mm lens.

Memorial Drive

Arlington National Cemetery consists of over 600 acres of land where more than 300,000 people are buried. It is an expanse of rolling hills that is at once beautiful and somber.

A walk from the Visitor's Center along Roosevelt Drive heading west will take you to the Tomb of the Unknown Soldier, and from there you can walk just west to see several monuments and memorials. From there you can walk north on Memorial Drive and follow Sheridan Drive to your right, now heading east (see figure 2.3).

This route takes you past several prominent areas of the cemetery as well as giving you a sense of the vast number of people who have been buried here (see figure 2.4).

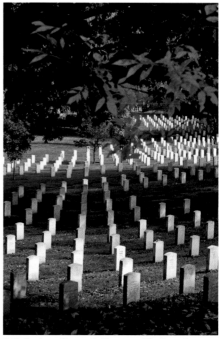

2.3 A view from Arlington National Cemetery along Sheridan Drive (see B on the map). Taken at ISO 100, f/8, 1/320 second with a 130mm lens.

2.4 Graves along Memorial Drive, half way between Wilson Drive and Sheridan Drive, in Arlington National Cemetery (see B on the map). Taken at ISO 200, f/5.6, 1/800 second with a 110mm lens.

The gravesite of Pierre L'Enfant

In front of the Robert E. Lee house and overlooking Washington, D.C., is the grave of Pierre L'Enfant (see figure 2.5). He was a French-born architect and engineer who was a volunteer in the American Revolutionary Army. George Washington hired L'Enfant to create the original plan for Washington, D.C. It was under his guidance that the Capitol and White House are where they are today, as well as much of downtown Washington, D.C.'s organization.

L'Enfant devised D.C.'s roads so that there would be many intersections that allowed for statues to be erected, as well as for wide, sweeping avenues throughout the city. He was eventually fired by Washington after several heated disagreements. His plan, however, was largely followed throughout the continual building of the city.

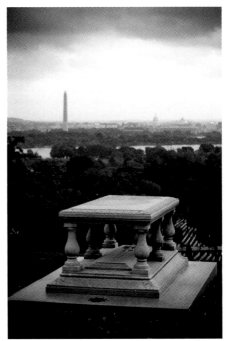

2.5 The gravesite of Pierre L'Enfant (see C on the map). Taken at ISO 400, f/8, 1/320 second with a 90mm lens.

How Can I Get the Best Shot?

First and foremost, a walk through Arlington National Cemetery is a way to honor those who have helped make the United States what it is today and to remember their service. Realizing the significance of the cemetery will go a long way in helping you make memorable images.

Equipment

It's a good idea here to pack lightly so you can walk a lot to explore the area.

Lenses

You can make a wide variety of pictures at the cemetery, so really there's quite a large range of lenses that could conceivably work. However, using a lens that is between 70 and 150mm when photographing the cemetery grounds works well to compress the land and create a more striking image of the many graves here.

Filters

A graduated neutral density and polarizing filter can be useful here when you want to include large amounts of sky in your composition.

Extras

Tripods are allowed on the cemetery grounds, although they aren't all that necessary unless you will be doing long exposures. They are not allowed to be used due to security precautions on Veterans Day and Memorial Day.

Camera settings

When photographing at the Tomb of the Unknown Soldier, it is required that you stay quiet. If you are using a dSLR, be sure to have it on a single-frame drive mode so that you don't make too much noise when you press the shutter. Shoot sparingly and try to avoid making noise when there is silence during the ceremony. For this reason, point-and-shoot cameras are a good idea here, since they are often noiseless. However, make sure any sound effects are turned off as well. It's unfortunately not uncommon when witnessing the Changing of the Guard to hear the faked electronic sound of a point-and-shoot camera taking a photo.

During most days, the white marble here is very, very bright (see figure 2.6). Many cameras will not meter the scene here correctly because it is so bright. You can

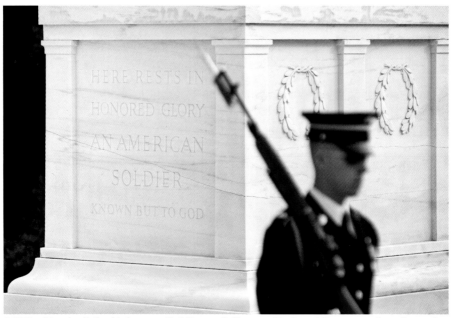

2.6 The Tomb of the Unknown Soldier at Arlington National Cemetery (see A on the map). Taken at ISO 200, f/4, 1/500 second with a 200mm lens.

correct this by using your exposure compensation dial and adding exposure or, if you have a fully automatic camera, you may try to use its Beach or Snow setting (both are designed to more faithfully reproduce very bright scenes).

Exposure

Because the cemetery is so scenic, good photos can be taken at any time of the day — but great ones can be taken in beautiful light.

Ideal time to shoot

The golden hours of morning and evening are nice times to be at Arlington National Cemetery. Especially in the fall and winter, the light will arc across the acres of land here and create beautiful scenes.

Working around the weather

Foggy, rainy, or snowy weather will help to make your images unique here. There are few places where you can go to take cover from the elements, so be prepared if inclement weather is predicted.

Low-light and night options

The cemetery is not open during the night to the public. It closes at 7 p.m. from April 1 to September 30, and from October 1 to March 31, it closes by 5 p.m.

Getting creative

There are hundreds of vistas and unique vantage points within the cemetery grounds. Aside from taking photos of the many rows of graves, keep an eye out for smaller details (see figure 2.7). Also there are many unique memorials and monuments that can be photo-graphed; see the visitor center for a map that has a list of all of them.

2.7 The grave of Mary Randolph, wife of General Robert E. Lee and the first person to be buried on the grounds that would become Arlington National Cemetery (see C on the map). Taken at ISO 500, f/5.6, 1/160 second with a 150mm lens.

3 Ford's Theatre

Ford's Theatre seen from along 10ᵗʰ St NW. Taken at ISO 3200, f/4 1/40 second with a 50mm lens.

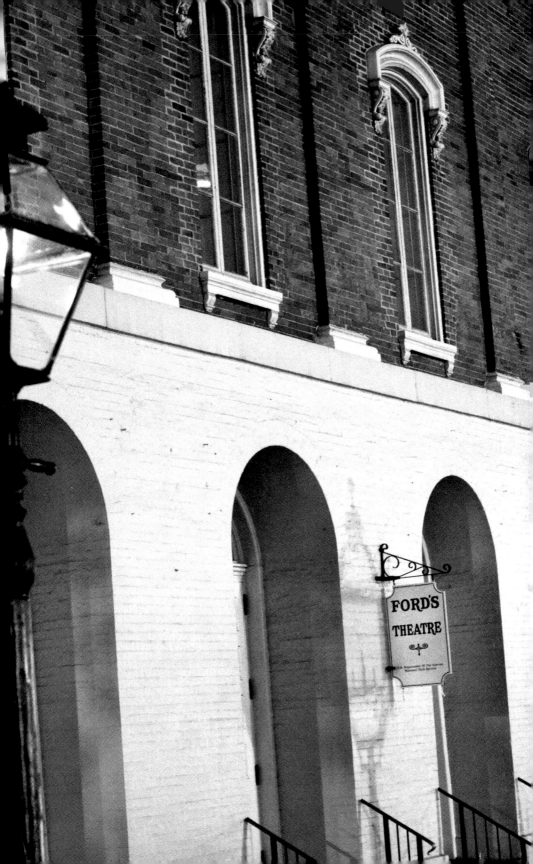

Why It's Worth a Photograph

Originally known as Ford's Athenaeum, this theater in downtown Washington, D.C., is remembered for a singular tragic event — the assassination of President Abraham Lincoln on April 14, 1865. John Wilkes Booth, a famous actor and staunch supporter of slavery and the Confederacy, shot President Lincoln in the back of his head during a play at Ford's Theatre. President Lincoln died the next morning at 7 a.m. in the Petersen House across the street.

The Petersen House is preserved and furnished with artifacts from the time. It's a small, narrow space where you can see the home's parlor, living area, and the room in which President Lincoln died.

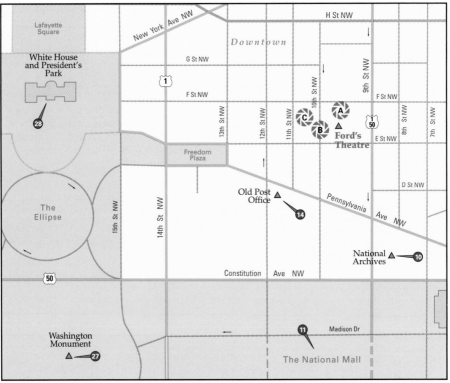

The best locations from which to photograph Ford's Theatre: (A) interior of Ford's Theatre, (B) exterior of Ford's Theatre on 10th St. NW, and (C) interior of Petersen House. Nearby photo ops: (10) National Archives, (11) National Mall, (14) Old Post Office, (27) Washington Monument, and (28) White House and President's Park.

Where Can I Get the Best Shot?

You can get great photos of Ford's Theatre both inside and out. For capturing images of the room where Lincoln died, visit Petersen House across the street.

Interior of Ford's Theatre

If there is one photo from Ford's Theatre that you must take, it is the image of the Presidential Box where Lincoln was shot (see figure 3.1).

You can participate in a group walk-through of the museum and balcony, which takes you first to the museum below the theater and then to the balcony of the theater. From here, you can see the Presidential Box as well as the entirety of the theater from the balcony (see figure 3.2).

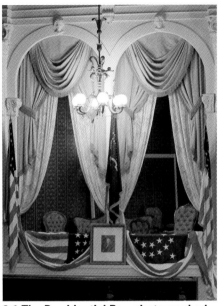

3.1 The Presidential Box photographed from the opposite side of the theater's balcony (see A on the map). Taken at ISO 3200, f/2.8, 1/125 second with a 90mm lens.

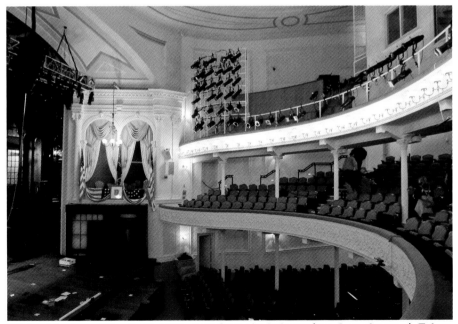

3.2 A wide view of Ford's Theatre, seen from the balcony (see A on the map). Taken at ISO 3200, f/4, 1/40 second with a 20mm lens.

Exterior of Ford's Theatre on 10th St. NW

Along 10th St. NW, you can get a good sidelong view of the front of Ford's Theatre (see figure 3.3).

The sidewalk in front of Ford's Theatre offers a few good opportunities to photograph the building, as well. Gas lamps and vintage-looking signs in front of the theater (see figure 3.4) add a little old-world charm to the block that has little of its original appearance left.

Interior of Petersen House

Visitors to the Petersen House use their ticket from Ford's Theatre for a quick five-minute walkthrough of a few rooms to see what the home looked like when Lincoln died (see figures 3.5 and 3.6).

3.3 A view of Ford's Theatre from 10th St. NW at night (see B on the map). Taken at ISO 1600, f/2, 1/60 second with a 65mm lens.

3.4 A detail from the front of Ford's Theater (see B on the map). Taken at ISO 100, f/4, 1/400 second with a 65mm lens.

3.5 The front parlor of the Petersen House where Mary Lincoln grieved (see C on the map). Taken at ISO 2000, f/4, 1/50 second with a 20mm lens and a flash bounced off the ceiling.

3.6 A desk and period pieces within the Petersen House (see C on the map). Taken at ISO 2000, f/4, 1/50 second with a 50mm lens and a flash bounced off the ceiling.

How Can I Get the Best Shot?

The following sections provide a few tips for taking photos at Ford's Theatre and Peterson House, which are dimly-lit places with limited space to move about.

Equipment

There are two general requirements for taking good photos: space and light. Space is good so that you are able to explore different angles and get a variety of images. Light is good so you can take pictures of decent quality. Inside Ford's Theatre and in the Petersen House, both are constrained to a certain degree.

Lenses

Inside the theater, you want to use about a 70-100mm lens to photograph the Presidential Box from across the theater. There are other vantage points from which to do this, but straight across affords the cleanest view. Taking a wide photo, one in which you see the lines of the theater's balcony, is another option.

Inside of the Petersen House (see figure 3.7), you need a fairly wide lens of between 20-35mm, up to a standard 50mm. Interiors look awfully strange when photographed with ultra-wide lenses, so it's often a good idea to stand as far back as you can and use the longest lens possible to minimize lens distortion.

Extras

You'll notice that within this book, there has been very little talk of flash. The reason is simple: Flash is pretty difficult to master. And using an on-camera flash is a prescription for ugly photos 90 percent of the time. However, to get photographs that were good enough to be used in this book, I resorted to using flash for the Petersen House because it is so dark.

3.7 The bedroom where President Lincoln died (see C on the map). Taken at ISO 2000, f/4, 1/50 second with a 35mm lens and a flash bounced off the ceiling.

I used an accessory flash on my camera that allowed me to aim it at the ceiling, rather than straight at the subject. Why the ceiling? Because direct flash — that is, flash that comes straight from the camera onto the subject — is unflattering. (Think of how good a deer looks in a car's headlights; it's the same effect with on-camera flash.) To get around this, I pointed the flash upward and let it bounce off the white ceiling. This achieves three things:

▶ It softens the harsh light coming from the flash by diffusing it off the ceiling.

▶ It redirects the light to come from a more natural angle.

▶ It broadens the light so that it fills more of the space.

Built-in flashes can't do any of that because they don't angle upward. Many accessory flashes have heads that rotate and swivel for this purpose.

Amazing advances in sensor technology are allowing for ISO speeds far beyond the traditional limits of 3200 or even 6400. The newest cameras have ISO speeds of over 100,000, meaning flash will become even rarer because it simply won't be needed in many cases.

Camera settings

Inside Ford's Theatre, you want to have your ISO set as high as possible. Using your on-camera flash won't do kind things to the photograph of the Presidential Box (see figure 3.1), so unless you have to use it (because your camera doesn't have a high enough ISO setting or the image quality isn't good enough when the ISO is set high), turn it off.

Be sure to use a fast-enough shutter speed to avoid camera shake. If you have a new camera that has very high ISO speeds, the lack of light inside here will be less of a problem. Otherwise there is just enough light here to handhold a camera and get some good shots. Using a monopod could also help to stabilize your lens, or you could brace your hands against the top of a seat or nearby wall.

Holding a camera completely still below 1/30 second is not easy, but it's okay to try if it's needed. Using anything below 1/10 second is not recommended. The photo will almost certainly be blurry.

Outside the theater, shooting is much easier. You can use an Auto, Shutter Priority, or Aperture Priority mode, and concentrate on good composition. Be sure to set your focus on what is most important: the building, rather than any foreground elements you may choose to use in your composition.

In the Petersen House (see figure 3.8), try setting your camera to an automatic mode and, if you're using an accessory flash, point it up at the ceiling. Most cameras that can use an accessory flash will automatically set the flash exposure to work with the flash pointed at the ceiling. (This assumes that you are using an accessory flash that is designed to work with your specific model of camera and can utilize its automatic flash feature.)

Things can get rather complicated quickly here, but a simple way to start is to set up your camera to let in a lot of light, such as 1/30 second at f/4 at ISO 1600. Then turn on your flash and see how the images come out. If the images are too bright, turn down your flash's power until they seem exposed correctly (if your flash enables you to manually change its power settings). If you can't control the flash's power, try raising the aperture value to a higher setting, which can help control the brightness of the flash exposure.

Exposure

Because most of these images are indoors, you want to avoid big crowds and buses of students.

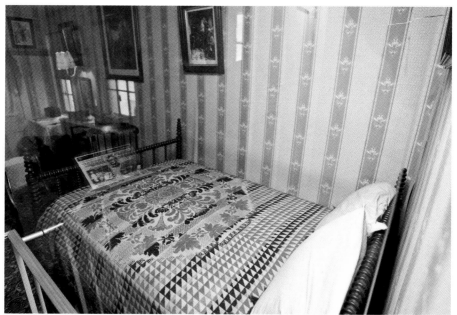

3.8 A replica of President Lincoln's deathbed (see C on the map). Taken at ISO 2000, f/4, 1/40 second at with a 20mm lens and a flash bounced off the ceiling.

Ideal time to shoot

I recommend calling ahead and asking about good times to visit. Early in the week and early in the morning are the standard times when fewer people are here, however. Also, keep in mind that Ford's Theatre is a working theater, so you have to plan your trip around show dates. See www.fordstheatre.org for more information on when to visit.

Low-light and night options

Night shots of the exterior of Ford's Theatre are nice because of the gas lamps and the interesting look night gives to any photo. However, the tours of Ford's Theatre and Petersen House are only given during mostly daylight hours, so you won't be able to make any interior photographs at night.

4 Franklin Delano Roosevelt Memorial

A portrait of Franklin D. Roosevelt's statue by sculptor Robert Graham at the beginning of the memorial. Taken at ISO 100, f/1.4, 1/200 second with a 65mm lens.

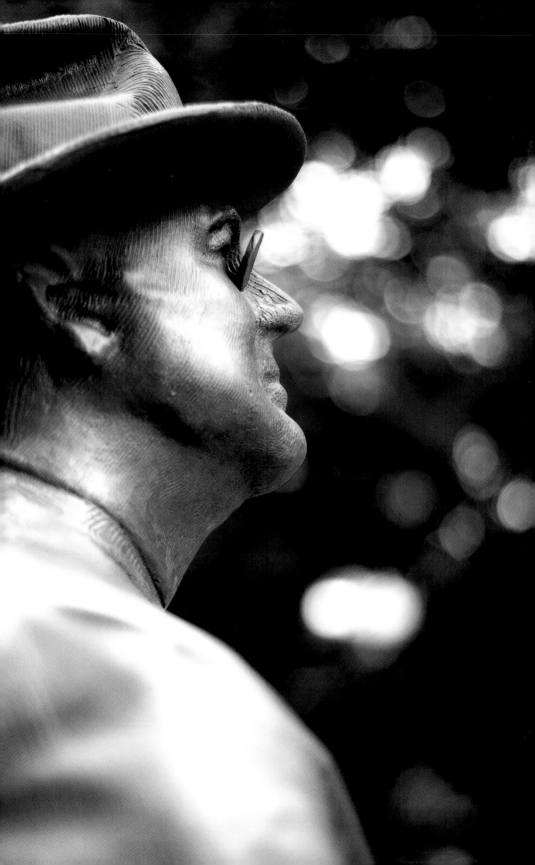

Why It's Worth a Photograph

President Franklin Delano Roosevelt was the United States' thirty-second president, elected in 1932 at the nadir of a financial catastrophe that forever defined American history, the Great Depression. His persona, leadership, and the era in which he governed are all represented through artwork, waterfalls, trees, statuary, and quotations organized into four "rooms" of the memorial on a total of 7.5 acres. The rooms represent his unprecedented four terms in the office of President from 1933-1945.

The FDR Memorial isn't one that is overtly photogenic like the Jefferson and Lincoln Memorials. It is much more subtle in nature and built in a way that inspires contemplation rather than all-out awe. Two of the greater shocks to humanity of the twentieth century, the Great Depression and World War II, are events that shaped this time, and the somber and reflective tone of this memorial reflects that period.

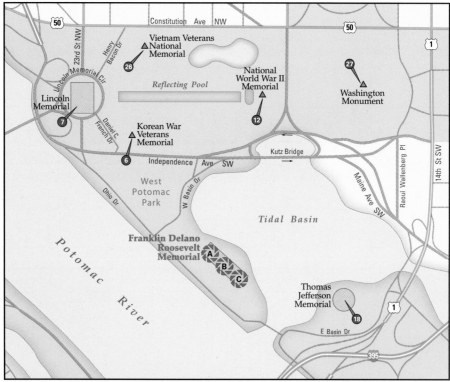

The best locations from which to photograph the Franklin Delano Roosevelt Memorial: (A) Room 2, (B) waterfalls in Room 3 and Room 4, and (C) Neil Estern's FDR statue. Nearby photo ops: (6) Korean War Veterans Memorial, (7) Lincoln Memorial, (12) National World War II Memorial, (18) Thomas Jefferson Memorial, (26) Vietnam Veterans National Memorial, and (27) Washington Monument.

Where Can I Get the Best Shot?

Unlike other landmarks in the area that are mammoth in size, the FDR Memorial's intimate setting poses quite a different photographic challenge.

Room 2

George Segal created *The Breadline* for the FDR Memorial in 1991. Segal was part of the Pop Art movement along with Roy Lichtenstein and Andy Warhol. You can see his other iconic public sculptures in areas such as the Golden Gate Park and the Port Authority Bus Terminal in New York.

It's a rather immediate reaction for tourists to line up with the men and take snapshots of themselves. While this is tempting, it seems to all but obfuscate the very serious and somber demeanor of the artwork. The weather and tourist-polished bronze figures both soak up and reflect light in a beautiful manner and are eminently photographable, as are all of Segal's sculptures in this room (see figure 4.1).

Waterfalls in Room 3 and Room 4

War dominated President Roosevelt's third term in office. The loud, crashing water hammering chaotically placed boulders reflects the stresses of World War II on the

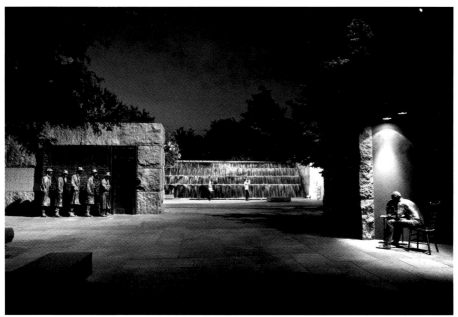

4.1 Room 2 of the FDR Memorial at night (see A on the map). Taken at ISO 3200 f/2.8, 1/6 second using a 24mm lens.

world, the country, and the President himself in Room 3 of the FDR Memorial (see figure 4.2). At the end of the memorial, a larger waterfall in front of a wide open space allows visitors to pause and think about what it represents: This was a time in U.S. history that was filled with unprecedented turmoil as well as significant forward progress.

The waterfalls were created both for their symbolic nature as well as the memorial's proximity to the landing path of Reagan National Airport. The waterfalls help to drown out the whine of the aircraft.

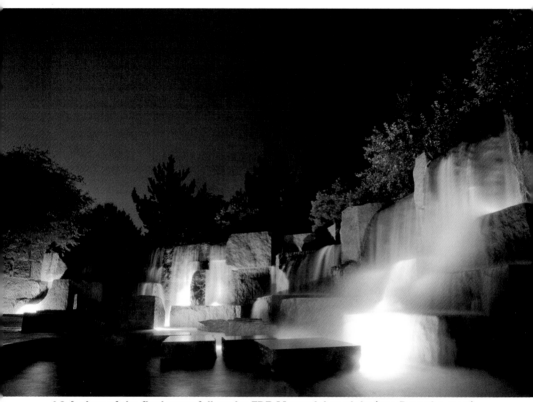

4.2 A view of the final waterfall at the FDR Memorial at night (see B on the map). Taken at ISO 400, f/10, 5 seconds with a 20mm lens and a table-top tripod.

Neil Estern's FDR statue

The FDR statue in Room 3 is larger than life but in a scale that lets a viewer enjoy the detailed precision of the art work and feel as if you are standing in a room with him. His commanding presence is offset somewhat by his dog, Fala, sitting obediently to his side (see figure 4.3).

Photographing the statue here gives you a choice: You can create a simple record of what you saw — Roosevelt with his dog — or you can focus on the subtleties and create a portrait from the shadowy, intricate details that Estern carefully imbued into his artwork. Roosevelt's sculpted hair, the lines on his forehead, the manner in which his fingers drop — there's much to take in.

How Can I Get the Best Shot?

At the FDR Memorial, plan on spending some time taking in its symbolism as well as how to best compose your image. You may want to sit down and watch as people drift in and out, and consider different compositions and interpretations of the site.

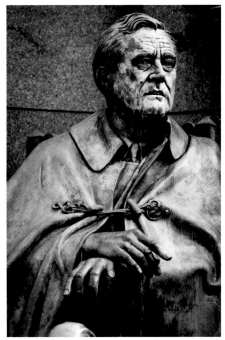

4.3 Estern's FDR statue taken on an overcast, late afternoon (see C on the map). Taken at ISO 400, f/4, 1/640 second with a 260mm lens.

Equipment

A trip here requires more of an investment in composition and using the light to your advantage than a multitude of lenses or other gear.

Lenses

For the photograph in Room 2, (refer to figure 4.1), you can shoot it a variety of ways: close and with a wide lens, using a normal focal length lens, or farther away with a longer lens. When changing focal lengths, be sure to experiment with a variety of positions with each focal length. And try to get out of the habit of standing a standard distance and height from your subject. For example, what does the scene look like from very low? Or can you make the shot more interesting by including a foreground element by standing farther away? Also experiment with horizontal and vertical photos as well.

When photographing the waterfalls (refer to figure 4.2), getting in close and using a wide lens creates a sense of "being there" (and will also risk getting you and your camera a bit wet — having a small towel with you can help). If you don't have a wide-angle lens you can always do a tighter version, focusing on a graphically elegant part of the waterfall.

Typically, longer focal length lenses are best for portraits (the standard *portrait lens* often refers to an 85mm focal length), and at the FDR Memorial it is a good idea to start with such a lens when photographing statues. Try to use longer lenses to clean up the background (the longer lenses make it easier to drop the backgrounds out of focus) and to focus on elements of the statue. Even though they aren't living people, there is little difference between them and a living person when you're photographing — other than a statue's unparalleled patience.

 Wide-angle lenses distort features of a person in a way that is rarely becoming. This includes statues, so remember that when you photograph the many statues in the FDR Memorial.

Filters

With a lot of images, a polarizer or neutral density filter is a good idea. Here, a basic, protective filter over your lens can help shield your lens from water spray. The standard UV protecting filter is an especially good idea when you are around water because it keeps moisture from landing on the front of the lens.

Extras

For nighttime and when photographing the water at slow shutter speeds (to get the "flowing" effect), a tripod is necessary (refer to figure 4.2). However, during peak periods the guards often do not allow full-size tripods to be used, but there are a variety of places where a small, table-top tripod is perfectly suitable. When using a tripod, please be aware of other visitors and if asked by park police to not use it, you should of course respect their request. Instead, plan to return late or at night or early in the morning when few or no visitors will be there.

 Buses often unload throngs of tourists, and those tourists are often only there for a few minutes before they are whisked away to the next stop. A few minutes of waiting may be all you need for more space.

Camera settings

During the day, use your camera's Aperture Priority mode to set a wide aperture, such as f/4 to minimize background distractions when photographing statues and artwork. When shooting with wide-angle lenses and close to subjects, set a higher aperture and focus on something that is slightly in the foreground. Doing so helps to get the entire photograph in focus.

If you want the cool, slow-shutter speed waterfall photo, be sure to acquaint yourself with how to set such shutter speeds beforehand. If you use Shutter Speed Priority mode, keep in mind that your camera may set a very wide aperture at night and thus focusing will be more critical. To get around this, use your camera's manual setting if possible, or use Aperture Priority mode, and use a higher aperture value such as f/11 that causes your camera to automatically set a long shutter speed.

Setting your color balance is more important if you are visiting at night; during the day, most cameras' Auto white balance does a reasonable job, because the scenes are mostly neutral colors. At night, experiment with different white balance settings. The yellowish lights in the memorial give you the opportunity to use their color to your advantage to make a warm scene, or you can set your camera to its tungsten setting to whiten them to some degree.

Finally, at night the waterfalls are perfect candidates to be photographed using a *high-dynamic range method* (HDR). Your eyes can see an extremely wide range of light to dark tones, much more than a camera can record. What your camera is able to "see" is defined by its *dynamic range*. To get around this limitation of a camera, you can create multiple photographs of the exact same picture but vary each photo's exposure from very dark to very light.

By using software designed to do so, you can blend these photographs together to get around the dynamic range limitations inherent to a camera. To do this, you can use your camera's exposure compensation feature and step it from 3-stops underexposed in equal parts to 3-stops overexposed. If you do this in 1-stop steps, you will have three underexposed photographs, one normal exposure, and three overexposed photographs to work with afterwards.

Exposure

The FDR Memorial is one where you can shoot in almost any weather and any light, and come away with something interesting.

Ideal time to shoot

The FDR Memorial sits in a mostly north-south orientation, which means morning and evening are times you can take advantage of the good light. However, cloudy days mean the memorial is evenly lit, which makes for wonderful light to shoot in, too. An overhead sun on a cloudless day presents some challenges regarding contrast and reflections, but try to use whatever light you have to your advantage.

For example, if it's overcast and there are subtle shadows, you can shoot tighter shots of the statues' heads; you'll be able to easily see detail in the shadows. But if the sun is direct, and overhead, you may want to show the entire scene of, say, Estern's FDR statue because the hard shadows show abundant textures and give depth to the entire artwork.

Working around the weather

Oddly enough, this memorial can be great to shoot just before or after a rain. Just like movie sets use water-drenched streets to evoke a mood, so too will rain here. The rain-slickened rock glistens and reflects the statues and artwork and creates a completely different feel from a dry, sunny day — especially at night.

Low-light and night options

Here the difference between day and night is stark. Although a bit more challenging, night is an interesting time to photograph here, particularly to photograph the waterfalls. At night, the dark stone fades away and the artwork glows. You need a tripod, whether it be a small, portable one or a full-size model.

The published hours of the memorial are 9:30 a.m. to 11:30 p.m., but this is only when rangers are available to answer questions and give tours. The actual monument, like most monuments in Washington, D.C., is accessible 24 hours a day, seven days a week. If you are looking for fewer crowds at night, plan on going after 10 p.m. (earlier if it is off season).

Getting creative

The many bronze artworks at the FDR Memorial can be interesting to photograph in color or black and white. Experiment with close-up shots of such details that may go unnoticed by people otherwise. Consider composing your shot with people in it to add a sense of scale and interest to the photo. Finally, be sure to view the exhibits from positions other than your normal conversational distance — go extra close as well as farther away — and see what ideas come to mind for photographs.

 Much of the artwork in the FDR Memorial is copyrighted. Commercial use of photographs requires the permission of the copyright holder, generally the artist of the work. See www.copyright.gov for more information.

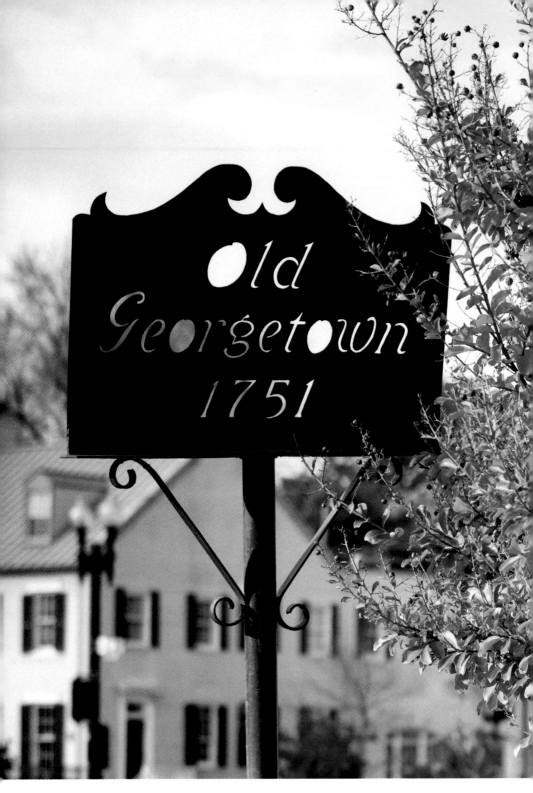

A sign denoting the beginnings of Georgetown, along Pennsylvania Avenue. Taken at ISO 100, f/4, 1/125 second with a 100mm lens.

5 Georgetown

Why It's Worth a Photograph

Georgetown predates Washington, D.C. by a fair amount of time. It was an important area for trade and also was the farthest vessels could navigate up the Potomac River. Today, it is a confluence of old money, college students, trendy shopping, politicking, and Washington, D.C. history.

Two of the popular historical features of Georgetown that are interesting to photograph are the Chesapeake and Ohio Canal (known as the C&O) and the Old Stone House.

The C&O Canal was created to join the headwaters of the Ohio River in western Pennsylvania with the tidewater of the Potomac River in D.C. An intact section of it still operates in the middle of Georgetown, and you can take rides on a canal boat during the warm months of the year.

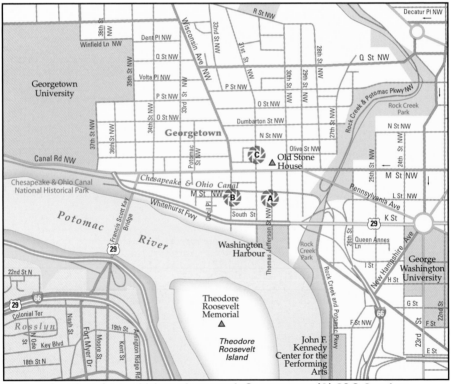

The best locations from which to photograph Georgetown: (A) C&O Canal at Thomas Jefferson St. NW, (B) the C&O Canal at Wisconsin Avenue, and (C) The Old Stone House.

The Old Stone House is the oldest structure in Washington, D.C., thanks to a rumor many years ago that George Washington and Pierre L'Enfant had met at the house on several occasions. (They apparently had actually been meeting at nearby Suter's Tavern).

Where Can I Get the Best Shot?

After you are done shopping and eating cupcakes, here are a few historic places to photograph Georgetown.

C&O Canal at Thomas Jefferson St. NW

At this location along the C&O Canal, you can see a functioning lock along with a historic row of Georgetown townhouses in the background (see figures 5.1 and 5.2). During the warm months some of the locks in this area are in use, giving you more to photograph.

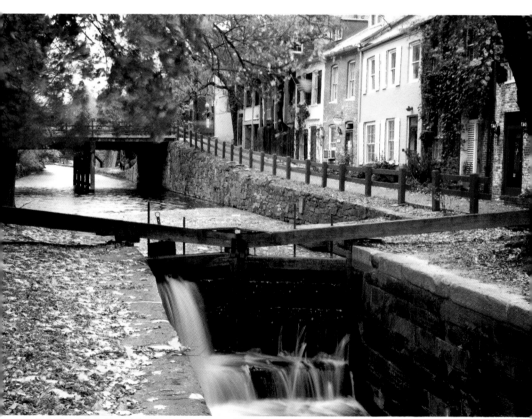

5.1 The C&O Canal in Georgetown at Thomas Jefferson St NW (see A on the map). Taken at ISO 100, f/22, 1/8 second with a 50mm lens and using a tripod.

C&O Canal at Wisconsin Avenue

Just next to Wisconsin Avenue, you can take a set of stairs down to the C&O Canal — just to the west is one of the historic bridges that spans the canal (see figure 5.3). Historic buildings are located along this area, and you can get a sense of what the original George Town was like when paper, textile, and flour mills were the lifeblood of the area.

Old Stone House

Visiting the Old Stone House can be a different photo excursion compared to the rest of the big-name places to visit in D.C. When you enter, you are greeted at the door and then you can walk through the house and the garden to see how things looked for common people in Washington, D.C., in the late 1700s (see figures 5.4 through 5.6).

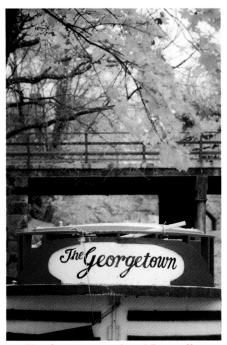

5.2 The Georgetown Canal Boat offers rides during warm months through Georgetown on the C&O Canal (see A on the map). Taken at ISO 400, f/4, 1/200 second with a 150mm lens.

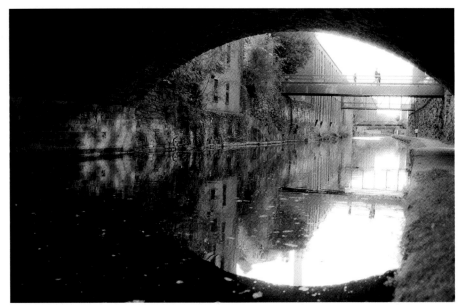

5.3 Looking along the C&O Canal at Wisconsin Avenue (see B on the map). Taken at ISO 200, f/2, 1/500 second with a 35mm lens.

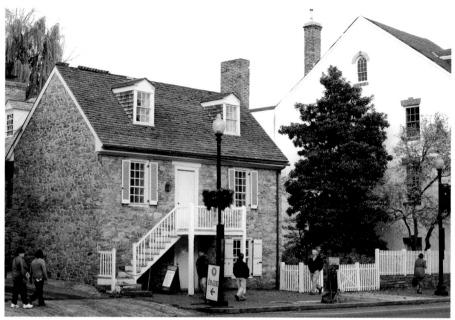

5.4 The Old Stone House photographed from across M St NW (see C on the map). Taken at ISO 100, f/5.6, 1/100 second with a 65mm lens.

How Can I Get the Best Shot?

Georgetown is an enjoyable place to take a walk through the streets, as well as for a few pictures along the way.

Equipment

Perhaps it's the antique charm of Georgetown that makes using simple gear with little fuss a good idea.

Lenses

All the photos in this chapter can be made by using basic lenses that are found on most zooms and popular prime (fixed) lenses such as 35mm, 50mm, and 70mm.

5.5 One of the rooms within the Old Stone House (see C on the map). Taken at ISO 1600, f/4, 1/15 second with a 35mm lens.

5.6 Details from the kitchen of the Old Stone House (see C on the map). Taken at ISO 1600, f/4, 1/30 second with a 50mm lens.

Extras

You may want to bring some extra money for a bite to eat and a little shopping. Other than that, you won't need much else. A tripod isn't recommended inside of the Old Stone House due to the building's small size — there's barely enough room to walk though it two abreast.

Camera settings

Most of these photographs could all be handled well using your camera's Program mode or another automatic function such as Aperture Priority — you may just need to be very still when taking them because there may be little light within the Old Stone House (refer to figures 5.4 through 5.7). Definitely avoid using a flash inside the house — that's the easiest way to make what would otherwise be a quaint, simple photograph look over-lit and harsh. The window light is a big part of the old-world feel here.

For the images of the C&O Canal (refer to figures 5.1 through 5.3), try setting a normal aperture of f/8 and focus within the middle of the image. Doing so ensures

that you have enough focus in the foreground and background. Of course, you can also try to use very low aperture values, such as f/2.8, to capture a different look, especially if you convert the photograph to black-and-white.

Exposure

Experiment by photographing at different times of the day and play with your composition.

Ideal time to shoot

At the C&O Canal, you can get good pictures at almost any time during the day, although early and later in the day look more interesting because the light spills across the canal at more of an angle.

5.7 A bedroom within the Old Stone House (see C on the map). Taken at ISO 3200, f/4, 1/15 second with a 50mm lens.

At the Old Stone House, having more light to work with makes your photo better. An overcast day's soft shadows work nicely with lighting the interior of the house, but it's a tradeoff between brightness and subtle lighting.

Working around the weather

Interesting weather, such as snow and rainstorms, can make for great photos along the canal. And there are almost too many good places nearby to take refuge in Georgetown if the elements become unbearable.

Low-light and night options

The Old Stone House is only open during business hours, so any low light or night photography is limited to outdoor shots.

Nighttime, tripod-mounted views of the canal work very well. There's usually ample light from the city illuminating the scene.

The Korean War Veterans Memorial on a snowy day. Taken at ISO 640, f/4, 1/400 second with a 180mm lens.

Korean War Veterans Memorial

Why It's Worth a Photograph

The Korean War Veterans Memorial honors members of the United States Armed Forces who served in the Korean War, especially those who were killed in action, are still missing in action, or were held as prisoners of war. The memorial was dedicated in 1994 by President Bill Clinton with South Korean President Kim Young Sam.

The memorial consists of 19 stainless-steel statues, depicting soldiers from the Army, Marines, Navy, and Air Force on patrol during the Korean War. Next to the statues is the Mural Wall, a 164-foot-long mural that has some 2,400 photographs of the Korean War from the National Archives. The reflective nature of the wall is also meant to double the number of soldiers to 38, which is symbolic of the 38th parallel as well as the number of months that the conflict lasted.

The best locations from which to photograph the Korean War Veterans Memorial: (A) next to the U.S. Flag and (B) the Mural Wall. Nearby photo ops: (7) Lincoln Memorial, (12) National World War II Memorial, (27) Washington Monument, and (28) White House and President's Park.

Where Can I Get the Best Shot?

The Korean War Veterans Memorial is along the west end of the National Mall, southeast of the Lincoln Memorial.

Next to the Column

A prime view of the Korean War Veterans Memorial is next to the U.S. Flag, placed at the front of the formation of troops on patrol. From here, you can photograph the memorial a variety of ways. When viewed from this direction, the soldiers appear to be coming from out of the dark woods which creates the feeling that there could be more soldiers within the woods. Another interesting image can be made from behind the statues, giving the viewer a feeling of being with the group of soldiers (see figure 6.1).

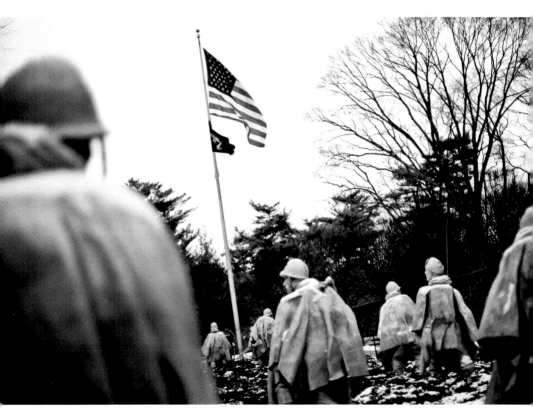

6.1 The Korean War Veterans Memorial gives a viewer a unique feeling of "being there" (see A on the map). Taken at ISO 200, f/1.4, 1/1250 second with a 65mm lens.

The Mural Wall

The Mural Wall, designed by Louis Nelson, is covered with images from the National Archives of the Korean War, and it's a fascinating sight to see so many faces from the conflict (see figures 6.2 and 6.3). The wall is organized by Army, Navy, Marine Corps, Air Force, and Coast Guard and depicts the various roles of each armed force. Note, too, that the people pictured on the wall are facing the statues of the troops.

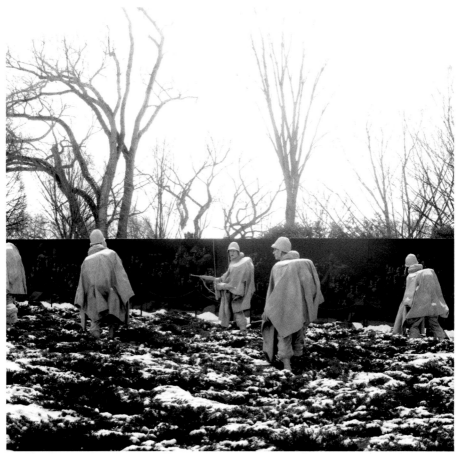

6.2 The Korean War Veterans Memorial on a snowy day (see B on the map). Taken at ISO 500, f/8, 1/400 second using a 90mm lens.

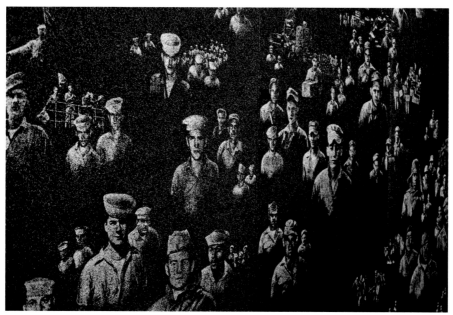

6.3 A detail of the Mural Wall at the Korean War Veterans Memorial, designed by Louis Nelson (see B on the map). Taken at ISO 400, f/5, 1/60 second with a 65mm lens.

How Can I Get the Best Shot?

When faced with a scene that has many elements, try to show parts of the whole to make a strong photograph, rather than attempt to capture it all in one picture.

Equipment

The Korean War Veterans Memorial is a starkly straightforward memorial, but you can photograph it in a number of ways.

Lenses

For the image from the U.S. Flag looking west or from the opposite side looking east (refer to figure 6.1), use a moderately long focal-length lens (70mm or longer) to compress some of the statues together. Some images can be made with wider lenses as well. The best lens to use depends on your composition and what ideas you have.

Filters

A polarizing filter works very well on the Mural Wall (refer to figure 6.3) to remove any reflections cast by other visitors (of which there may be a lot).

Camera settings

When shooting from the U.S. Flag (refer to figure 6.1), set your camera to Aperture Priority mode and set a low aperture value of between f/4 to f/5.6. Doing so helps to provide a limited depth of field and, depending on where you focus, enhances the strength of your image by blurring out anything extraneous in the background.

Exposure

The manageable size and clean appearance of this memorial make photographing it a rather straightforward endeavor, as compared to some of the other memorials that require more time and exploration.

Ideal time to shoot

You can photograph here at almost any time during the day, because it is always accessible. I recommend shooting earlier in the day so that you can get a clean view without many other visitors.

Working around the weather

Because the statues are wearing rain ponchos, it seems right to photograph here in overcast, wet conditions. If you're lucky enough to be here during fog or snow, that weather will only enhance your photo.

Low-light and night options

Nighttime shots here are possible, but the kind of lighting directed on the statues is very contrasty and also not very consistent from statue to statue — both in color and in strength. If you are going to be at the memorial at night, there are certainly opportunities, but it will be more of a challenge than during daylight hours.

Try turning your flash off and look for compositions that use a well-lit statue in the foreground and a few others in the background to give the image a sense of space.

Getting creative

You may try for a photo of the statues reflected in the Mural Wall. However, capturing an image that conveys both the statues and the photographs on the Mural Wall in a way that reads well can be difficult depending on the lighting. Look for

Copyright at the Memorial

It may surprise you to learn that the artwork in the Korean War Veterans Memorial is copyrighted by the artists and/or by the Korean War Veterans Memorial Foundation.

The Korean War Veterans Memorial Foundation, Inc. was created to make grants to the National Park Service to supplement the maintenance of the Korean War Veterans Memorial, protect the copyright of the Memorial, and to support the continuing process of educating future generations about the Korean War and its impact on the world. The organization raises money through donations, sales of products such as video tours of the Memorial, and interactive documentaries about it. For more information see their Web site: www.koreanwarvetsmemorial.org.

Photography here for personal use is acceptable. Commercial use requires permission from the copyright holders. See www.koreanwarvetsmemfnd.org for more information.

reflections of the statues in the Mural Wall from various angles, and use the actual statues in the foreground of the photo.

You can find several areas where the numbers of casualties are given as well as the memorial's "Freedom is not free" quote. People often leave wreaths next to this quote — another possible photo opportunity.

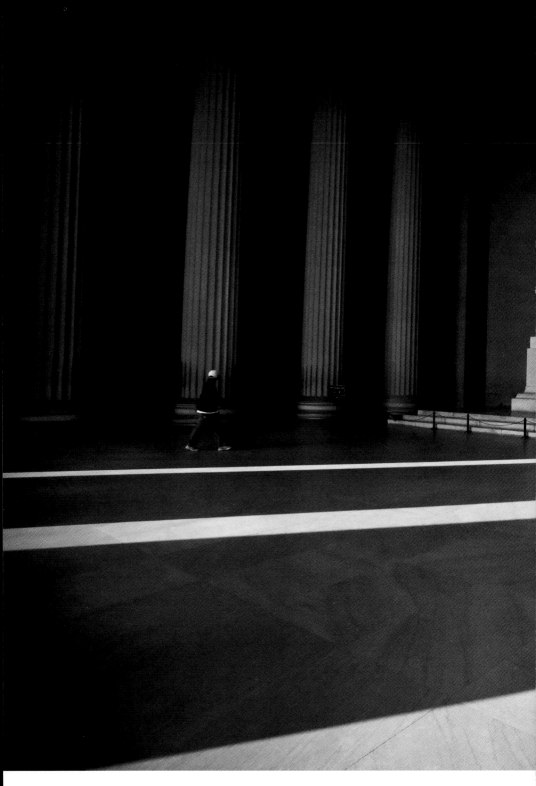

The interior of the Lincoln Memorial as the autumn sun rises. Taken at ISO 400, f/10, 1/100 second with a 16mm lens.

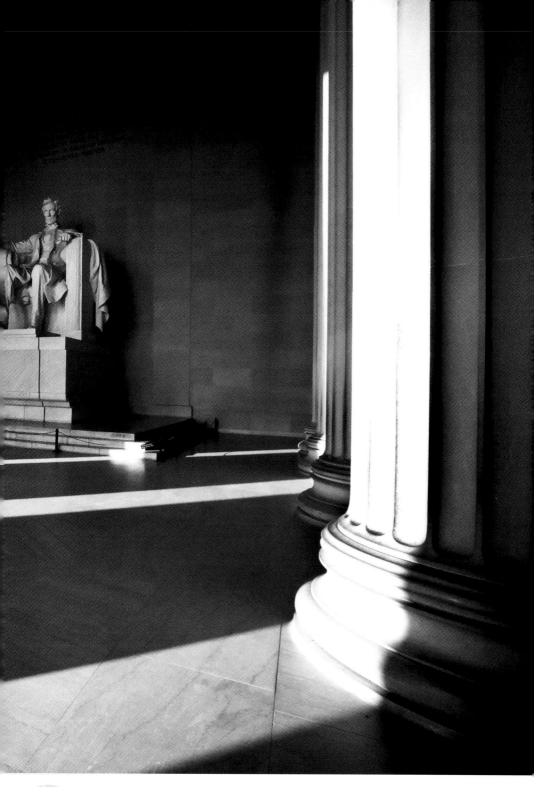

7 Lincoln Memorial

Why It's Worth a Photograph

The Neoclassical temple of the Lincoln Memorial is a tribute to Abraham Lincoln, sixteenth president of the United States. President Lincoln oversaw the end of the American Civil War and the reuniting of the Confederate and Union states under one flag, as well as the ending of slavery through his Emancipation Proclamation.

Where Can I Get the Best Shot?

There are great vantage points of the Lincoln Memorial from several areas; the locations described here concentrate on areas where the sculpture of Lincoln is viewable within the photograph.

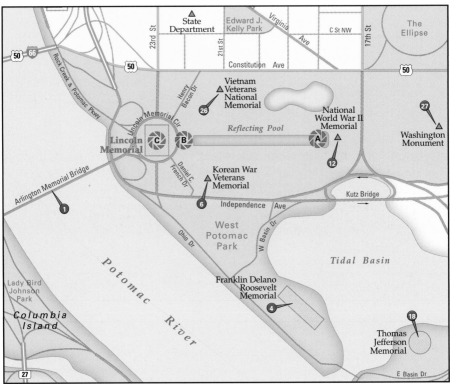

The best locations from which to photograph the Lincoln Memorial: (A) east end of the Lincoln Reflecting Pool, (B) east side of the memorial, and (C) inside the memorial. Nearby photo ops: (1) Arlington Memorial Bridge, (4) Franklin Delano Roosevelt Memorial, (6) Korean War Veterans Memorial, (12) National World War II Memorial, (18) Thomas Jefferson Memorial, (26) Vietnam Veterans National Memorial, and (27) Washington Monument.

East end of Lincoln Reflecting Pool

Looking out over the Lincoln Reflecting Pool offers a nice view of the memorial during most any time of the day (see figure 7.1). Here, you can photograph the memorial using a wider lens to get the trees that line the pool, or you can use a longer lens to capture the memorial's reflection in the water. You'll be standing just between the Reflecting Pool and the World War II Memorial — by facing toward the Washington Monument, you get a great vantage point looking east as well.

East side of the memorial

Closer in to the memorial, there are a number of ways to photograph it. The first is to get an overall shot of its exterior (see figure 7.2), while other images (such as figure 7.3) can include the details of the building along with the statue, or just images of its many architectural features.

Inside the memorial

It's definitely worth a walk around the inside of the Lincoln Memorial to read his words, view the paintings, and take in the grand spectacle before you. Figures 7.4 and 7.5 can be done to a varying degree at anytime during the day.

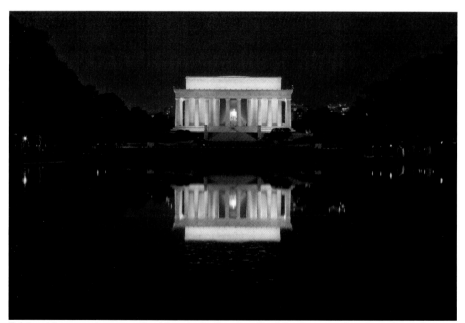

7.1 Looking west across the Lincoln Reflecting Pool in the morning (see A on the map). Taken at ISO 250, f/11, 6 seconds with a 120mm lens mounted on a tripod.

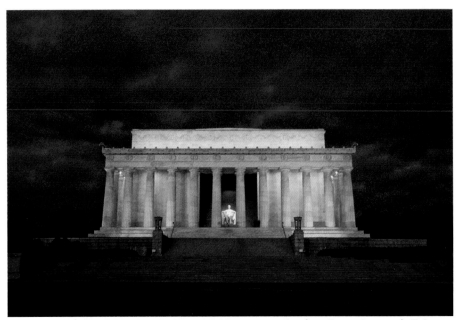

7.2 The east side of the Lincoln Memorial just at sunrise (see B on the map). Taken at ISO 400, f/18, 5 seconds with a 35mm lens and a tripod.

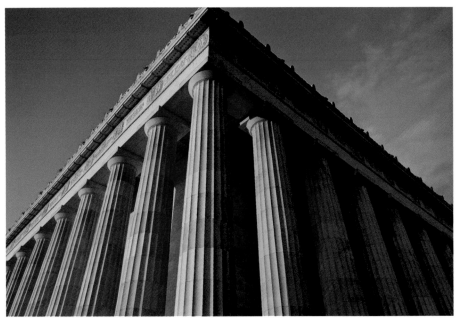

7.3 A detail image of the Lincoln Memorial's exterior (see B on the map). Taken at ISO 125, f/8, 1/80 second with a 28mm lens.

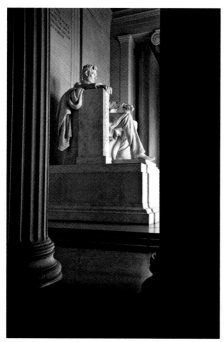

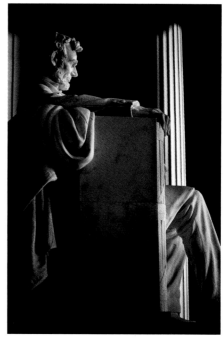

7.4 The Lincoln statue seen through columns from the inside south side (see C on the map). Taken at ISO 500, f/5.6, 1/60 second with a 35mm lens.

7.5 Using a longer lens to frame the statue of Lincoln minimizes distractions — a good idea if the interior of the memorial is crowded with other visitors (see C on the map). Taken at ISO 1000, f/4, 1/100 second with a 120mm lens.

How Can I Get the Best Shot?

Plan to spend some time at the Lincoln Memorial, whether it is for photography or just taking it all in. Of all D.C.'s memorials, the Lincoln stands out by virtue of its welcoming and majestic setting that allures people to sit on its steps and linger for hours.

Equipment

A variety of different images can be taken here using many different focal lengths.

Lenses

When looking across the Lincoln Reflecting Pool (refer to figure 7.1), focal lengths between 50-200mm can be used, depending on how wide or tight you want to shoot. As you get closer to the memorial and are working on the west side of the Reflecting Pool, a standard 35mm lens works well to capture the front of the

memorial from the area below the last set of stairs, next to the cement blocks that form the border between Lincoln Memorial Circle. Inside the memorial, the images vary from quite wide (20mm) to rather tight (100-120mm).

Filters

Adjusting the exposure of the sky by using a graduated neutral density can work well here, depending on how bright the sky is and how much of it is in your composition. Otherwise, using a software-based graduated filter to adjust contrast in your image can help balance out areas of extreme contrast. For example, if you are photographing the exterior of the memorial during the day, often the statue within the memorial will be quite dark.

Sometimes the exposure will just be too extreme (especially in periods of bright, late morning sun), but by reducing the exposure on the outside of the building using a software-based graduated filter, you can balance out the brightness to some degree. Also, when photographing details of the building that include sky, a polarizing filter can help darken and increase the saturation of the sky and the contrast with the clouds.

Extras

Tripods are not allowed within the Lincoln Memorial, or any part of its marble exterior. The general rule explained by the guards here is that they aren't to be used until after the second set of stairs that lead to the entrance of the memorial. As with all the major landmarks in D.C., the rules may change from time to time, so it's best to ask a guard or National Park Service official at the monument to double-check. A very small, table-top tripod is a good alternative for areas of the memorial where regular tripods are not allowed.

 Carry a piece of newspaper to put under small tripods so they don't touch the memorial.

You can also use a table-top tripod to capture the front exterior shot (refer to figure 7.2) by placing it on one of the cement blocks along Lincoln Memorial Circle. This can be a great weight and space saving idea if you choose not to carry a full-size tripod.

 A polite greeting and an inquiry to a staff member about where tripods may be used at such venues is a good idea at such popular locations. By doing so, you'll often get a few tips about good locations and other helpful information as well.

Camera settings

The important thing to remember at the Lincoln Memorial is that you'll often be photographing areas of great contrast, especially inside the monument. If you are using your camera's Priority modes, you may have to adjust the exposure compensation to get your desired look because of the brightness of the memorial.

For example, when looking into the memorial from its steps (see figure 7.6), the areas outside are very bright and reflect a lot of light, while the interior of the memorial is quite dark. You want to get an exposure that balances the two, which often means a compromise between either light or dark.

Figure 7.6 has areas of very dark tones and very light ones, and it was important to preserve some details inside while keeping the outside from being too bright. This is a situation that will fool many a camera's meter, so do some test shots and adjust your exposure up or down by using the exposure compensation feature.

If you want to do long exposures on a tripod, logic says to use Shutter Priority mode to set a long shutter speed. However, many cameras compensate by setting a very low aperture value. Instead, you can trick your camera into using a long shutter speed by using Aperture Priority mode and then setting a high aperture value of, say, f/16 if it is at night. With a low ISO setting between 100 and 400, your camera will then set a fairly long shutter speed. Also, if your camera has a Night mode, that may work well, too.

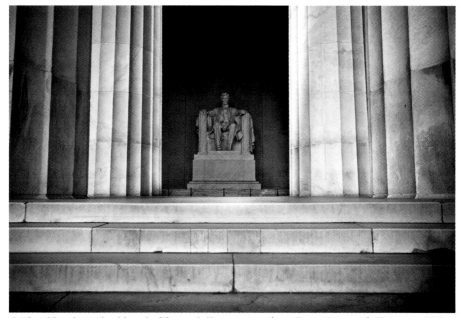

7.6 Looking into the Lincoln Memorial's entrance (see B on the map). Taken at ISO 100, f/4.5, 1/100 second using a 28mm lens.

No matter what you do, turn your flash off when you are here. You want to use either natural light to photograph the statue inside, or the decently bright spotlights on the statue itself. On-camera flash used on the statue can turn the otherwise beautiful work of art into something quite garish. When looking out across the mall from the memorial, having a flash on will do nothing but waste your batteries and possibly get a very bright fellow visitor in the frame.

Exposure

There are great photo opportunities here year-round and basically all day and night (see figure 7.7).

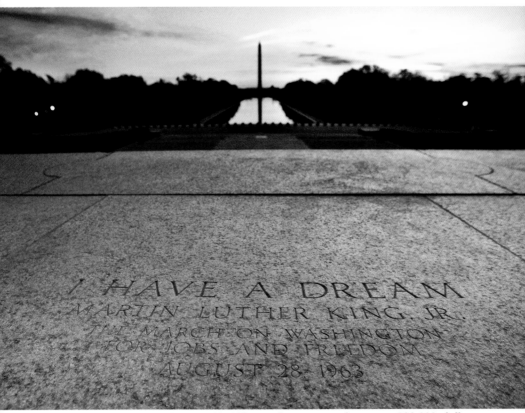

7.7 Martin Luther King, Jr. gave his I Have a Dream speech to over 200,000 civil rights supporters on the steps of the Lincoln Memorial in 1963 (see B on the map). Taken at ISO 800, f/4, 1/50 second with a 20mm lens.

Ideal time to shoot

The Lincoln Memorial is by the far one of the most visited monuments in D.C. There's a good chance that when you are there, many other visitors will be, too. During peak tourist times, there will be hundreds of people inside and outside the memorial. You can actually use this to your advantage; people turn the area into something akin to Paris's Montmartre on a warm summer's evening. But, if you're looking to get images that aren't crowded with people, think either early morning or at night. It's open all the time, so there's plenty of time to explore.

The memorial faces due east, and it is nothing short of spectacular to watch the sun rise over the Capitol, the National Mall, Smithsonian Castle, Washington Monument, and finally the World War II Memorial. During the morning from spring through late summer, the rising eastern sun spills into the inside of the memorial. Figure 7.8 shows the statue of President Lincoln illuminated in early sunlight.

Working around the weather

If the weather isn't cooperating, you can take plenty of good shots inside the memorial, so you could concentrate your efforts there. Otherwise, try to take advantage of what you are given: If there are big clouds and a blue sky, use those as part of your composition with architectural details. If, however, there is a lot of direct sun, you may have to limit your exterior images if you're also trying to get the statue in the photos — the contrast will likely be too great.

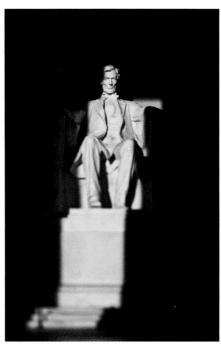

7.8 The statue of Lincoln as the morning sun rises (see C on the map). Taken at ISO 100, f/4, 1/1000 second with a 90mm tilt-shift lens (which creates the blurred effect at the top and bottom of the image).

Overcast days are therefore great here because the lack of contrast means more opportunities for displaying the exterior and interior areas in the same shot.

Low-light and night options

The Lincoln Memorial is an absolutely great subject at night for two reasons: The statue stands out in a dark night brilliantly, and there are often fewer people to contend with. There are also fantastic images to be taken of the National Mall from the Lincoln at night as well.

Interior images of the Lincoln statue at night require a high ISO to avoid using flash. On-camera built-in and accessory flashes will cast a large shadow behind the statue of Lincoln and are only really powerful enough to partially light the statue, so it's best to avoid using one. Inside photos at night work well because the background goes very dark and helps the Lincoln statue to stand out well. More modern cameras with quality high ISO settings and *faster* lenses (with lower aperture values) will make this easier, because tripods are not allowed here. No matter what, use a steady hand and take several pictures in a row if you are using slower shutter speeds, to ensure that you get at least one frame tack sharp and free of camera-shake blur.

Getting creative

There are many more ways to photograph the Lincoln Memorial, and some are clearly reminiscent of famous photographs of the Parthenon in Greece (see figure 7.9).

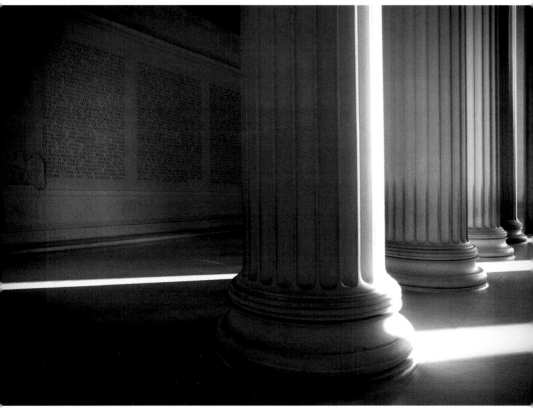

7.9 Explore all the angles when inside the Lincoln Memorial. Here the north wall is seen with the morning sun casting across it (see C on the map). Taken at ISO 500, f/5, 1/60 second with a 20mm lens.

As you can see also from the toned black-and-white photographs featured in this chapter, the Lincoln Memorial's subtle gradations of light inside during the day and the artificial light at night work well for such styles of photography.

Finally, try tilting your camera a bit to change the composition of your images. While it may annoy some purists to no end, doing so can also help to create a more interesting and dynamic composition, if used cautiously, of the Lincoln statue (see figure 7.10).

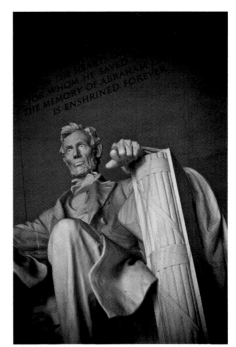

7.10 Try tilting your camera a bit to get a more dynamic composition of the statue of Lincoln (see C on the map). Taken at ISO 400, f/5, 1/160 second with a 70mm lens.

A view from the east side of the Mount Vernon mansion. Taken at ISO 200, f/8,1/100 second using a 20mm lens.

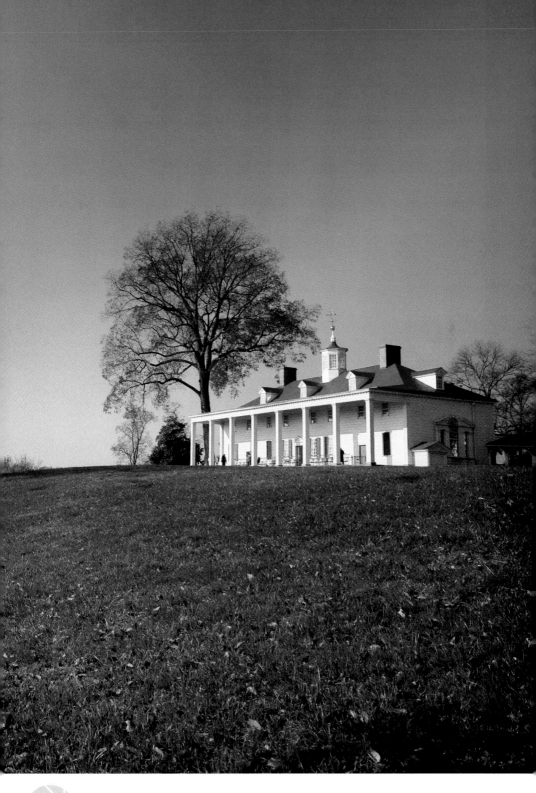

8 Mount Vernon Estate

Why It's Worth a Photograph

Mount Vernon, George Washington's estate and final resting place, is a few miles down the Potomac River from Washington, D.C.

The area open to the public is where Washington and his family lived, and is called Mansion House Farm. Washington designed the 500 acres to be largely self-sustaining. He began living there when he was just three years old, when Augustine Washington, his father, moved there in 1735.

Washington lived on the property for over 45 years, with the notable exception of his time as the commander in chief of the Continental Army during the Revolutionary War and his time as the first President of the United States.

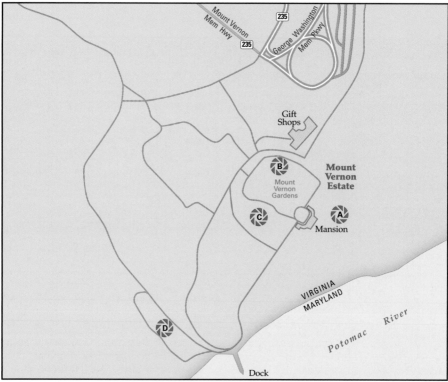

The best locations from which to photograph Mount Vernon Estate: (A) East mansion lawn, (B) west side of the mansion across the Bowling Green, (C) the outbuildings, and (D) George Washington: Pioneer Farmer.

Where Can I Get the Best Shot?

There is much to see and photograph at Mount Vernon, with one important exception: No pictures are allowed within the mansion. However, after a tour through the intricately restored home, there is enough elsewhere to keep a photographer occupied for several days.

East mansion lawn

On the east side of the mansion, you can explore a large lawn that is open to the public, and from here you can view the mansion from several nice angles (see figures 8.1 and 8.2).

Because the mansion is east-facing, morning is a good time to photograph from this location.

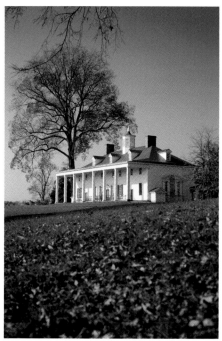

8.1 Another view of the Mount Vernon mansion's east facing side (see A on the map). Taken at ISO 100, f/4, 1/160 second with a 65mm lens.

8.2 A detail shot of the gilded dove atop the mansion's cupola (see A on the map). Taken at ISO 100, f/4, 1/800 second with a 260mm lens.

West side of the mansion across the Bowling Green

A popular spot to photograph the mansion is from its western side, across its Bowling Green (see figure 8.3). Two spots offer good views. One spot is just next to the lawn, or try the field a little farther back. You may see the worn spot where many a tripod has been set — this spot allows you to shoot from a more elevated point.

Outbuildings

Over 15 buildings have been authentically recreated to show what life was like during the 1700s at Mount Vernon. Whether you choose the Salthouse (see figure 8.4) or the Coach House (see figure 8.5), for example, all the refurbished buildings make for great photo opportunities.

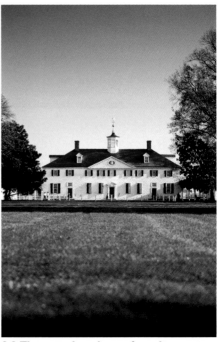

8.3 The mansion shown from its west side, across the Bowling Green (see B on the map). Taken at ISO 100, f/2.8,1/200 second with a 90mm lens.

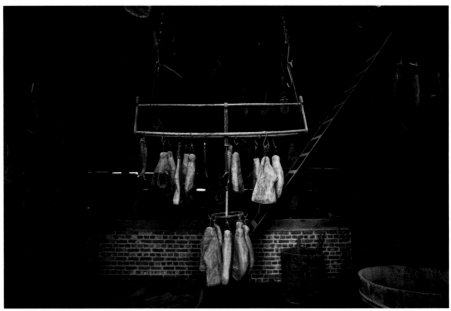

8.4 The Salthouse, where meats and fish were preserved (see C on the map). Taken at ISO 800, f/5.6, 1/60 second with a 20mm lens.

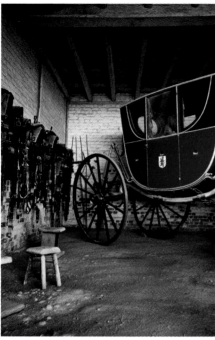

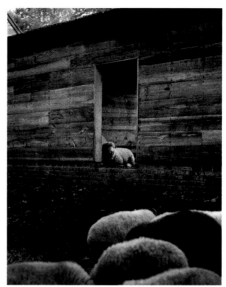

8.6 A few sheep at Mount Vernon's farm (see D on the map). Taken at ISO 320, f/2.8, 1/500th with a 65mm lens.

8.5 The Coach House, where Washington kept his horse-drawn coach (see C on the map). Taken at ISO 2500, f/4, 1/100 second with a 35mm lens.

George Washington: Pioneer Farmer

This is a working, cultivated area that illustrates the farming techniques Washington used that were advanced for the time (see figure 8.6). Next door is the Mount Vernon Wharf, where visitors who arrive by boat disembark (see figure 8.7).

How Can I Get the Best Shot?

Plan on a lot of walking and learning while at Mount Vernon, and having an occasional run-in with a contemporary of Washington's from the late 1700s, such as one of his farm's slaves, a government associate, or a hired worker.

Equipment

Travel relatively lightly because of the amount of walking involved here. In general, you have plenty of light, so a tripod isn't necessary, which reduces your load.

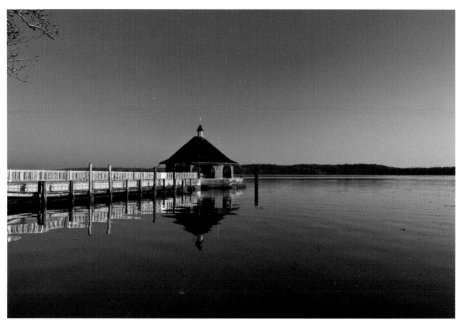

8.7 The Mount Vernon Wharf, next to the Pioneer Farmer site (see D on the map). Taken at ISO 100, at f/22, 1/4 second with a 24mm and a tripod.

Lenses

The kinds of photos you can take at Mount Vernon vary widely, but a lot of the photographs here can be made using focal lengths of 24-70mm. You can get rather close to many of the subjects here, so long lenses aren't all that necessary. An exception can be made for the western side of the mansion, where a long lens such as 200mm works well to compress the entire scene — but this, too, could be photographed with a wider lens to show the vast size of the Bowling Green (refer to figure 8.3).

Filters

The standard polarizing and graduated neutral density filters can come into play here for images of the buildings.

Camera settings

Keep a strong subject in mind as you photograph here, and adjust your camera settings accordingly to your subject matter. For example, if you are photographing the mansion and the land around it, use a higher aperture to get the entire scene in focus. If, however, you are focusing on a scene inside one of the outbuildings

(refer to figures 8.4 and 8.5), using a lower aperture value such as f/4 will limit your depth of field so that only the subject is in focus, which helps to create a stronger photograph. (Using your camera's Aperture Priority mode is therefore a good idea.)

Within these buildings, the exposures may get a bit tricky because of the strong contrast. Try to adjust your exposure based on an area that is neither very bright nor very dark. Your camera's full auto or Program modes may be easily fooled by the contrast in these areas. By using a Priority mode such as Aperture Priority combined with exposure compensation you can fine-tune your exposure to the scene. If the picture looks too bright, reduce the exposure. Conversely, if it is coming out too dark, increase the exposure.

Also, white balance will affect your photos to a large degree. Using Auto white balance may result in photos that are bit too cold and blue. Try using the Cloudy or Shady setting to capture warmer images.

Be sure to keep your flash off inside the outbuildings, as well. Try to use the natural light whenever possible. Many of the outbuildings have windows and beautiful light flowing through them at all times (see figure 8.8).

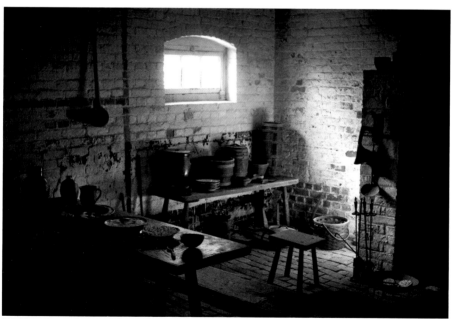

8.8 The Greenhouse Slave Quarters, where as many as 15-20 men and women slaves would live (see C on the map). Taken at ISO 1000, 1/50th at f/5.6 with a 50mm lens.

Exposure

Sunlight shows off the many areas of Mount Vernon differently — taking advantage of this with your compositions is a wise move.

Ideal time to shoot

Because of the sheer variety of things to photograph, there's always something that can be done no matter what time of the day. Morning and evening light are great to shoot the eastern-and western-facing sides of the mansion as well as to get interesting light at the farm and surrounding fields. Getting here early and planning a full day is a good idea. Because there's a food court, museums, and in general plenty to do and see, you can easily stay the entire day — meaning you can take advantage of a lot of different light (see figure 8.9).

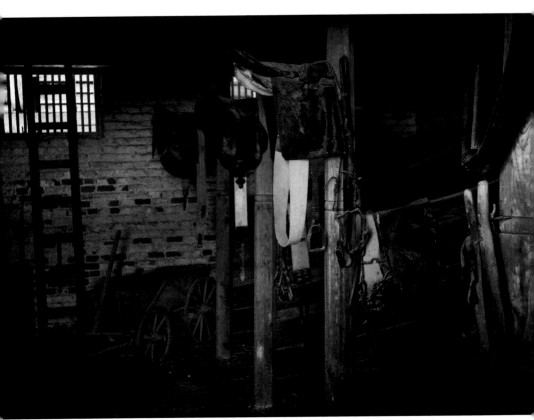

8.9 The stable at Mount Vernon (see C on the map). Taken at ISO 1600, f/4, 1/100 second with a 50mm lens.

Working around the weather

The weather can present a challenge here. Of course, if you are lucky enough for a winter snowfall, there can be rare opportunities to get some interesting images. Because most of the locations are outdoors, pack some rain clothes in the car and maybe something to cover your camera in case the skies let loose.

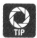 A simple trash bag has saved many a camera from rain and also helped to create some great rainy day images.

Low-light and night options

Because you have to work around the hours that Mount Vernon is open to the public, night and low-light options are limited. However, you can plan your trip around the special candlelit tours of Mount Vernon offered in November and December.

Getting creative

Be sure to check out the many events going on within the grounds of Mount Vernon for ideas of things to photograph. For example, there is often a blacksmith working in the blacksmith's shop, and many other activities continually going on throughout the year.

 Check out www.mountvernon.org for an up-to-date calendar of the estate's activities. If you live near Mount Vernon, the annual pass for $25 is an absolute bargain. For only $10 more than the daily admission, you can come here to photograph as often as you want for a year.

In the National Air and Space Museum, the Bell X-1, the first airplane to fly at the speed of sound, and SpaceShipOne, the first privately funded human-piloted aircraft to reach space. Visit www.chuckyeager.com and www.scaled.com for more information about these aircraft. Taken at ISO 800, f/4, 1/125 second.

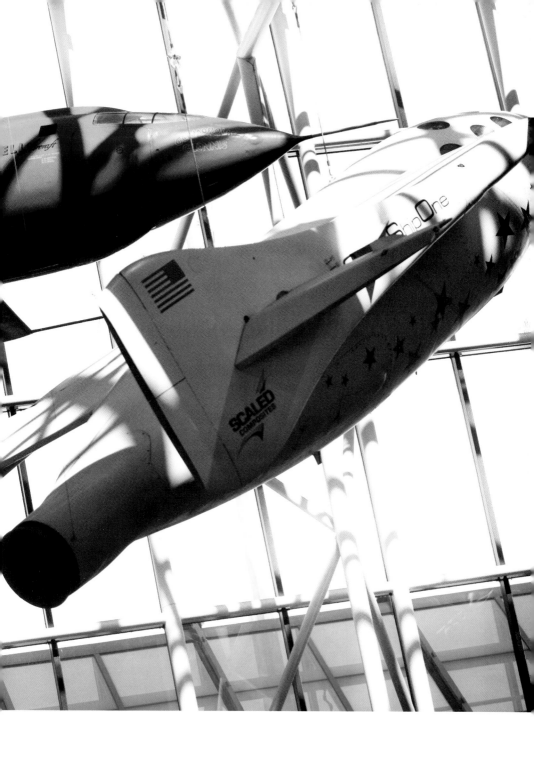

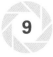

Why It's Worth a Photograph

The National Air and Space Museum is the world's most visited museum, according to the Smithsonian Institution. Its annual visitation regularly tops out around six million people, and with good reason: The museum is packed wall-to-wall with the largest collection of artifacts from air and space flight ever assembled in one place. If you're fascinated by flight, it's an absolute must-see.

Where Can I Get the Best Shot?

Located on the south side of the National Mall between 7th St. SW and 4th St. SW, the Air and Space Museum at the National Mall has 22 exhibition galleries that cover over 160,000 square feet. You can see and learn a lot.

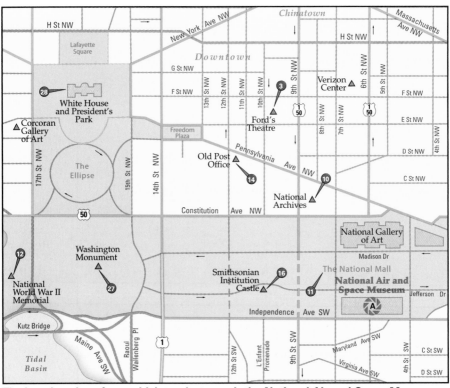

The best locations from which to photograph the National Air and Space Museum: (A) The museum's interior. Nearby photo ops: (3) Ford's Theatre, (10) National Archives, (11) National Mall, (12) National World War II Memorial, (14) Old Post Office, (16) Smithsonian Institution Castle, (27) Washington Monument, and (28) White House and President's Park.

The museum's interior

Exhibits change at the Air and Space Museum, so the focus of this chapter is about techniques you can use to get better photos, rather than specific locations.

Breaking the frame

One of the main concepts of making good photos inside a museum is to minimize distractions in the photo by careful framing of your composition. A good technique is to use the concept of *breaking the frame;* this simply means you get close enough to the subject to let some of it go beyond the frame of the photograph. Showing a complete subject in the picture can look very static and, for lack of a better word, boring. By getting up close and letting some of the Lunar Module break the frame in figure 9.1, I've enabled the viewer to feel more as if she were part of the subject, rather than a spectator.

Integrate the subject with its surroundings

The 1903 Wright Flyer is an example of an amazing sight to see that is rather hard to capture nicely in a photograph. Its svelte airframe is easy to lose in a photo because of its narrow and thin appearance; it's very easy to end up with a photo where you see straight through the main subject to the background.

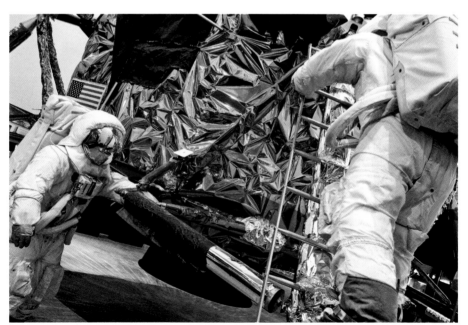

9.1 The Apollo Lunar Module number two at the National Air and Space Museum at the National Mall. Taken at ISO 1600, f/4.5, 1/60 second with a 35mm lens.

Instead of trying to avoid background elements that are distracting, try to use the surroundings of such a challenging subject to your advantage with careful composition. Don't immediately start taking a photo when you first walk up to it. Take a walk around the object and see what lines up where. Look for a background that is complementary to the subject as well as a camera angle that enhances its shape and form. You want to see everything first — background, foreground, the subject's form, and lighting. In the case of figure 9.2, the historic buildings and darker background help to create a scene as well as offset the brightly lit flyer from its background.

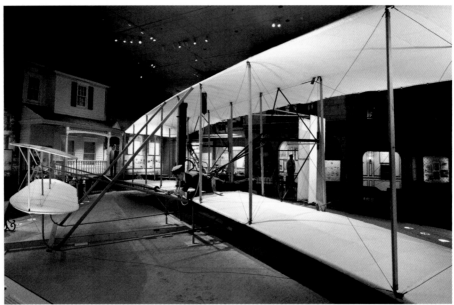

9.2 Orville and Wilbur Wright's 1903 Wright Flyer, taken at its temporary location inside The Wright Brothers and The Invention of the Aerial Age exhibit. Taken at ISO 3200, f/4, 1/30 second with a 20mm lens.

Although it may be possible to get a photo of the entire subject, focusing on unique details of the subject can often be a much more powerful way to understand it in a photograph.

Getting in close by either walking up next to the object or using a zoom lens can help you get detail shots that tell a great story. In figure 9.3, Charles Lindbergh's Spirit of St. Louis is represented with an image of its hand-painted text and flags on its engine cowling.

The plane is on view under the Air and Space Museum's glass roof, which lets in a lot of light. The glass roof helps with getting good photos since you can use lower ISO values and the light is more even than artificial lighting. There are also simpler backgrounds in these areas, which make for cleaner photos.

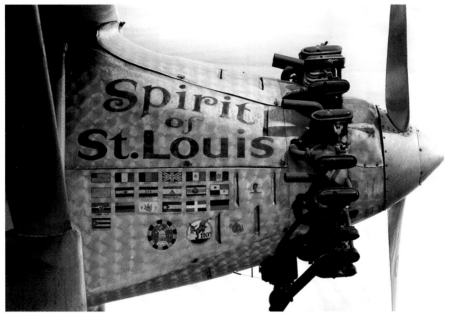

9.3 A detail of Charles Lindbergh's Ryan NYP Spirit of St. Louis. The flags represented some of the many countries Lindbergh flew to after his trans-Atlantic voyage. Taken at ISO 2500, f/5, 1/80 second with a 180mm lens.

Look for harmony with multiple subjects

The common hallmark of a good photo is a strong emphasis on a main subject. Unfortunately, emphasizing the main subject is not always possible to do in the crowded confines of a museum. When presented with a busy, complicated scene, you often have two choices: Find detail shots that can represent the space, or walk around and try to find a composition that captures the entirety of the space in a graceful way.

At the America by Air exhibit shown in figure 9.4, you can see the enormity of just one room of the Air and Space Museum, and all the objects within the frame are composed in such a way that they grace each other's presence. Finding a visual rhythm and some harmony within disparate elements is your goal. It's not always possible, but when it is, you'll get a much more pleasing photo to show off.

Use the light to your advantage

Lighting in museums is specialized for your human eye, not for cameras. Although the exhibits will look stunning to your eye, the results are often far from spectacular when you try to record them with a photo. Artificial spotlights create light that is very high in contrast, meaning some areas go very dark while other areas become very bright on the subject. Mixed types of light bulbs produce a variety of

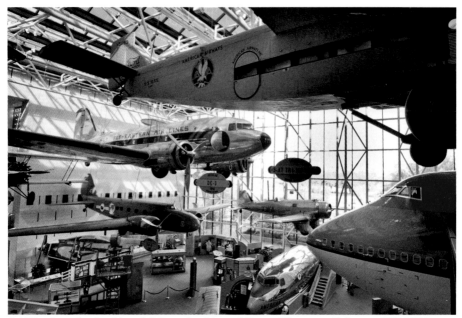

9.4 The America by Air exhibit at the Air and Space Museum. Taken at ISO 2000, f/6.3, 1/40 second with a 20mm lens.

different colors of light, which is rarely appealing photographically. Finally, the light levels are so low that you're often forced to use very high ISO values, slow shutter speeds, and low aperture values.

So, what do you do? Instead of taking photos in areas where the light is problematic, keep an eye out for where you can use the light to your advantage. Compose your images to take advantage of the light that you think may work well for a photo. Pools of natural light coming from a window are always good.

If you're in a room that is lit entirely by artificial spotlights, work on finding a spot where the light works with the subject rather than against it. The lights are often set in such a way that when you stand in the normal viewing area, you can see the subject illuminated in a standard way: from the top down. But what happens if you stand somewhere else, such as down low or off to the side? Try to find a vantage point where the subject is lit in an interesting way, as in figures 9.5 and 9.6 — it will help make your photos captivating.

Rotate your camera to make an image more dynamic

Don't assume that you have to always keep your camera perfectly straight while photographing something. Lines that crisscross the frame, rather than go straight through it, add interest to what would be a very static looking picture in figure 9.7.

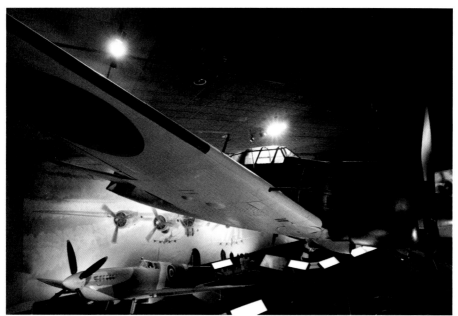

9.5 Using light behind the subject for a more dramatic effect: A Mitsubishi A6M5 Zero (above) and a Supermarine Spitfire F.Mk.VII in the World War II Gallery at the National Air and Space Museum. Taken at ISO 3200, f/4, 1/40 second with a 20mm lens.

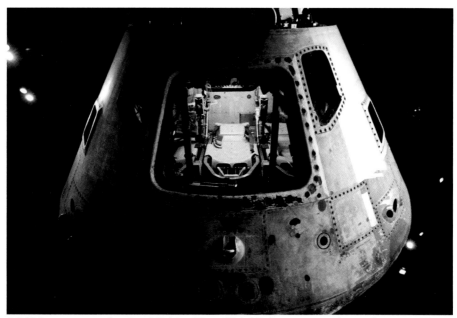

9.6 Using an area of natural light with artificial light creates a dramatic scene: The Skylab 4 Command Module in the Apollo to the Moon exhibit at the National Air and Space Museum. Taken at ISO 2000, f/4.5, 1/50 second with a 20mm lens.

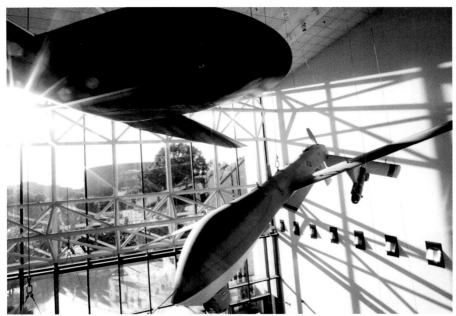

9.7 A Lockheed Martin/Boeing RQ-3A DarkStar (left) and a General Atomics Aeronautical Systems, Inc. MQ-1L Predator A in the Military Unmanned Aerial Vehicles exhibit at the National Air and Space Museum. Taken at ISO 800, f/20, 1/30 second with a 20mm lens.

Rotating your camera can often work well to help the composition of your photo be more dynamic, as shown in figure 9.8.

How Can I Get the Best Shot?

Taking good photographs inside of any museum, however, is often rather difficult for several reasons. Light levels are usually very low. Objects are often

9.8 A mockup Grumman X-29 in the Beyond the Limits exhibit at the National Air and Space Museum. Taken at ISO 1600, f/2.8, 1/100 second with a 120mm lens.

behind transparent plastic walls, which usually reflect either the photographer's image, the light from your flash, or both. It's usually tough to get a clean shot of something without extraneous things in the frame. You are often limited in the locations you can shoot from. And there are usually lots of people surrounding the objects. All told, good museum photography is tough.

Equipment

Forgo the tripod and bring a few extra lenses to the Air and Space Museum.

Lenses

Lens choices at the Air and Space Museum often run the entire range from very wide to long focal lengths, and most everything in between. Keep in mind that with longer focal length lenses, you need to be careful not to shake your camera — select a shutter speed that is somewhat close to the rule of *one over your lens' focal length* to minimize camera movement. If you are using a dSLR, hold the very end of the lens to stabilize it. If the lens has a hood, be sure to use it; it will lengthen the lens and, therefore, let you hold the lens even more steadily.

Filters

When going over your images using image-editing software, using a software-based graduated filter (which both darkens areas like a graduated neutral density filter as well as lightens them in a similar manner) in addition to traditional dodging and burning techniques can help eliminate distractions in the images from high-contrast artificial lighting and other less-than-ideal lighting situations.

Extras

Tripods are not allowed past security at the Air and Space Museum. The museum is much too crowded to use one anyway.

Camera settings

Because museums are often lit with a variety of lighting methods, getting a good exposure can be a little more difficult. Your camera's meter may miss the bright spots of an image and overexpose them, or it may read the abundant natural light in one of the sunlit exhibits and underexpose the subject you're actually trying to photograph. This is a good time to use your camera's exposure compensation feature. Often you have to over or underexpose scenes by one to two stops to get the right exposure on your subject.

Your camera's on-board flash is typically not very powerful, so if you are in a dark room photographing a large subject, it will only illuminate a part of it — which is not very flattering. Also, you are often too far away from things for your flash to really make a difference. And, if there's any transparent plastic surrounding the object, the flash will reflect on the plastic. All in all, you want to keep your flash off for the vast majority of pictures in a museum. If you do want to use a flash, using an accessory flash with a cord that lets you shoot with it off-camera is a good move, although this step gets into somewhat advanced territory of balancing existing light with flash.

When you use wide lenses, keep in mind that you don't need as high an aperture value to keep everything in focus as you do with longer focal-length lenses. For example, whereas you may need to use f/8 to ensure you get most of a subject in focus with a 200mm lens, when using a 24mm lens you can often get away with a lower aperture value of f/4 and still maintain a good depth of field. Using a smaller aperture value is helpful when shooting in low-light areas of a museum so that your camera lets in more light. Also, you want to err your focusing towards the front of the subject, because you get more depth beyond the focus point than you do in the front of it.

Using your camera's Auto white balance function can be a savior here, because there are mixed kinds of lighting. Shooting in RAW mode lets you adjust color balance after the fact as well.

Exposure

Because all the exhibits are indoors here, there are photography opportunities year-round. Just try to visit in the morning or in the off-season to avoid large crowds.

Ideal time to shoot

Because the Air and Space Museum is the most visited museum in the world, getting here early is a wise move to avoid the crowds. (Averaged out among the 364 days the museum is open, there are roughly 16,500 people visiting *per day*.) Although less light may be coming from the glass roofs, the brightness inside will still be adequate and it's much easier to photograph things here with fewer people around.

Working around the weather

Overcast days are actually pretty good times to photograph the big exhibits under the glass roof areas here because the light is more even throughout the space.

Low-light and night options

The Air and Space Museum is open from 10 a.m. to 5:30 p.m., so night photographs are not options here.

Getting creative

Beyond the techniques I outline earlier, blurring out distracting background elements can help your museum photos. You can do this by using image-editing software, although too much of the effect can cause a very unnatural (and therefore distracting) look to a photograph.

Finally, don't limit yourself to getting photographs of the entire exhibits as they look to the eye. There have been artistic renditions of the airplanes by photographers using slow shutter speeds and moving the camera, which makes the planes look as if they are in motion. Or, in addition to the photos you take of the exhibits, you can concentrate on details of the many different things on display, such as geometric shapes or color.

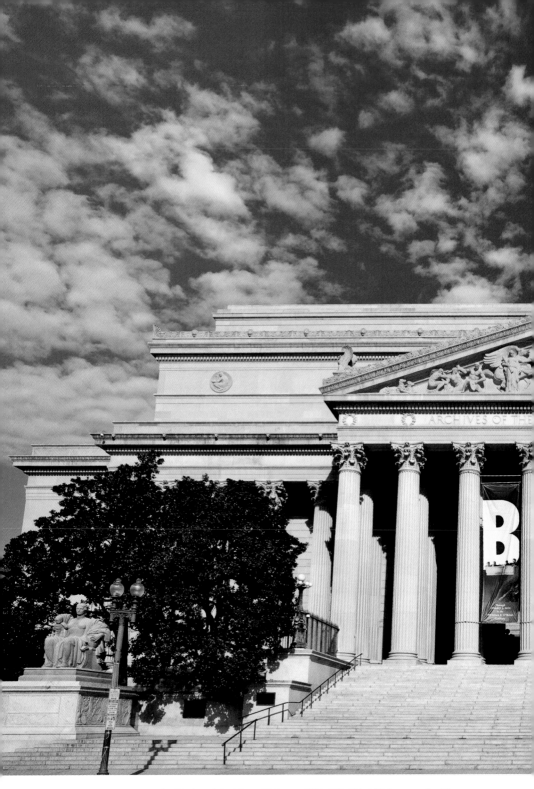

The south entrance to the National Archives. Taken at ISO 100, f/8, 1/250 second with a 19mm lens.

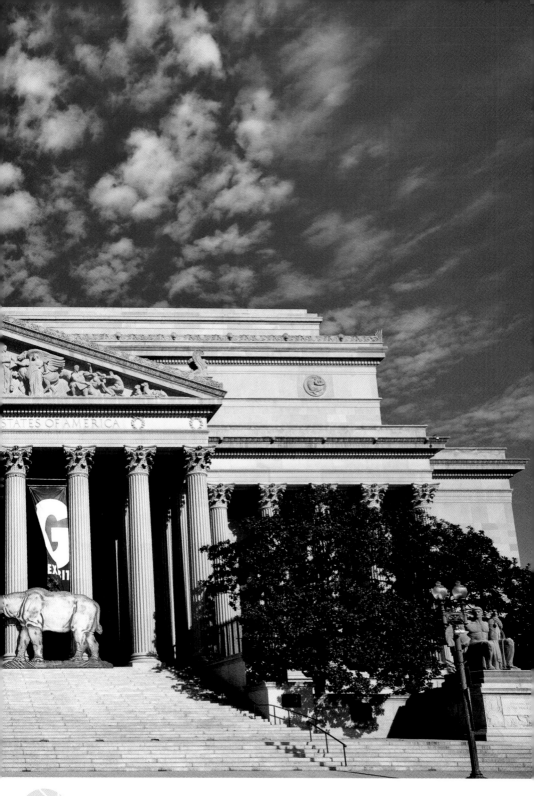

10 National Archives

Why It's Worth a Photograph

At the National Archives, you can see the documents that defined the United States and the freedoms that its citizens enjoy. Together, the Declaration of Independence, the Constitution of the United States, and the Bill of Rights make up the Charters of Freedom.

A visit to the National Archives offers a rare chance to see all these documents together. In addition to the rotunda, the National Archives building and statues that adorn it symbolize the importance of these documents as well as the historical records kept by the nation's archivists. Together, they tell the story of America.

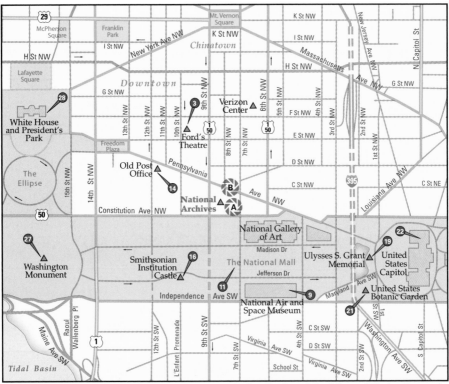

The best locations from which to photograph the National Archives: (A) the Rotunda for the Charters of Freedom and (B) the building's north entrance. Nearby photo ops: (3) Ford's Theatre, (9) National Air and Space Museum, (11) National Mall, (14) Old Post Office, (16) Smithsonian Institution Castle, (19) Ulysses S. Grant Memorial, (21) United States Botanic Garden, (22) United States Capitol, and (28) White House and President's Park.

Where Can I Get the Best Shot?

There are two very different areas to photograph here: inside the dark, cavernous rotunda, and outside in what will often be the bright outdoor light.

Rotunda for the Charters of Freedom

Besides photographing the documents that make up the Charters of Freedom, the Rotunda where these documents are stored is a spectacle unto itself (see figure 10.1). Two murals painted by Barry Faulkner depict fictional scenes of the presentation of the Declaration of Independence and the Constitution, and below these are some of the most important documents to the free world (see figure 10.2). You can photograph the documents here if you like, but it is also possible to download high-resolution images of them from the National Archives Web site, www.archives.gov.

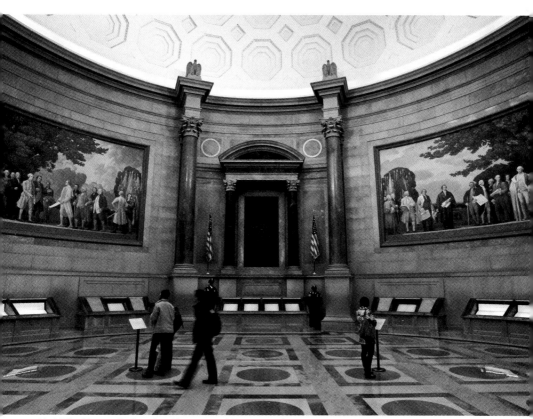

10.1 The Rotunda for the Charters of Freedom (see A on the map). Taken at ISO 3200, f/4, 1/10 second with a 20mm lens.

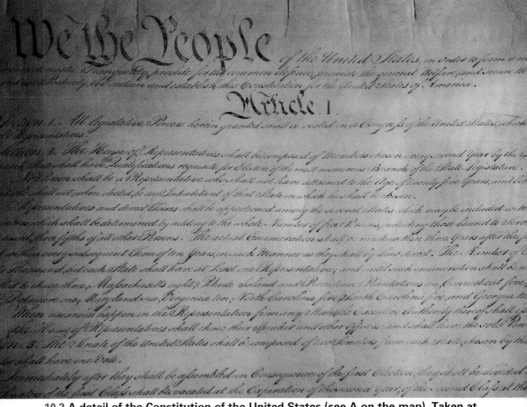

10.2 A detail of the Constitution of the United States (see A on the map). Taken at ISO 3200, f/3.5, 1/15 second with a 50mm lens.

The building's north entrance

The north side of the National Archives building is a little easier to photograph than the south because there is a good amount of space from which to photograph both its pediment (see figure 10.3) and its two main sculptures by Robert Aitken, *The Past* and *The Future*. But you may want to choose whichever side has the better light — the south side has less room, and you'll likely have to view it from across Constitution Avenue.

The pediment on this side was sculpted by Adolph A. Weinman, and is called *Destiny*. Here figures representing The Arts of War and The Arts of Peace stand next to a Zeus-like figure. Surrounding them are figures representing The Romance of History and The Song of Achievement.

10.3 The pediment and columns of the north side of the National Archives Building (see B on the map). Taken at ISO 400, f/7.1, 1/250 second with a 100mm lens.

How Can I Get the Best Shot?

Many people realize when their camera's flash goes off, but not so for their auto-focus light. When some cameras sense there is not enough light or contrast to perform an autofocus, they will emit a light to find a focus point. With some cameras, you can turn this light off and still use the autofocus (although it will be slower or may not work at all), but with other cameras the only way to do so is to switch the autofocus off. Therefore, you want to figure out how to manually focus your camera.

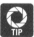

Turn your flash off! In order to help preserve the documents within the rotunda, flashes are not allowed.

Photography Restriction in the Archives

As this book went to press, the National Archives tightened its photography restrictions. Absolutely no photography will be allowed in the main exhibit hall after February 24, 2010, in order to protect the historic documents there.

Equipment

Within the National Archives, more modern cameras with higher ISOs fare much better, because it is quite dark (see figure 10.4).

Lenses

Within the Rotunda, you want to use a wide lens of about 20mm for a horizontal shot that spans most of the two paintings. If you don't have such a wide lens, you can also choose to photograph a horizontal image of the center of the Rotunda, which can be taken with a 35mm lens.

If you choose to photograph the documents, you want to use a standard lens of about 50mm. Outside, longer lenses work well to separate the subjects from their backgrounds, as well as simply to see high enough to the details of the pediment. Lenses between 100-200mm work well here.

10.4 A detail of the floor in the Rotunda; figures here symbolize Legislation, Justice, History, War and Defense (see A on the map). Taken at ISO 3200, f/3.5, 1/15 second with a 50mm lens.

If you choose to photograph the doors on the south entrance, you'll need a wide lens of 20-24mm (a slightly longer focal-length lens may work as well).

Filters

Using a polarizing filter to deepen the sky and increase contrast with the clouds when outside can help your images.

Camera settings

When photographing an overall shot of the Rotunda, you may have to use a very slow shutter speed to expose it enough. Figure 10.1 was shot at 1/10 second, which means you have to have a very steady hand and depress the shutter care-fully. You can also use your camera's timer to automatically shoot the picture. In this way, you only hold the camera still, and the camera will snap the photo with-out you moving any fingers. This can help you to hold the camera still. Otherwise, shoot a few pictures in a row by either holding down the shutter button (this will keep your hand more steady) or lightly depressing the shutter consecutively sev-eral times — often one of the photos within that group will be tack sharp.

You may want to choose to use Aperture Priority mode so that your camera doesn't inadvertently set a very low aperture value such as f/2.8. With a wide-angle lens, it's easier to keep things in focus, but sometimes the combination of a very low aperture value and a focus point that isn't perfect (such as too far away or too close) will mean an out-of-focus picture. By setting a higher aperture value, such as f/4, that has a little more depth and carefully focusing with a steady hand, you should be able to make a good photo.

Exposure

Before you enter the National Archives building, you should understand two things: how to turn off your flash, and how to also turn off any autofocus lights that your camera may emit. Flash photography, and any extraneous lighting in general, is prohibited within the Rotunda. It is especially important to make sure your camera doesn't emit any sources of light next to the Charters of Freedom.

Ideal time to shoot

Indoors at the National Archives, the best times to go are first thing in the morning or very late in the day, when the crowds will be minimized. During the day, there are often hundreds of people surrounding all the documents, as well as a line forming on the left side to walk though them all (although it's really not necessary to wait in it, because people come and go to different parts of the exhibit).

10.5 The Past, by Robert Aitken, on the National Archives Building's north side (see B on the map). Taken at ISO 200, f/5, 1/250 second with a 165mm lens.

Outside, you can work on the side that has the best sun exposure when you are there, but figure 10.5 was shot when the building's north side was in shade, which works well anyway.

Working around the weather

Outdoors, use the weather to your advantage. If there are big clouds and blue sky, incorporate them into your composition. On a cloudy day, use the soft light to make nice portraits of the different sculptures and artwork that cover the building.

Low-light and night options

Night can be an interesting time to photograph here. There are a variety of lighting types on the building which each produce a different color of light. Be sure to explore the south entrance doors — those are the largest bronze doors in the world, and they don't look half bad photographed at night (see figure 10.6).

10.6 The south entrance of The National Archives at night. Taken at ISO 1250, f/2.8, 1/30 second with a 20mm lens.

Looking west on the Mall during an August evening. Taken at ISO 320, f/4.5, 1/200 second with a 130mm lens.

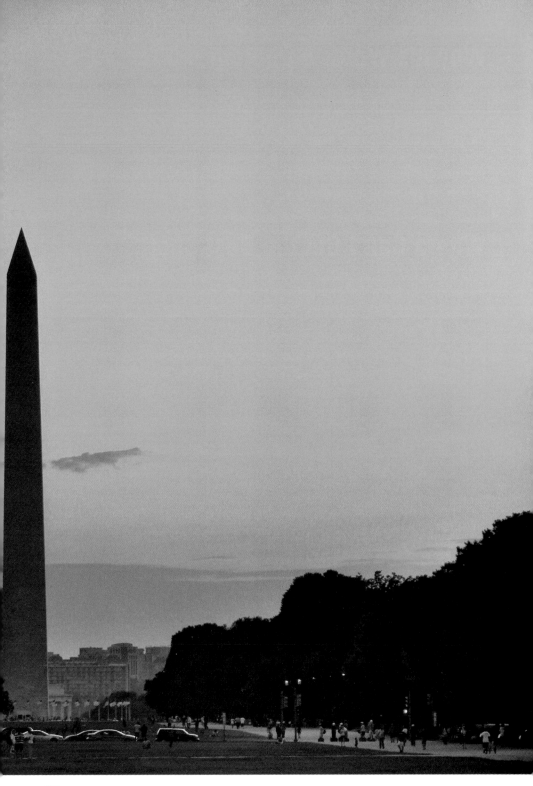

⌀ 11 **The National Mall**

Why It's Worth a Photograph

The National Mall is an essential part of the United States' collective being. It is where the documents that formed the nation and defined the rights of those who live under its flag are kept. The Mall is where the memorials to those who founded the country are and where those who have fought to protect it are remembered. The nation's collection of art, culture, and wisdom are exhibited and protected at the Mall. Definitive protests and infamous speeches here have altered the consciousness of the country forever.

Where Can I Get the Best Shot?

There are a few classic places from which to photograph the National Mall, and there are hundreds more great vantage points to find as well.

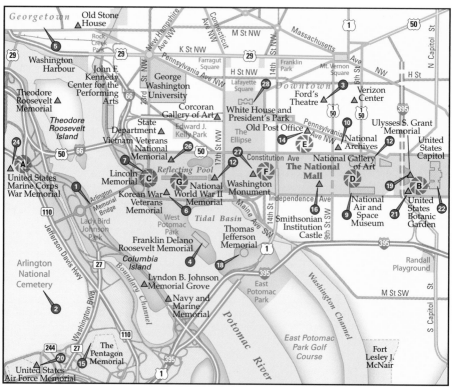

The best locations from which to photograph the National Mall: (A) south of the U.S. Marine Corps War Memorial, (B) the west side of the Capitol, (C) the southeast corner of the Lincoln Memorial, (D) between 3rd St. NW and 14th St. NW within the Mall, (E) the Old Post Office Tower, (F) atop the Washington Monument, and (G) next to the Lincoln Reflecting Pool. Nearby photo ops: (3) Ford's Theatre, (9) National Air and Space Museum, (10) National Archives, (14) Old Post Office tower, (16) Smithsonian Institution Castle, (19) Ulysses S. Grant Memorial, (21) United States Botanic Garden, (22) United States Capitol, (27) Washington Monument, (28) White House and President's Park.

South of the U.S. Marine Corps War Memorial

Perhaps the best location from which to photograph the iconic skyline of the National Mall, here you can line up the Lincoln Memorial, Washington Monument, and Capitol all in one shot (see figure 11.1). There are several ways to compose this image just a short walk from U.S. Marine Corps War Memorial.

The west side of the Capitol

At the base of the Capitol's west side, you can look out over the Ulysses S. Grant statue, the Washington Monument, and the Lincoln Memorial (see figure 11.2).

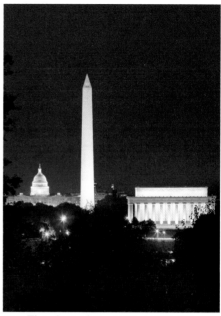

11.1 The view of the National Mall from just south of the U.S. Marine Corps War Memorial (see A on the map). Taken at ISO 320, f/10, 8 seconds with a 280mm lens mounted on a tripod.

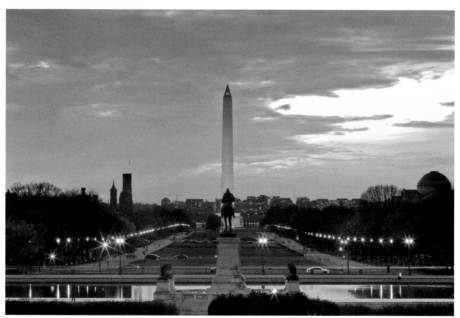

11.2 Looking west from the U.S. Capitol towards the Washington Monument (see B on the map). Taken at ISO 100, f/32, 20 seconds with a 140mm lens mounted on a table-top tripod.

11.3 From the southeast corner of the Lincoln Memorial, it's a great view of the National Mall (see C on the map). Taken at ISO 400, f/16, 15 seconds with a 200mm lens mounted on a table-top tripod.

Southeast corner of the Lincoln Memorial

From the Lincoln Memorial, you can get a spectacular view of the World War II Memorial, Washington Monument, and Capitol all in one picture (see figure 11.3).

Between 3rd St. NW and 14th St. NW within the Mall

The Mall can vary from having hundreds or thousands of people on it to being almost desolate, depending on when you go.

There are plenty of interesting locations within this 11-block area where you can use the Capitol, Washington Monument, or other landmarks in your compositions (see figure 11.4), especially during interesting weather.

11.4 Looking east toward the Capitol from the Mall (see D on the map). Taken at ISO 400, f/3.5, 1/100 second with a 90mm tilt-shift lens.

The Old Post Office tower

You'll see several different angles of Washington, D.C. and the National Mall from the heights of the 315-foot clock tower at the Old Post Office (see figure 11.5).

11.5 Looking toward the Washington Monument from the Old Post Office tower (see E on the map). Taken at ISO 100, f/2.8, 1/32 with a 100mm lens.

The Washington Monument

The ultimate view of the National Mall, as well as Washington, D.C., can be seen from the top of the Washington Monument, the tallest structure in the District (see figure 11.6).

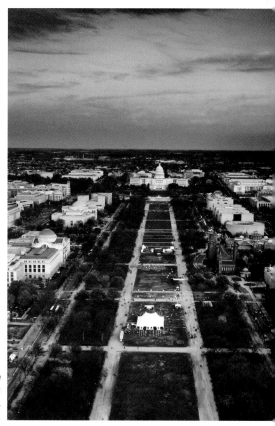

11.6 Looking east from the top of the Washington Monument on a fall evening (see F on the map). Taken at ISO 400, f/5, 1/50 second with a 50mm lens.

Next to the Lincoln Reflecting Pool

There is a variety of ways to view the skyline of the National Mall from the reflecting pool next to the Lincoln Memorial (see figure 11.7).

How Can I Get the Best Shot?

These iconic photographs are perhaps the best way to see D.C., and they are all fairly simple to capture as well.

Equipment

The National Mall is wide open as far as photo possibilities, whether you are going for iconic images of the landmarks or more subtle detail images around the Mall.

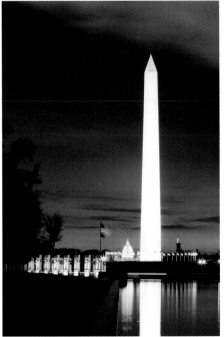

11.7 An early morning view from the north side of the Lincoln Reflecting Pool (see G on the map). Taken at ISO 400, f/18, 25 seconds with a 100mm lens mounted on a tripod.

Lenses

The photographs from the U.S. Marine Corps War Memorial (refer to figure 11.1) require the longest lenses of all these locations. Somewhere from 250-300mm is a good focal length, although scenes here could be photographed with a shorter lens and still work to some degree.

From the west side of the Capitol (refer to figure 11.2), a 150mm lens works well to get a tight enough shot of the Mall to read well.

From the Lincoln Memorial (refer to figure 11.3), a 200mm lens works well. You can go wider or looser depending on your preferences and the conditions at the time.

Photographing the Mall between 3rd and 14th St. is really open to your individual interpretation (refer to figure 11.4). Lenses from 50-100mm can be used to good effect to select a specific area of the vast landscape here. A good rule when faced

with wide-open spaces and/or busy scenes is to select one area to focus in on that can represent the whole. One big, wide shot can often leave a little to be desired in a photograph because there's no clear subject represented.

A *tilt-and-shift lens* was used for figure 11.4. This lens tilts and shifts the elements within the lens to create different types of depth of field depending on how the lens is adjusted. You can make similar effects using a filter within an image-editing program.

When photographing from the Old Post Office tower (see figure 11.5), you are presented with one challenge: There are steel wires covering the windows here. Although image quality may be lessened, there are a few tricks to getting around the steel wires:

1. **Use a long focal length lens, something preferably longer than 50mm.**

2. **Get as close to the wires as possible.** It seems counterintuitive, but the closer the wires are to the lens, the less contrast the lens picks up on them and the less you'll see them.

3. **Use the lowest aperture value your camera has, such as f/2.8 or f/4.** Doing so limits the depth of field as much as possible and minimizes the distraction the wires can cause to an image.

Also, you may want to concentrate your efforts on the windows that have no sun hitting them directly — the brighter the wires are, the more they will impair the image. The wires reduce the contrast within your image, which you may need to adjust later in a photo-editing program.

There are several creative possibilities from the top of the Washington Monument (refer to figure 11.6) that can vary from wide to longer focal lengths, but using a moderate length lens, such as a 35-70mm, is a good idea. These come somewhat close to representing what our eyes see naturally and, therefore, give a good feeling of the view from the monument. They also reduce some of the issues with photographing through the often murky glass here.

Next to the Lincoln Reflecting Pool, you want to use longer lenses to pull all the elements together — something from 70mm all the way up to 300mm works, depending on your composition (mainly how much of the Washington Monument you are getting in the image — see figure 11.8 for an example).

11.8 Looking east from the Lincoln Reflecting Pool during a late summer afternoon (see G on the map). Taken at ISO 400, f/8, 1/1250 second with a 280mm lens.

Filters

You can bet that with compositions as varied as they are at the National Mall, there are times to use a polarizer and graduated neutral density filter. Both can be used to help increase contrast and even out exposures of the sky and ground.

Using a glass or digital graduated filter for images from the top of the Washington Monument will often be necessary, but of course it depends on what the light is like. From this vantage point, using a digital warming filter or setting your white balance to the cloudy setting can also help deal with the less-than-ideal glass you'll be shooting out of.

Extras

In general, tripods are permitted to be used briefly on the Mall, provided they are not an obstruction. However, next to the U.S. Capitol they require a permit. See this book's Introduction for more information on tripod use.

For the image from the west side of the Capitol as well as from the southeast corner of the Lincoln Memorial, using a tiny table-top tripod for these photos is convenient. (Full-size tripods aren't allowed in either location.)

Camera settings

Because of the Washington Monument, most of these images have a large amount of sky in them, which means potentially throwing off your camera's light meter. When adjusting your exposure, try to look for the areas of the image that are closest to a neutral gray in brightness. Sometimes this may be the grass on the National Mall, or it could be an overall scene of buildings. Either way, look for such an area to get a starting exposure for a scene.

For example, from the Washington Monument looking down toward the White House (see figure 11.9), you can point your camera straight down at the expanse of grass below you and figure out a good exposure there.

Then you can either set that exposure by using your camera's Exposure Lock function, or you can note what it is, flip your camera to manual, and dial in the settings yourself. This way, when you recompose to let a lot of sky in the image, the ground areas don't go too dark. (You may want to further adjust the exposure to limit the brightness of the sky, as well.)

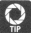 Depending on the time of day, it may be impossible to get both the ground and the sky well exposed due to the limitations of the camera's sensor.

11.9 The view of the White House and President's Park South (also known as the Ellipse) on a fall afternoon (see F on the map). Taken at ISO 320, f/8, 1/80 second with a 50mm lens.

It's a good idea to set your camera to Aperture Priority mode and use a low aperture value such as f/4 or f/5.6 to minimize the glare from the Washington Monument's windows.

When photographing from the top of the Old Post Office tower (refer to figure 11.5), use a low aperture value, such as f/4, when shooting through the wires here. This will help to further blur them out when they are close to your lens.

Exposure

Early morning and late evening are hands-down the best times to photograph the Mall area. When you do, the scene will change every few minutes rather drastically — so plan on taking a lot of photographs in a short period of time.

Ideal time to shoot

When photographing from the top of the Washington Monument, things get a bit difficult. For starters, following the notion of when the good light is — morning and evening — doesn't always work as well here. The reason is that the windows at the Washington Monument have a fair amount of, for lack of a better term, environmental crud on them. When the morning or evening sun strikes them, the light gets diffused all over the window, which means that your images will lose a tremendous amount of contrast. You must find either a cleaner area to shoot from or avoid those areas that are being hit directly with the sun. For this reason, visiting here during midday, or when the sun isn't at such an angle that it's directly shining on the windows, is a good idea to get photos from all four vantage points.

Either way, you will likely have to increase the contrast of your images in post-processing to deal with shooting through the glass here. Also, black-and-white images work well from the Washington Monument because of the color shifts that happen from the glass and lack of contrast.

Also note that the Lincoln Reflecting Pool is drained occasionally. When it was completed in 1930, it was made without any circulation system that would prevent problems that arise with stagnant water. Therefore, approximately three to four times per year the Reflecting Pool is drained so that National Park Service workers can clean the area of leaves and litter and refresh the water. It is commonly done in the fall (after much of the leaves have fallen), as well as the hottest parts of the year (July or August), and then one to two other times as it's needed.

Working around the weather

Weather at the National Mall can vary from blistering hot and humid to finger- and toe-numbing cold. Whenever you go, be prepared for a lot of walking. The Mall is vast, so if you're trying to cover a lot of ground in hot or cold weather, be prepared.

Some of the most unique images from the Mall happen during interesting weather: Snow (see figure 11.10), rainstorms, and big weather fronts make for unique photos, whether they are of the landmarks or images from within the Mall.

Low-light and night options

Night and low-light times are full of potential at the Mall. The monuments stand out brilliantly in the night sky, and fewer distractions are around them. During the weekends and non-working hours there are also many people out on the Mall, which helps to add a sense of scale to photographs here.

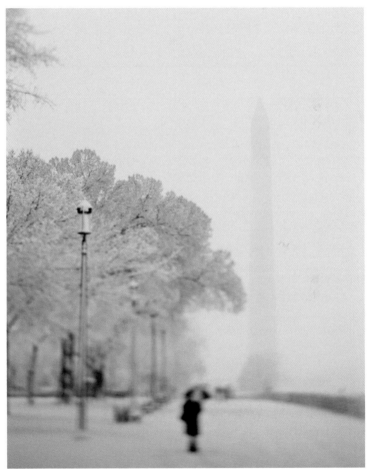

11.10 Looking east from the Mall on a day thick with snow (see G on the map). Taken at ISO 200, f/4, 1/800 second with a 90mm tilt-shift lens.

The National World War II Memorial and the Washington Monument on an early fall morning from its west side. Taken at ISO 200, f/22, 1.3 seconds with a 35mm lens.

National World War II Memorial

Why It's Worth a Photograph

The National World War II Memorial is dedicated to Americans, both civilian and military, who served during World War II. The ceremonial entrance to the memorial is from 17th St. SW. Here, the bases of granite feature the military service seals of the Army, Navy, Marine Corps, Army Air Forces, Coast Guard, and Merchant Marine.

At either end of the memorial are pavilions representing the victory in the Atlantic and Pacific theaters. Granite pillars surround the memorial, representing the American states and territories, arranged by their order of entry into the Union. On the western side of the memorial is the Freedom Wall, adorned by sculpted gold stars representing Americans who gave their lives during the war.

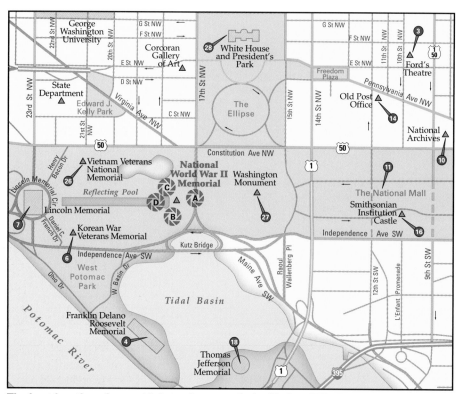

The best locations from which to photograph the National World War II Memorial: (A) 17th St. SW entrance, (B) between Delaware and New Jersey pillars, (C) next to Atlantic and Pacific Pavilions, and (D) across the Rainbow Pool. Nearby photo ops: (3) Ford's Theatre, (4) Franklin Delano Roosevelt Memorial, (6) Korean War Veterans Memorial, (7) Lincoln Memorial, (10) National Archives, (11) National Mall, (14) Old Post Office, (16) Smithsonian Institution Castle, (18) Thomas Jefferson Memorial, (26) Vietnam Veterans National Memorial, (27) Washington Monument, and (28) White House and President's Park.

Where Can I Get the Best Shot?

The National World War II Memorial's spare, open design is somewhat challenging to photograph. In the next sections, I go over some good vantage points to get you started.

17th St. SW entrance

The ceremonial entrance to the memorial off of 17th St. SW provides a higher vantage point to see the memorial, and it's also just far enough away to capture the entire memorial. Because the memorial's design is horizontal, cropping the photo at the bottom to eliminate some of the grass area helps the composition.

This location is also a good opportunity to take a panoramic photo like figure 12.1. To do this, use a tripod and shoot several images in sequence by rotating your tripod's head from one side of the memorial to the other. You can stitch the photographs together manually or use software to create one large image.

Between Delaware and New Jersey pillars

You can position yourself between these two pillars and get an elevated view of the other side of the memorial. (Of course, the same location on the other side should work as well.) This vantage point works well not only for the composition (shown in figure 12.2) but also because you are high enough to capture the image over other visitors below.

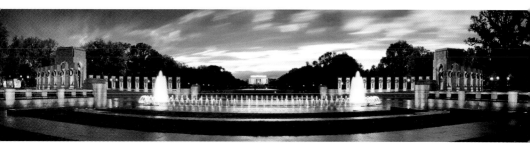

12.1 A panorama of the National World War II Memorial image using three separate frames (see A on the map). Taken at ISO 100, f/13, 30 seconds with a 50mm lens and a tripod.

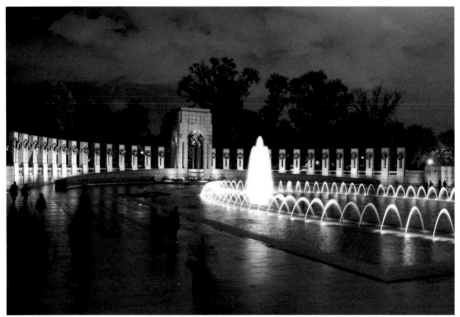

12.2 Looking to the north pillar at the World War II Memorial (see B on the map). Taken at ISO 1000, f/5.6, 2 seconds with a 35mm lens and mounted on a table-top tripod.

Next to Atlantic and Pacific Pavilions

Viewing the pavilions from their north or south sides is another good vantage point. On the inside, you can get the fountains that are next to each one, while on the outside you can see the rest of the memorial through the pavilion and pillars (see figure 12.3).

Across the Rainbow Pool

Another idea is to look across the Rainbow Pool to the pillars on the opposite site (see figure 12.4). This can be photographed from either next to the pool or from within the pavilion. An alternative is to go to either side of the pool and compose the shot with the pavilion in the back.

How Can I Get the Best Shot?

The World War II Memorial definitely requires a thorough exploration before you begin photographing. You have plenty to see, and there are also usually many veterans of the war here, especially on the weekends.

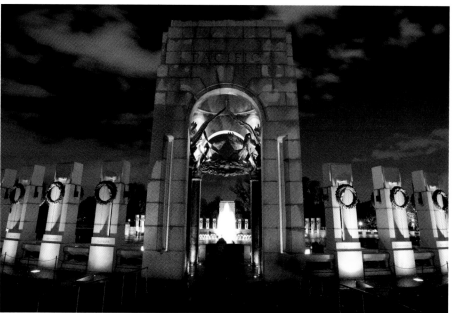

12.3 The Pacific Pavilion at the World War II Memorial (see C on the map). Taken at ISO 800, f/8, 6 seconds with a 20mm lens and a tripod.

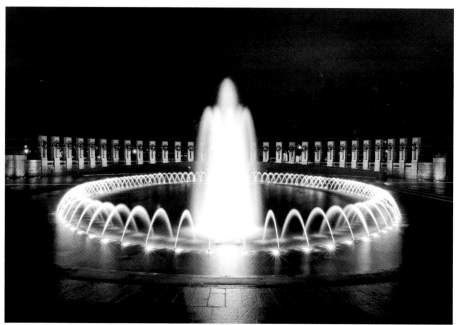

12.4 The view from across the Rainbow Pool at the World War II Memorial (see D on the map). Taken at ISO 200, f/18, 30 seconds with a 35mm lens and a tripod.

Equipment

Spectacular images here require good composition but generally basic equipment.

Lenses

Most of the images in this chapter were shot using a 35-50mm lens, the standard lenses on most any camera with a zoom lens. The exception is the image of the Pacific Pavilion, but you can get a similar shot perhaps by being farther from it and using a longer lens. Also, an image from the 17th St. SW entrance requires a wide lens of between 16 and 20mm. It is possible, however, to capture a similar image from the east side of 17th St. SW with a longer lens.

Filters

Because the sky can often play a big role in images from here, having a polarizing filter is a good idea to help enhance the sky during the day, as well as a graduated neutral density filter to even out the exposure between the sky and the memorial.

Extras

Tripods are allowed inside the memorial here, although they are restricted near the Freedom Wall (which contains the Field of Stars) because of the large number of visitors in this area. Also, be respectful to other visitors anywhere you have a tripod setup. This memorial can become very crowded, and each individual photographer who visits acts as an emissary for all photographers.

Camera settings

When photographing here during the day in direct sunlight, you will likely need to help your camera determine the proper exposure by dialing in some additional exposure compensation or by using an automatic setting for snow or the beach. It definitely depends on your camera, but the granite in the memorial can become very bright in direct sun and if your camera sees an abundant amount of it, it may underexpose the scene simply because it is so bright.

Photographing at night before digital cameras were the norm was not terribly simple, but now that LCD screens are standard on cameras, it's much easier to both see the composition and judge exposure. Many cameras have an automatic Night setting that is usually geared towards handholding your camera. If you're not using a tripod, give this mode a try.

If you are comfortable using your camera's Aperture Priority or Shutter Priority settings, you can simply set an aperture of f/11, for example, to see how its computer is deciding to expose the scene. Most cameras when set to these priority settings allow you to use exposure compensation, so you can adjust the exposure up or

down depending on what your preview shows. One thing to keep in mind is that digital cameras have maximum shutter speeds that vary by camera.

Finally, white balance can dramatically change the look of the images. Most camera's Auto white balance modes should do a good job, but sometimes they may try to make the scene overly warm (yellow) looking, which can make the image appear muddy and lacking contrast. Try out the different settings while shooting to see which one looks the best (or if you are shooting in RAW mode, you can change the white balance later).

Exposure

There are two ways to think about photography here: If you can determine when you get there, try for dusk to night. If you can't (for example, if you are going to be part of an organized tour), concentrate on using the existing light to your advantage.

Ideal time to shoot

The difference between night and day at the World War II Memorial is significant, to the point that it almost appears as two different places. At night, the memorial comes alive — the pillars light up, the fountains sparkle, and the difference is remarkable. All the previous images can be photographed at any time during the day, however.

Working around the weather

Because the memorial's design is airy and open, the sky above you determines a lot about how your pictures look — so capturing it when the sky is clear is definitely advantageous. It's also a nice scene when the memorial is still wet from a rain, because much of the surface becomes reflective.

It's a good idea to factor in the weather when you are thinking about how to photograph here: Sunny, contrasty days could work well with using repetition in your photo with lots of highlights and shadow, such as with all the pillars in a line. On the other hand, a cloudy, foggy day could mean evenly lit, ethereal images of the memorial.

Low-light and night options

The transition between evening and night is a nice time to visit here (see figure 12.5), but later at night works out well, too. At night, any low clouds usually reflect all the yellowish lights from the city, which gives an interesting but sometimes artificial look. Note that the fountain lights are often turned off late at night through the morning, so unfortunately, morning shots with the fountains illuminated are rare.

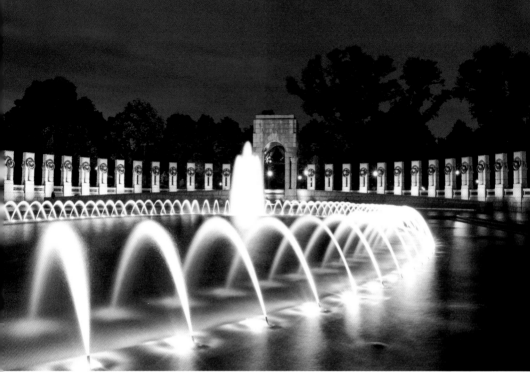

12.5 An alternative composition across the Rainbow Pond (see D on the map). Taken at ISO 200, f/14, 30 seconds with a 35mm lens and a tripod.

Getting creative

As always, these shots are great starting points for your exploration of the memorial. There are certainly many more to be done.

The World War II Memorial is especially good for exploring low angles, because the space is so open. You can use your camera as an excuse to explore the fine details of the memorial, as in figure 12.6.

12.6 A detail of the National World War II Memorial. Taken at ISO 100, f/4, 1/80 second with a 70mm lens.

Detail of a western tiger salamander in the National Zoo's Amazonia exhibit. Taken at ISO 1600, f/4, 1/50 second with a 50mm lens.

13 The National Zoo

Why It's Worth a Photograph

The National Zoo, part of the Smithsonian Institution, is best known for its three giant pandas: Tian Tian, Mei Xiang and their cub, Tai Shan. However, the National Zoo is much more than just a place where you can see pandas and elephants. It is essentially a specialized university that focuses on being a leader in the studies of animal care, science, education, and sustainability. There's so much to see that a photographer could spend weeks here. The zoo's peaceful atmosphere and creative layout make for hours of exploration.

Where Can I Get the Best Shot?

You can take great photographs inside the National Zoo from many locations. The following sections highlight some options.

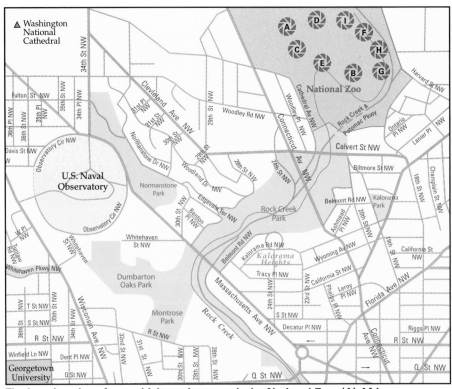

The best locations from which to photograph the National Zoo: (A) African Savanna, (B) Amazonia, (C) Asia Trail, (D) Asian Elephants, (E) Bird House, (F) The Great Ape House and The O Line, (G) Great Cats, (H) Invertebrates, and (I) Small Mammal House.

African Savanna

If there's any place in the zoo that makes you want to wear a pith helmet and talk about your near-death experience with a lion in an East African savanna, this is it. This area includes several cheetahs, as well as zebras, a scimitar-horned oryx (see figure 13.1), maned wolves, gazelles (see figure 13.2), and tammar wallabies.

All the animals are within very close proximity and are easy to photograph. It still takes some patience, but zooming in on them with your camera is a great way to study their behavior and marvel at their beauty.

13.1 A scimitar-horned oryx at the National Zoo photographed during the late afternoon (see A on the map). Taken at ISO 640, f/4, 1/160 second with a 360mm lens.

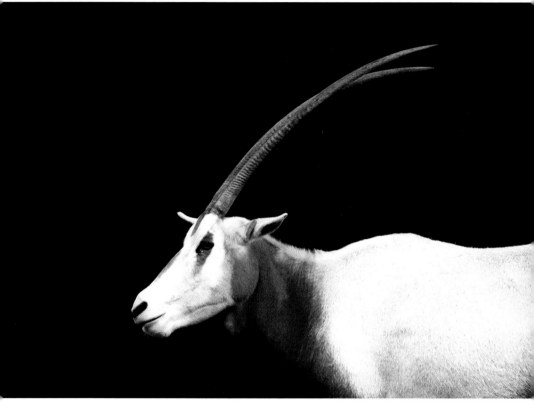

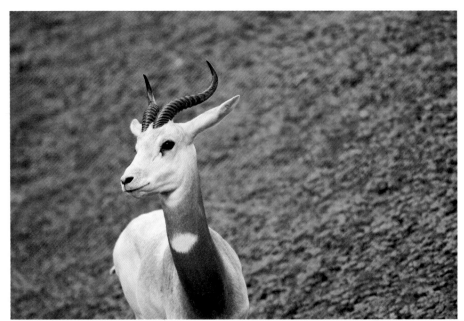

13.2 A dama gazelle at the National Zoo photographed during the late afternoon (see A on the map). Taken at ISO 1000, f/4, 1/200 second with a 360mm lens.

Amazonia

The National Zoo's largest and most complex exhibit is also easily missed, mostly because of its location off the main Olmsted Walk. It's also relatively far from the main entrance and parking areas. But this is to its advantage because crowds here tend to be lessened, relative to the rest of the zoo. At peak visitation times, however, lines will form to enter here because zoo officials only allow a certain number of visitors at a time.

Inside, you find 15,000 square feet of rainforest, including a tropical river and an aquarium. The animals within the exhibit are generally free to move about on their own. The aquarium houses mammoth fresh water fish (see figure 13.3), above which are 50-foot trees where titi monkeys zip about (see figure 13.4).

Here the photography experience is much more like that in the wild — the notable exception being the lack of bugs feasting on you. You need some patience and a keen eye in the rainforest to spot the various animals.

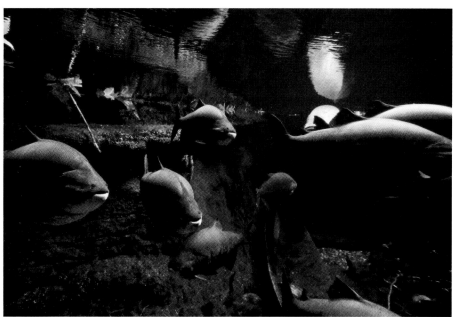

13.3 One of the aquariums in the Amazonia exhibit at the National Zoo (see B on the map). Taken at ISO 2500, f/4, 1/6100 second with a 20mm lens.

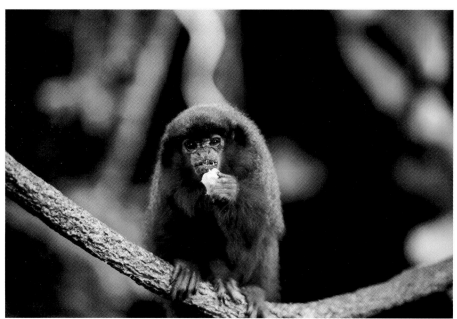

13.4 A titi monkey has a late morning snack in the National Zoo's Amazonia rainforest exhibit (see B on the map). Taken at ISO 2000, f/2.8, 1/320 second with a 215mm lens.

The Giant Panda Family

Panda cubs born at the National Zoo are sent to China after they turn two. Tai Shan moves to China in early 2010. His parents, Tian Tian and Mei Xiang, are on loan from the Chinese government until late 2010. So do note that the window of photographic opportunity for Washington, D.C.'s famous giant panda family is closing.

Asia Trail

The Asia Trail is home to six Asian species, including the National Zoo's prized exhibit: the giant pandas (see figure 13.5). There are also sloth bears, the ever-cute red panda (see figure 13.6), as well as small-clawed otters and clouded leopards.

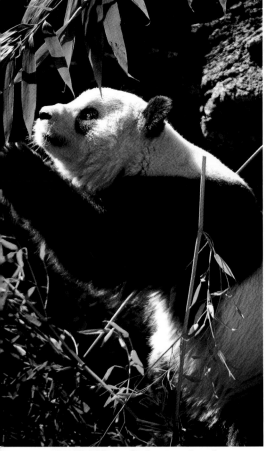

13.5 **Mei Xiang finds some bamboo to her liking at the National Zoo (see C on the map). Taken at ISO 400, f/4, 1/320 second with a 265mm lens.**

Red pandas often sit in trees that are only a few feet from a viewing area, while the otters watch you as much as you are watching them. They are, however, constantly on the move, so getting good photos of them takes some time. The red pandas, however, are model-like in their demeanor: They practically pose for you on the trees.

The giant pandas are one of the most popular attractions at the zoo. Getting photos of them is easier when they are outside and active — when it's colder, and early and late in the day. They otherwise may not be visible or close enough to get good photos. When they are active, they play and eat close to the spectator areas, at which point they are rather easy to photograph.

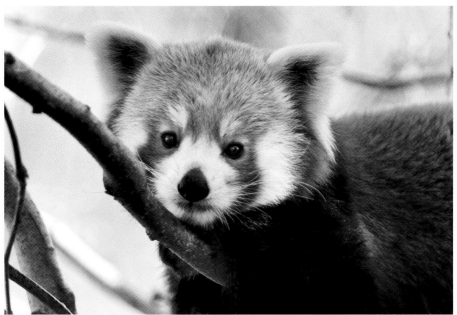

13.6 A red panda takes a midmorning break in a tree (see C on the map). Taken at ISO 800, f/4, 1/320 second with a 320mm lens.

Asian Elephants

The National Zoo has three Asian elephants: Ambika, Shanthi, and Kandula.

Elephants make for great photography subjects because of their relatively slow speed and large size, and you can get rather close to them at the National Zoo. They are also beautiful — their wrinkly skin alternatively soaks up and reflects light, and their form is all at once prehistoric, bizarre, and elegant (see figure 13.7).

They make for great black-and-white photographs as well. The simplicity of a black-and-white photograph emphasizes their details and form and greatly accents the light and dark areas of their bodies (see figure 13.8).

The zoo's elephant habitat, Elephant Trails, is under construction until 2011. However, the elephants are on display outside during exhibit hours.

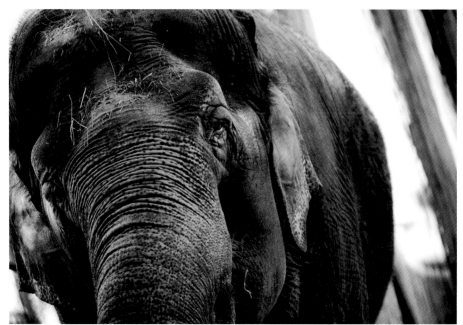

13.7 Ambika, photographed at the National Zoo during the late afternoon (see D on the map). Taken at ISO 800, f/4, 1/320 second with a 360mm lens.

13.8 Shanthi, photographed at the National Zoo during the late afternoon (see D on the map). Taken at ISO 800, f/4.5, 1/320 second with a 360mm lens.

Bird House

Bird watching and bird photography, in particular, can be an extremely specialized form of photography. Serious bird photographers go to great lengths to get close to birds of all kinds and use some very specialized lenses to do so — some nearing the size of a telescope.

The bird exhibits present a rare chance to get up close to many different varieties of birds, and many are at relative ease with people watching them, too (see figure 13.9).

Although photographing birds at the zoo definitely takes some of the sport out of the entire affair, it's also a nice chance to get some interesting photos (see figure 13.10).

Several areas encompass the bird exhibits: the Bird House, which has an indoor area of enclosed exhibits, and an Indoor Flight Room. There is an Outdoor Flight Cage (the birds of the Outdoor Flight Cage move indoors between November 1 to April 30), as well as several outdoor exhibits that include birds with glorious names, such as the double-watted cassowary and the white-crested laughing thrush.

13.9 A Western Crowned Pigeon, a native of New Guinea, in the National Zoo's Indoor Flight Room (see E on the map). Taken at ISO 1600, f/2.8, 1/200 second with a 260mm lens.

13.10 The Flamingos exhibit is always incredibly colorful (see E on the map). Taken at ISO 1250, f/4, 1/400 second with a 360mm lens.

The Great Ape House and the O Line

The O Line, or the Orangutan Transport System, was created by the National Zoo staff as a novel solution to a problem they had: They wanted to include the orangutans in the zoo's Think Tank exhibit, but they didn't have the space for all the animals there.

To solve the problem they created the O Line to let them travel back and forth from the Think Tank to their Great Ape House along suspended cables connected to 50-foot towers. The whole system is almost 500 feet in length and crosses the main pedestrian thoroughfare of Olmsted Walk twice. The best time to see the orangutans on the O Line is between 11 a.m. to 12:30 p.m. on warm days (see figure 13.11).

The outdoor yards of The Great Ape House are a good place to photograph the apes because there is ample light, plenty of locations from which to work, and the apes are often frolicking about in the area. You have to shoot through some thick glass — look for areas where you can put your lens directly against the glass so that you can minimize distortion and reflection.

Also, try to keep your camera pointed straight through the glass. Doing so helps to reduce the amount of glass you are shooting through as well as keep reflections on the glass out of your photos. Also, you'll most likely have to use software after you shoot to deal with the contrast and white balance, because the glass can alter both a fair amount.

It may seem counterintuitive, but keeping the glass, wire fences, and other distracting objects as close to the lens as possible reduces the impact these items have on your photos.

13.11 Kiko some 50 feet in the air on the O Line at the National Zoo (see F on the map). Taken at ISO 100, f/8, 1/1000 second with a 90mm lens.

Great Cats

The lions and tigers are always a zoo favorite, but there's one small catch: They are strong, agile, and fast. To keep this from being a liability, it's necessary for the zoo to keep the edge of their habitats a good distance away from the viewing area. That means it's a bit tougher to photograph them because of the sheer distance involved (see figure 13.12).

13.12 An African lion at the National Zoo's Great Cats exhibit (see G on the map). Taken at ISO 800, f/4, 1/640 second with a 360mm lens.

Invertebrates

If there is a group of animals that need a good public relations kick, the inverte-brates are it. Perhaps it's because of their rather broad classification based on the fact that they don't have a vertebral column. It could be because some are down-right scary (think tarantulas and scorpions), or that we consider them routine food (American lobsters and crayfish) or pests (ants and roaches).

However, invertebrates make up more than 90 percent of all known living species and are essential to the existence of life as we know it on our planet, yet they just don't seem to garner the attention at the zoo like the elephants or lions. But what they lack in cuteness, they make up for in extreme color, wild looks, and complete accessibility at the zoo (see figure 13.13). This is also a good area for standard photography equipment — big telephoto lenses aren't necessary here.

13.13 Elegance coral in the Invertebrate exhibit at the National Zoo (see H on the map). Taken at ISO 500, f/4.5, 1/60 second with a 50mm lens.

Small Mammal House

Although it doesn't have an exotic sounding name, the Small Mammal House is a worthwhile exhibit to visit for a good photographic challenge. The exhibit is indoors, so there's limited natural light, but the access you have to a variety of animals outweighs that. All the animals here are not too small yet not too big — as the National Zoo Web site says, they are all "no bigger than a breadbox."

You can find an array of wild-looking creatures most people rarely see, including the endangered golden lion tamarins (see figure 13.14), two-toed sloths (see figure 13.15), shrews, and porcupines.

Check out the zoo's Web site at http://nationalzoo.si.edu to plan your trip.

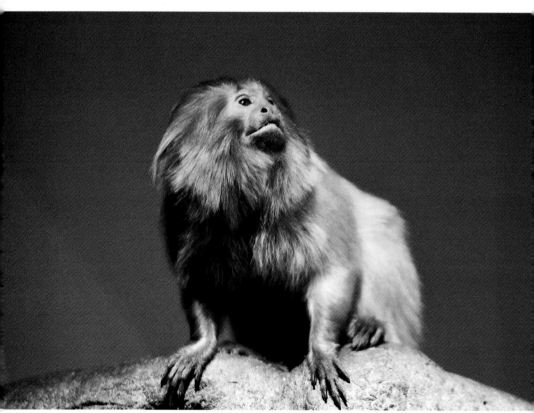

13.14 A golden lion tamarin photographed inside the Small Mammal House at the National Zoo (see I on the map). Taken at ISO 1600, f/2.8, 1/200 second with a 260mm lens.

13.15 A two-toed sloth within the Small Mammal House at the National Zoo (see I on the map). Taken at ISO 800, f/2.8, 1/160 with a 90mm lens.

How Can I Get the Best Shot?

Good photographs from the National Zoo are a result of understanding the various areas to shoot in and how well your gear will work with them.

Equipment

Big lenses are a fairly common sight at the zoo, but many great shots can be made with more common gear as well.

Lenses

For many outdoor exhibits, you need a telephoto lens of at least 200mm. For large, fast animals, such as cheetahs, lions and tigers, focal lengths of 300, 400, and 600mm are necessary to get in close (see figure 13.16), which is probably the hallmark of good zoo photography: The closer you are, the better the photos.

Another option is to compose your photos to include the habitat of the animal, which means that you don't need as long of a lens because you can take photos that show more of the animal's environment. If you wait and keep at it, you can usually find a composition that doesn't include many man-made features and graces the animal well with shorter lenses.

13.16 Two of the National Zoo's cheetahs in the late afternoon (see A on the map). Taken at ISO 1600, f/4, 1/160 second with a 360mm lens.

If you have a good quality, fast telephoto lens (such as a 70-200mm zoom), adding a 1.4X teleconverter is one option for longer focal lengths. Using this lens reduces the light entering your camera by 1.4X as well as increases its focal length by the same amount. For example, if you have a 70-200mm f/2.8 lens, it will turn into a 98-280mm f/4 lens with a 1.4X teleconverter.

Another option is to borrow, rent, or purchase a long lens such as a 100-400mm f/4 – 5.6 zoom, or if you want to lug one around, a professional prime lens of anywhere from 300mm on up. These are big and heavy lenses, though, and are wickedly expensive. However, you can rent them from local camera stores in the D.C. area or from online rental houses.

FONZ Photo Club

If you're interested in being a regular at the National Zoo with your camera, be sure to check out the Friends of the National Zoo (FONZ) Photo Club. Members can attend special photographic events and learn the ins and outs of what it takes to make a great photo in a zoo. You can also help support the zoo by offering your photos for sale at special events.

If you rent, be sure the lens is insured.

dSLRs that have a 1.3X or 1.6X crop factor are at an advantage here. Whereas a full-frame dSLR needs a 600mm lens for certain shots, a 1.6X crop camera requires a 375mm lens for the same shot. Be sure you consider your camera's crop factor before making a choice of what lens to bring. Of course, having too long of a lens is often not a problem at the zoo.

However, having a long telephoto lens isn't a requirement at all. Plenty of photos in this chapter were taken with wide to normal focal length lenses (those between 16-200mm, which are more common lens focal lengths), as demonstrated by figure 13.17. Take some time to figure out what exhibits will work best with the gear you have.

Because the light may often be lower than what is optimal and many exhibits require using longer lenses, stabilize your camera on railings or fences that often surround the exhibits. Doing so helps you avoid camera-shake motion blur, which is especially important with longer focal length lenses that are much harder to hold completely steady.

13.17 Orangutans at the Great Ape House of the National Zoo (see F on the map). Taken at ISO 640, f/5, 1/250 with a 150mm lens.

One consideration to keep in mind as well is that new generations of cameras are coming out that have incredibly high ISO values — reaching over 100,000. Although the shallow depth of field of a large aperture value is nice, being able to use an f/4 lens instead of a much bigger and heavier f/2.8 lens will likely be an option in the not-too-distant future thanks to the greater sensitivity of these new cameras.

Filters

Lens filters at the zoo aren't extraordinarily necessary and, in fact, may actually pose more problems than they are worth. Anything placed over your lens reduces the amount of light entering it, and more often than not at the zoo you need all the light you can get. You can always add software-based graduated filters after the

fact to control some of the light better. In general, you want to concentrate more on the animals than on messing around with filters.

Extras

A monopod is a good choice over a tripod for supporting your camera. Monopods are much lighter, easier to maneuver, and are less prone to being tripped on by small kids.

Next, wear dark clothing. Why? By doing so, you reflect less in the glass of the various exhibits. You can also bring a black shirt or cloth with you to hold against the glass to reduce reflections in the area you are pointing your lens through. If you have a friend coming along, have him wear dark clothing, too, so he can block the light that is reflecting on the glass just by standing near you.

Finally, be sure to have your lens hood with you. These control excess light from entering the camera's lens and bouncing all around, which reduces image quality. A lens hood also helps to block extraneous light from hitting the glass you are shooting through. You can also use a hood to hold your lens directly against the glass or a wire fence without worrying about damaging it.

Camera settings

When shooting at the zoo, anticipation of an animal's movements is the first requirement. The next is to have your camera ready for the action. If you see an animal sitting in a nice spot (see figure 13.18), go ahead and focus on it and set your camera to what you'll want to capture before anything happens.

If you're using a full auto mode, take a few test pictures to see how your camera is handling the exposure. Sometimes areas of extreme contrast

13.18 Tian Tian devours some bamboo in the morning at the National Zoo's Fuji Film Giant Panda Habitat (see C on the map). Taken at ISO 800, f/4, 1/250 second with a 360mm lens.

will confuse your camera — if the picture looks too dark or light, try composing the shot so that very dark or very light areas aren't in the frame. If you're comfortable using a priority mode, a good idea is to use Aperture Priority mode and set a smaller aperture value, such as f/4 or f/5.6 to blur out the background and make sure that the ISO you have chosen is allowing your camera to give you a relatively fast shutter speed of between 1/500 and 1/1000 seconds.

TIP If your camera doesn't allow you to set the aperture, take a look at the manual. It often states which automatic modes use a smaller depth of field: Portrait mode often does this, but you also want to make sure it doesn't do something else also, like turn on the flash. It's a good idea to get accustomed to what each creative mode will do.

After you have your camera ready, work on composition ideas before the animal does anything. Go ahead and frame it up and see what you like. Look around to see if you can tell where the animal will go next. Many animals follow patterns of behavior repeatedly and will have a well-worn path in the dirt or grass. The goal is to have the camera ready and have a photo in mind and mostly composed. When the animal begins eating or looks right at you, you'll be ready. When the moment strikes, be sure to take many photos (see figure 13.19); the animal may not repeat that behavior for the rest of the day.

13.19 A lioness has a late morning yawn (see G on the map). Taken at ISO 800, f/4, 1/400 second with a 600mm lens.

As you go on shooting the same scene, you can be more creative with composition and framing. Try taking some images both horizontally and vertically. You basically want to "sketch" with your camera and experiment. It doesn't matter if your original idea for the composition didn't pan out. The point is that you were ready for something and that you had some ideas already hatched about what you wanted. Try to get the odds on your side — this is my best advice for zoo photography. That means having your camera ready, knowing where the nice light is relative to the animal you're shooting, figuring out a little of its behavior patterns, and thinking about your composition beforehand.

Exposure

When photographing at the zoo, concentrate on avoiding anything man-made in your photos, like bars, cables, boxes, lights, and so on. Your photos can be greatly improved by showing the animals in as much of their natural environment as possible.

Ideal time to shoot

A lot of animals at the zoo, especially those that live outdoors, are most active in the morning and then again late in the day (see figure 13.20), which means photographs that are more dynamic and more easily attainable. The light is typically more interesting earlier and later in the day as well, but it can also be a bit harder to work with since it will be less bright and many areas will only be partially lit. That said, there's plenty to see at all hours here, so it really depends on what you are most interested in seeing.

 For updated opening and closing times for the National Zoo as well as all Smithsonian locations, see www.si.edu/visit/hours.htm.

Working around the weather

Interesting weather at the zoo can add some difficulty because there may be less light, but it can also greatly enhance your experience. Snowy days are excellent for the pandas and many other animals that are used to such conditions. Luckily, during the zoo's open hours, several indoor places are available in which to take refuge if it's raining too much or too cold to stay outside for a long time.

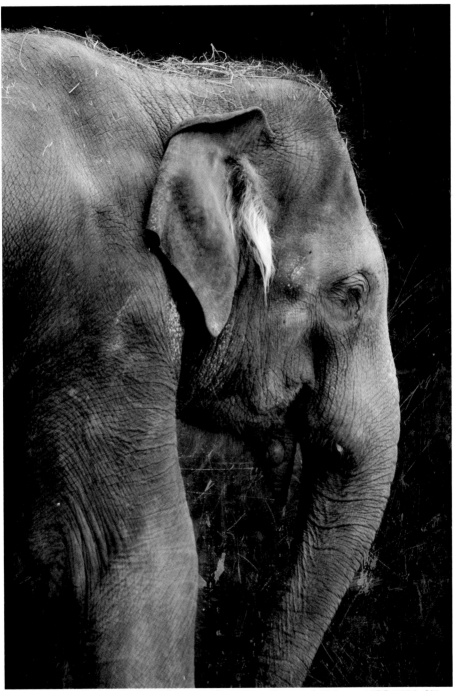

13.20 Shanthi during the late afternoon (see D on the map). Taken at ISO 1000, f/4, 1/320 second with a 360mm lens.

⚙ 14 Old Post Office

The Old Post Office during early evening. Taken at ISO 200, f/11, 25 seconds with a 50mm lens and a tripod.

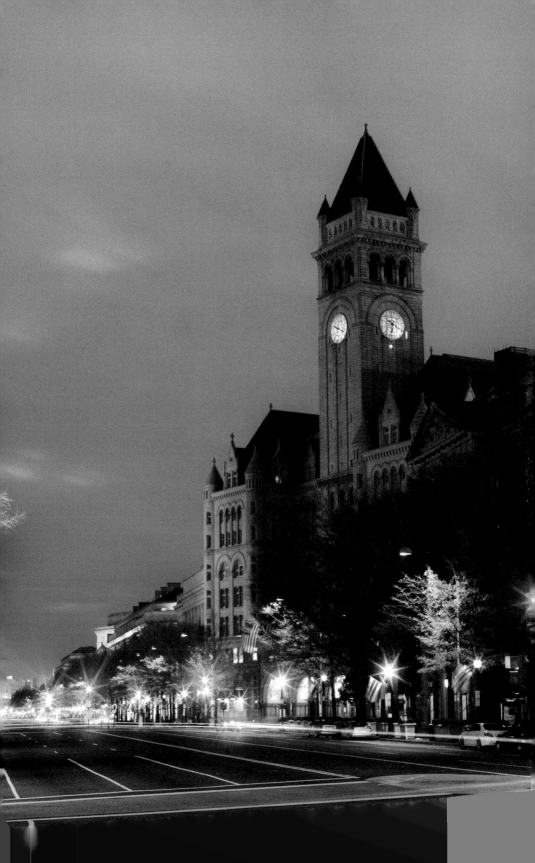

Why It's Worth a Photograph

The Washington, D.C. skyline is punctuated by a few landmarks that everyone knows, such as the Washington Monument, the U.S. Capitol, and the Smithsonian Castle. And then there's the one that most people don't recognize. It looks somewhat like a cathedral from Medieval Europe, albeit with a clock tower.

It was originally conceived to house both the U.S. Post Office Department headquarters and the post office for the District of Columbia. Today, the Old Post Office is undeniably an interesting contrast to the strict classicism of Federal Triangle buildings built in the 1930s and the blocky, monolithic designs of buildings constructed in the 1970s.

Where Can I Get the Best Shot?

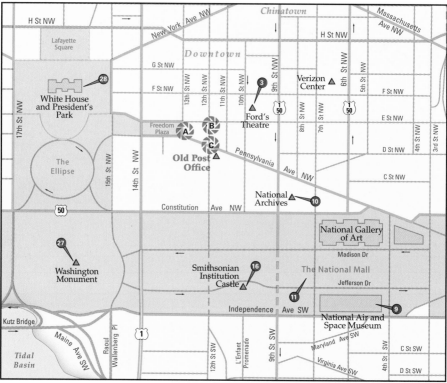

The best locations from which to photograph the Old Post Office: (A) the 1300 block of Pennsylvania Avenue NW, (B) the 1200 block of Pennsylvania Avenue NW, and (C) in front of the Old Post Office. Nearby photo ops: (3) Ford's Theatre, (9) National Air and Space Museum, (10) National Archives, (11) National Mall, (16) Smithsonian Institution Castle, (27) Washington Monument, (28) White House and President's Park.

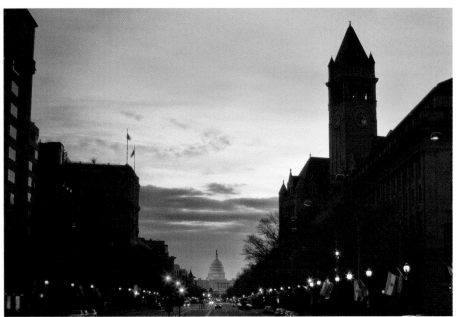

14.1 The Old Post Office and the Capitol in the morning (see A on the map). Taken at ISO 100, f/29, 3 seconds with a 70mm lens mounted on a tripod.

1300 block of Pennsylvania Avenue NW, north side

Here, beside what is known as Freedom Plaza on the north side of the block, you can get a nice image of Pennsylvania Avenue as it leads up to the U.S. Capitol. This is a great vantage point from which to photograph the Old Post Office.

Depending on where you stand along this block of Pennsylvania Avenue between 13th and 14th St. NW, you can either photograph the building alone or with the Capitol in the distance (see figures 14.1 and 14.2).

14.2 A detail of the Old Post Office's clock tower (see A on the map). Taken at ISO 200, f/11, 20 seconds with a 100mm lens mounted on a tripod.

1200 block of Pennsylvania Avenue NW, north side

This is an alternate location where you can get a more frontal view of the Old Post Office, as well as many of its architectural details from the north side of this block (see figure 14.3).

In front of the Old Post Office

Here, you can get some closer images of the building (see figure 14.4), as well as a somewhat haggard-looking statue of Benjamin Franklin (see figure 14.5). The statue was originally a gift of Stilson Hutches, the founder of the Washington Post, and was dedicated on Franklin's birthday on January 17,

14.3 Another view of the Old Post Office, seen from the middle of the 1200 block of Pennsylvania NW (see B on the map). Taken at ISO 800, f/5, 1/60 second with a 50mm lens.

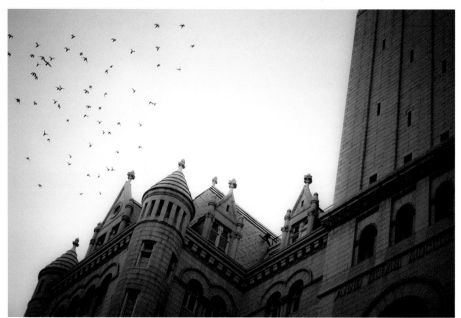

14.4 A detail of the Old Post Office's front façade on an overcast morning (see C on the map). Taken at ISO 100, f/1.4, 1/160 second with a 65mm lens.

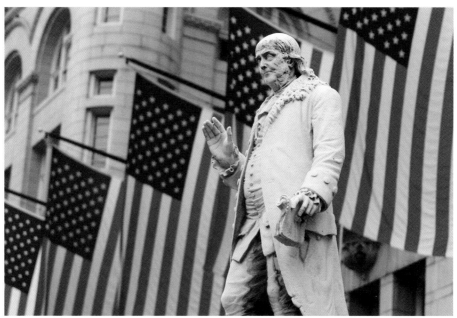

14.5 The statue of Benjamin Franklin in front of the Old Post Office (see C on the map). Taken at ISO 100, f/4, 1/100 second with a 130mm lens.

1889 by Franklin's granddaughter, Mrs. H.W. Emory. It was moved from its original location at 10th St. and Pennsylvania Avenue NW to this site in 1982.

How Can I Get the Best Shot?

Getting a nice photo here is fairly easy because of the open space and nice vantage points, especially as you look down from the 1300 block of Pennsylvania Avenue.

Equipment

Here focal lengths from 35mm to 100mm are the rule, except if you want to photograph the building from a closer vantage point near 12th St. NW.

Lenses

One of the best tips for photographing buildings is to use the longest focal length possible, because it prevents distortion to the building. The photos from the 1300 block of Pennsylvania Avenue (refer to figure 14.1) are therefore a bit easier on the eyes with regard to architecture because a 70mm lens distorts less than a wider-angle lens. With the Old Post Office, you'll have the option of using the lens you prefer or the one you have: The longer the focal length you choose, the farther west you can head on Pennsylvania Avenue NW.

Filters

If you do use a wide-angle lens with architecture, you can reduce the amount of distortion to a degree by using a lens distortion correction filter in an image-editing program. Such filters are also useful to learn about how lenses affect architectural details in general.

Extras

Photo enthusiasts who wish to use a tripod can do so briefly as long as they don't cause any obstruction (see this book's Introduction for more information about tripod use). If you choose to use one without a permit, note that the proximity of these photography locations to the White House, Capitol, and other high-security buildings adds to the likelihood of additional scrutiny. A small, table-top tripod can be used from the Freedom Plaza area along the north side of the 1300 block of Pennsylvania Avenue. You can place the mini tripod on one of the many walls or planters.

Camera settings

The camera settings you use largely depend on when you choose to photograph the Old Post Office. At the most basic level of photography, you want to be sure to correctly meter on the building during the daylight hours so that your image isn't too dark or light. If your camera has Center-weighted or Spot metering modes, use it to set an exposure off the building. Because the Old Post Office is a neutral gray color, your camera's meter should set an accurate exposure when based on it. If you need to recompose, note the settings you had when metering on the building and then manually set those after recomposing.

Another method of determining the correct exposure is of course to look at the image displayed on your camera as well as to use your camera's histogram (the graph that can be seen with the image on many cameras). The histogram is simply showing you how much of the darks, midtones, and bright tones are in an image: The darks and blacks are on the left, midtones are in the middle, and bright whites on the right.

A well-exposed image generally has the bulk of its tones within the middle of the graph. An overexposed image will weight the graph to the right, whereas an underexposed image will weight it to the left. This guideline is by no means a hard-and-fast rule, because images with lots of white in them would have a histogram that shows much of the information in the bright and white areas (right side) of the graph, whereas a night image may have little information in the bright areas and a lot in the dark areas of the graph (the left).

Because there may be a bright sky surrounding the buildings, your camera may set an exposure that will render the scene too darkly. If this happens, it is because your camera is metering the bright sky, not the darker building. By adding exposure with the exposure compensation function, you can brighten up the picture and get a better overall image. Or you can try to meter more specifically on the building, or a combination of both.

If you are photographing the Old Post Office toward the early morning or night, try setting a slower shutter speed such as 1/15 or 1/30 second and holding your camera very steady: This will let the cars and people blur a little, and reduces their distraction in the image as well as adding a different look than what people are used to seeing. (Your camera's Shutter Priority setting would be good for this.) If you hold still, you can get a similar image to what you would get when using a tripod.

Exposure

Think about the kind of photograph you want when shooting here to determine the correct time of day you want to photograph the Old Post Office.

Ideal time to shoot

The front of the Old Post Office faces north, which means that it doesn't often receive direct sunlight. Although some may see this as a limitation, it can be used to good effect because there will be more variance in the way the building is lit when the sun is rising and setting. Also, it can help to even out the exposure between the building and the sky. Because the building is never directly lit from the front or back, you have a better chance of getting a more even exposure at different times of the day.

As for the ideal time to shoot, because you will be facing east for some of these photos, working during the morning when the sun has risen and is directly opposite of you will be problematic (but of course that doesn't mean that a potentially interesting photograph can't be made then). Working with the sun behind you is the usual photographic advice, and it is indeed easier to work with — and for shooting the Old Post Office, it's a good idea.

If you're going for interesting color shots, you want to go in the morning and evenings, when the color in the sky is at its peak. Black-and-white photographs have a lot more options for light, including midday.

Working around the weather

Because there can be plenty of sky in these images, an interesting sky will help add a creative element to your photographs. Before and after storms, weather fronts and interesting clouds can all be used to good effect. If the weather is less

than spectacular, try to envision the images as black and white or with muted color. You can always find a creative answer to most any weather challenge.

If, however, the weather is less than ideal and you want to wait it out, the inside of the Old Post Office can be a good retreat: A trip up its clock tower can be done in any weather and offers scenic views of the city.

Low-light and night options

One note here is that because you are photographing in the downtown area, any low-hanging clouds will reflect the city lights, and the sky will take on a yellow-orange color when the sun has gone down. When mixed with the natural evening or morning light, this scene can take on an interesting look (see figure 14.6).

Getting creative

The Old Post Office's many details can be explored for no less than a full city block, so there are plenty of options here. Try using subtle angles with your camera to create a dynamic look with your pictures.

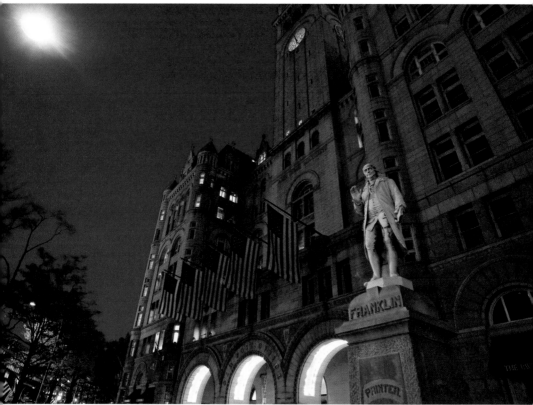

14.6 The front façade of the Old Post Office at night (see C on the map). Taken at ISO 3200, f/2.8, 1/15 second with a 20mm lens.

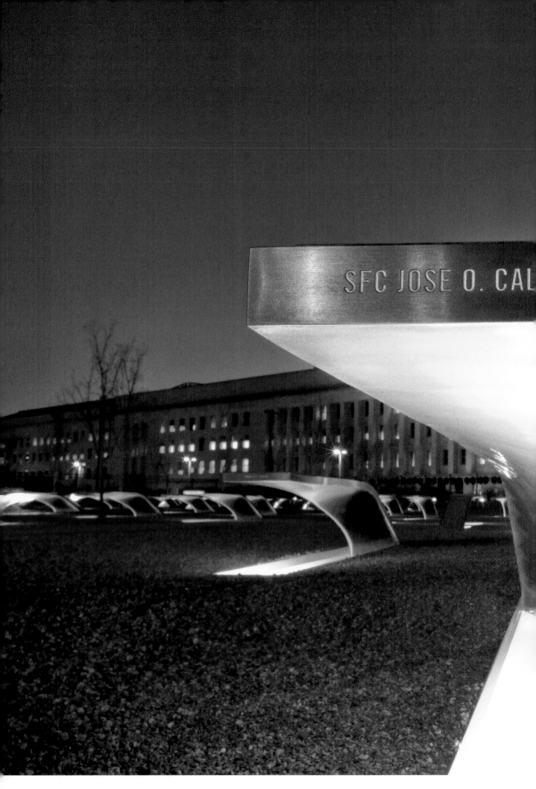

The Pentagon Memorial at night. Taken at ISO 400, f/16, 25 seconds with a 65mm lens and a tripod.

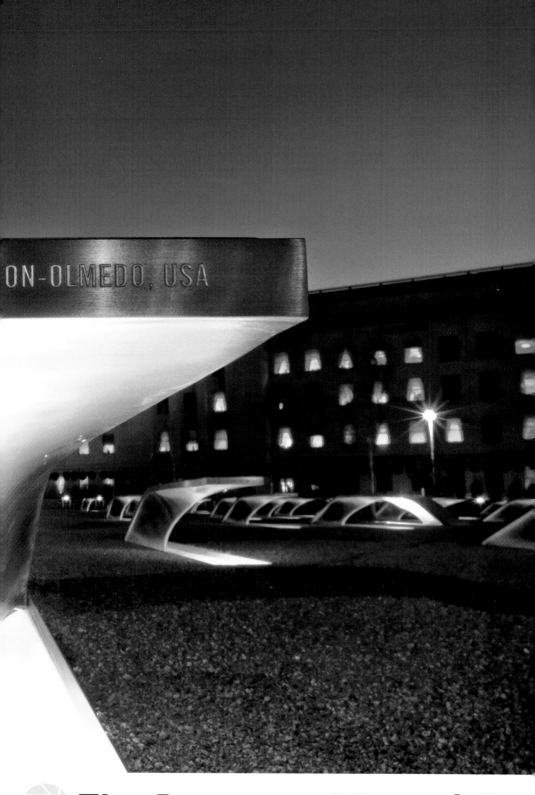

15 **The Pentagon Memorial**

Why It's Worth a Photograph

The Pentagon Memorial is a tribute to the victims of September 11, 2001, who were aboard hijacked American Airlines Flight 77 that was flown into the Pentagon by terrorists, and to the victims who were inside the Pentagon. These 184 people who perished are memorialized in an area adjacent to where the plane hit on the Pentagon's west side.

During the night the din of traffic and planes is reduced, and you can hear the sound of running water coming from each of the 184 benches changing constantly as you walk through the memorial. Those who died in the Pentagon have their names engraved on the benches in such a way that you see their names and the Pentagon in the same view, while the names of those on board American Airlines Flight 77 are engraved so that the viewer sees the sky.

Where Can I Get the Best Shot?

Photography is prohibited everywhere on the Pentagon Reservation except within the Pentagon Memorial grounds.

Within the memorial

The Pentagon Memorial is located next to the western wall of the Pentagon that was hit by Flight 77. The benches, designed to be sat on by visitors to give them time to reflect and think, are arranged by the birth dates of those who perished; the years are labeled on the area surrounding the benches on the memorial's west side. Within the center of the memorial you can see many of the benches together with the west façade of the Pentagon (see figures 15.1 and 15.2).

Remember that this is first and foremost a memorial to the victims of our nation's greatest tragedy, and conduct within it should be appropriate for those who are there to pay their respects. Snapping loads of photos, blocking people's views, or making a

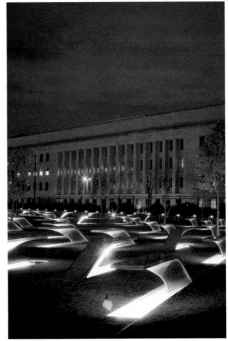

15.1 The Pentagon Memorial at night (see A on the map). Taken at ISO 400, f/14, 30 seconds with a 65mm lens.

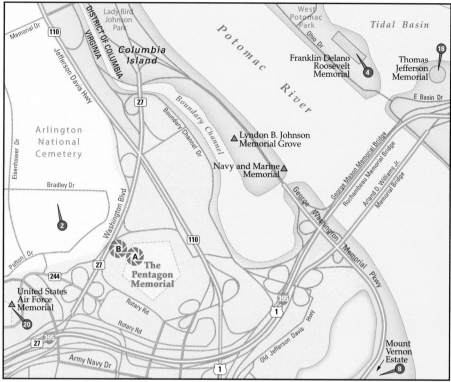

The best locations from which to photograph the Pentagon Memorial: (A) within the memorial and (B) along the Age Wall. Nearby photo ops: (2) Arlington National Cemetery, (4) Franklin Delano Roosevelt Memorial, (18)Thomas Jefferson Memorial, and (20) United States Air Force Memorial.

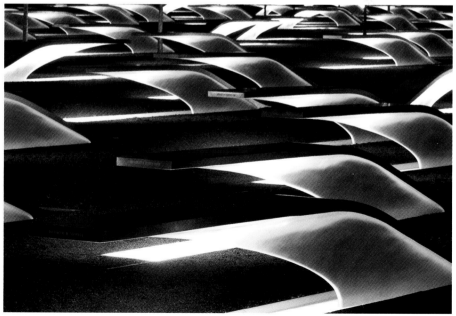

15.2 A detail of the Pentagon Memorial (see A on the map). Taken at ISO 400, f/16, 30 seconds with a 160mm lens mounted on a tripod.

lot of noise should be avoided. Choose your picture-taking moments carefully, so you will not be a distraction to other visitors.

Along the Age Wall

Just to the outside of the location of the benches, you find a walkway. Known as the Age Wall, it gets higher inch by inch along the age lines that organize the memorial. From this area (see figure 15.3), you can get a more overall view of the 184 benches as well as the Pentagon in the background.

How Can I Get the Best Shot?

Being at the Pentagon Memorial and paying tribute to its victims is an experience that requires time for contemplation. Walking through it and taking time to understand its meaning is crucial to making a photograph that captures the attitude of the memorial.

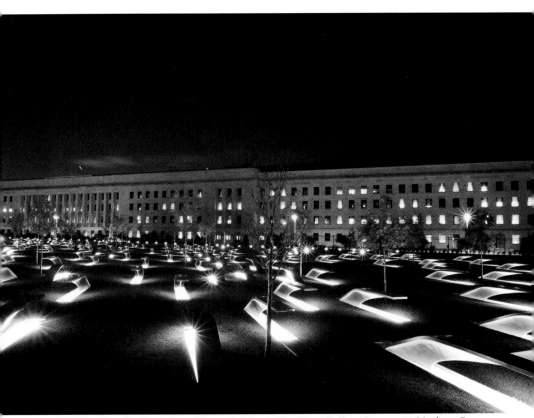

15.3 Viewing the Pentagon Memorial from the Age Wall on its west side (see B on the map). Taken at ISO 800, f/16, 30 seconds with a 28mm lens and a tripod.

Equipment

By using standard photography gear, you can take these shots either by day or night.

Lenses

For the photographs within the memorial, lenses between 50-70mm are good, depending on how you choose to compose the scene. To capture tighter detail shots, use lenses from 150-175mm. From the Age Wall that circles the memorial (refer to figure 15.3), try a wider lens in the range of 24-35mm.

Filters

If you are shooting during the day, you can use a graduated neutral density filter to darken the sky above the Pentagon.

Extras

A tripod is necessary for long exposure images here, but with a modern camera that has higher ISO settings that won't necessarily be required. From the walkway around the memorial, you can use a small table-top tripod that can sit on top of the wall here. Remember to respect those around you. Do not use such gear if it will impede visitors or cause a distraction.

Camera settings

These shots are nicely done with ample depth of field. Using Aperture Priority mode and selecting an aperture of f/11 or higher gets you a good amount of depth. During the day with ample light, you will be able to achieve this rather easily, but by night you will need to have a high ISO setting and a steady hand, or a tripod.

If you are handholding your camera at night, it's best to set a high ISO and use Shutter Priority mode and set a slow shutter speed of 1/30 to 1/60 of a second. Your camera will then set a lower aperture value, which will give you less depth of field. Focus on foreground elements, as you have more depth of field behind your focus point than in front of it, and take several pictures while being sure to keep a very steady hand. Also, the farther your focus point is from the closest foreground element, the more depth of field you will have overall.

Try a few shots at shutter speeds slower than you are comfortable using, such as 1/30 and 1/15 of a second as well. These shots may have too much camera shake, but if they are sharp, the increased exposure can create a brighter, more intense image. Of course, if you have a newer camera capable of very high ISO settings, you don't need to worry about this. Higher ISO speeds enable you to shoot at night with both a higher aperture value as well as faster shutter speeds while not diminishing quality to a large degree.

If you are using a tripod, you can use your camera's Program, Shutter Priority, Aperture Priority or Manual modes with long shutter speeds and lower ISO settings to get the best image quality. Using higher aperture values produces more of a star effect coming from the bright points in the photo, and because you are using a tripod, you can use the corresponding longer shutter speeds to do so.

Using flash here comes down to personal taste, but in general it floods a small area in the foreground of your shot with light, which will often look rather unnatural and also reduces the glow from the benches nearby. It's probably best to avoid it altogether.

Your camera's Auto white balance should handle the mixed lighting types here rather well, but if your images are looking unnatural, try the fluorescent or tungsten settings.

Exposure

Images here can be made in almost any weather, and in fact they will most likely be enhanced by more somber types of weather such as rain and snow.

Ideal time to shoot

Any time from dusk to night and sunrise to late morning can work out here. Because the memorial is open all the time, you can shoot at any of these times. The glow of the benches will greatly enhance your images, as the light is an essential part of their design. Direct, warm sun on them can create an interesting look as well.

Working around the weather

Interesting weather can certainly enhance the images from the Pentagon Memorial. There are, however, no facilities nearby other than some overpasses and the Pentagon Metro stop if you need to seek shelter from rain or snow.

Getting creative

Try using a bench as a foreground in the frame and also try to use many benches as a repetitive design element. Also, like the Vietnam Veterans War Memorial, items are often left by those remembering loved ones, which can make for interesting detail photos.

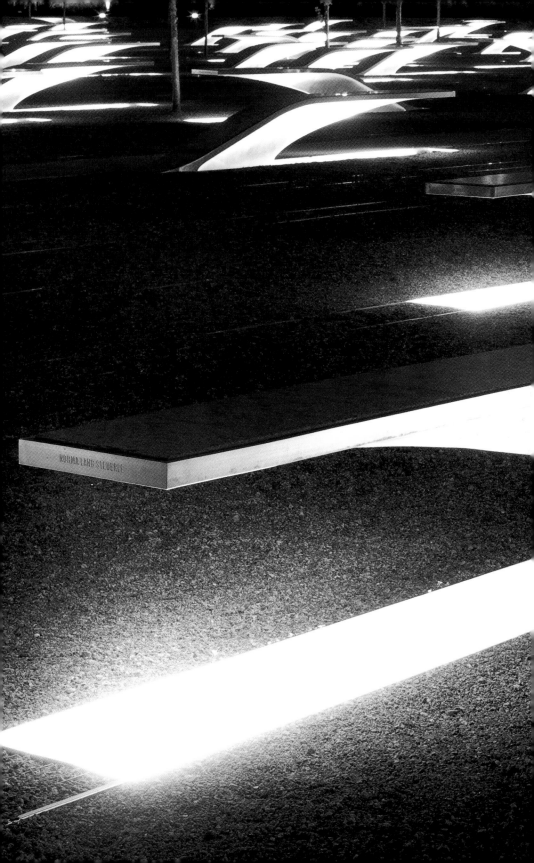

The Smithsonian Institution Castle seen from the National Mall in the morning. Taken at ISO 100, f/8, 1/320 second with a 70mm lens.

16 Smithsonian Institution Castle

Why It's Worth a Photograph

A standout even on the National Mall, the Smithsonian Institution Building — known simply as The Castle — was the first building of what is now a research institute and museum campus. Near the building's north entrance is the crypt of James Smithson, the English scientist whose name the Institution bears.

The red sandstone and design of the building makes it particularly photogenic, along with the immaculately tended gardens that surround it.

Where Can I Get the Best Shot?

The Castle has many good angles, as well as much to see within its gardens. It's definitely a rare opportunity to have access to such a unique building.

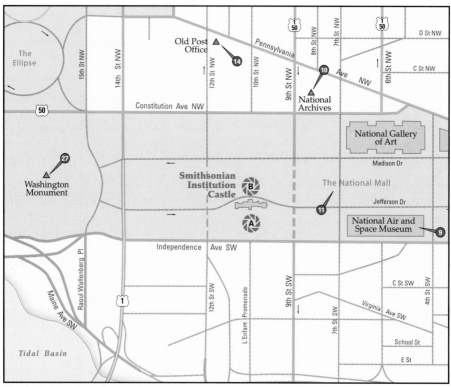

The best locations from which to photograph the Smithsonian Institution Castle: (A) the south-side garden and (B) the north side of the castle. Nearby photo ops: (9) National Air and Space Museum, (10) National Archives, (11) National Mall, (14) Old Post Office, and (27) Washington Monument.

16.1 The Smithsonian Institution Building seen from its south side (see A on the map). Taken at ISO 400, f/8, 1/50 second with a 25mm lens.

The southside garden

A lovely view of a gorgeous building, this is definitely the side to spend your time photographing. The north side of the building is attractive, but this side has no cars, roads, or anything of a modern bent — it retains much of its historic look (see figure 16.1).

The ruddy Maryland sandstone also is gorgeous when converted to black and white (see figure 16.2). The vintage look of a sepia-toned black-and-white photograph is a good match for the Norman design of the building.

16.2 The Smithsonian Institution Building from the east side of the south garden (see A on the map). Taken at ISO 100, f/11, 1/125 second with a 28mm lens.

The north side of the Castle

The front of the Smithsonian Castle is more architecturally imbued, but it also suffers somewhat from its proximity to modern Washington, D.C., life. Tour buses, loads of visitors, and parked cars often crowd this side. However, as mentioned earlier, the sandstone provides a lovely palette for black-and-white photos (see figure 16.3), and this side is great for getting up close and examining its intricate details (see figure 16.4).

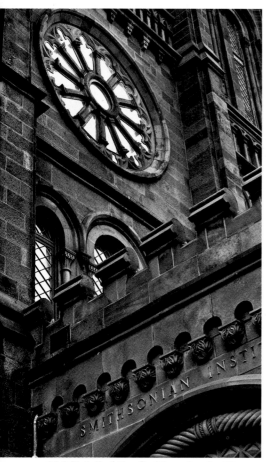

16.3 Detail of the Smithsonian Institution Building's north side (see B on the map). Taken at ISO 400, f/7.1, 1/80 second with a 65mm lens.

16.4 A statue of Joseph Henry, the first secretary of the Smithsonian Institution, in front of the Smithsonian Institution Building's north side (see B on the map). Taken at ISO 200, f/4, 1/200 second with a 180mm lens.

How Can I Get the Best Shot?

The gardens here are a nice respite to the busy Mall area. Be sure when photographing the details of the building to focus carefully on what will be the visual interest within the frame (see figure 16.5).

Equipment

The Smithsonian Building offers many interesting photographic opportunities, whether they are in color or black and white.

Lenses

Here, essentially standard lenses are the rule: The south side images of the building require somewhat wider lenses, although there is ample room to step back. The wider lenses, when placed closer to the gardens, accentuate the crisscross pattern there.

16.5 The north entrance of the Smithsonian Institution Building (see B on the map). Taken at ISO 320, f/5, 1/160 second with a 65mm lens.

Filters

Similar to other buildings, you can use a polarizer and/or graduated neutral density filters here.

Camera settings

One of the basic tips of photography is to know what general shade *neutral gray* is — traditionally what cameras base their exposures on. For the image of the building from its south side, you can lock your camera's exposure on the green grass here, which is usually quite close to neutral gray.

Making such images with a shallow depth of field can be beautiful, but you need to make sure that the focus point of the image makes sense. If you're focused on an element that isn't the focal point of the image, then the disparity of focus becomes immediately obvious.

Exposure

The gardens will obviously change their look throughout the seasons, but respectable photos can be made all year long.

Ideal time to shoot

Because the Castle is a north/south-facing building, the sun arches over it and casts long shadows unless it is an overcast day. Mornings and evenings provide nice light, but don't discount midday either. Sometimes the even illumination of such light, especially on the sandstone, is great looking.

Working around the weather

As with other buildings, unique weather can always enhance a photograph. Luckily, you have plenty of places to take cover if the weather turns ugly. For example, there is a coffee shop inside the building, which makes for a perfect, all-weather rest stop.

Low-light and night options

There are certainly opportunities to shoot late in the evening as well as night, although the sandstone soaks up a large amount of light. But the form of the building is quite graceful as a silhouette.

Getting creative

While here, check out the many beautiful details that adorn the area. Whether it be vibrant flowers or a flowing fountain (see figure 16.6), you have plenty to see.

16.6 A fountain on the east side of the Smithsonian Institution Building. Taken at ISO 100, f/2, 1/320 second, with a 50mm lens.

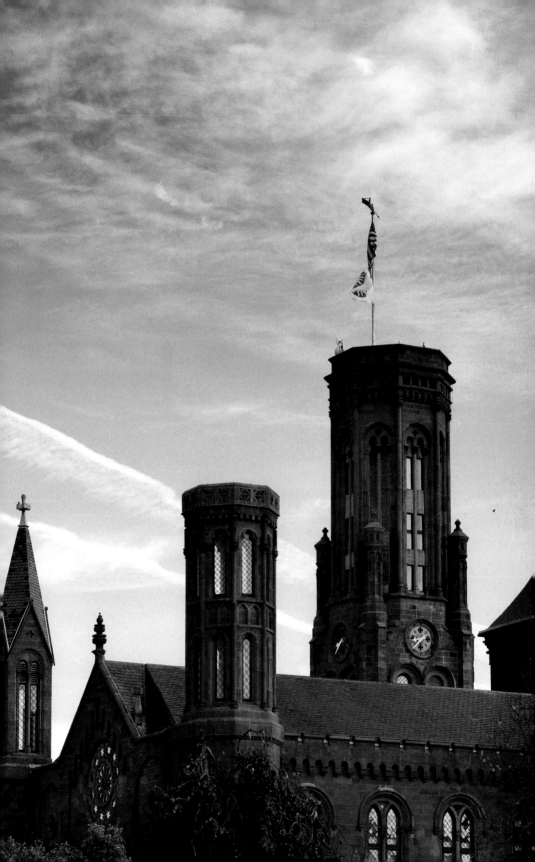

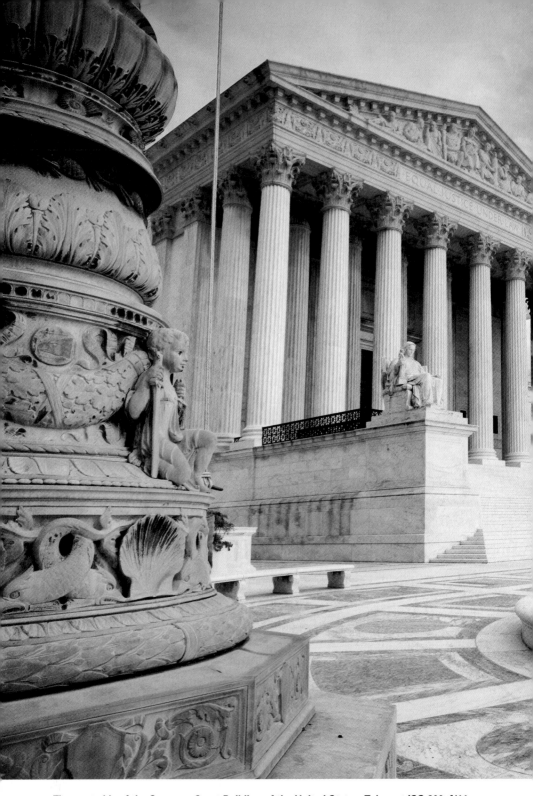

The west side of the Supreme Court Building of the United States. Taken at ISO 200, f/11, 1/125 second with a 20mm lens.

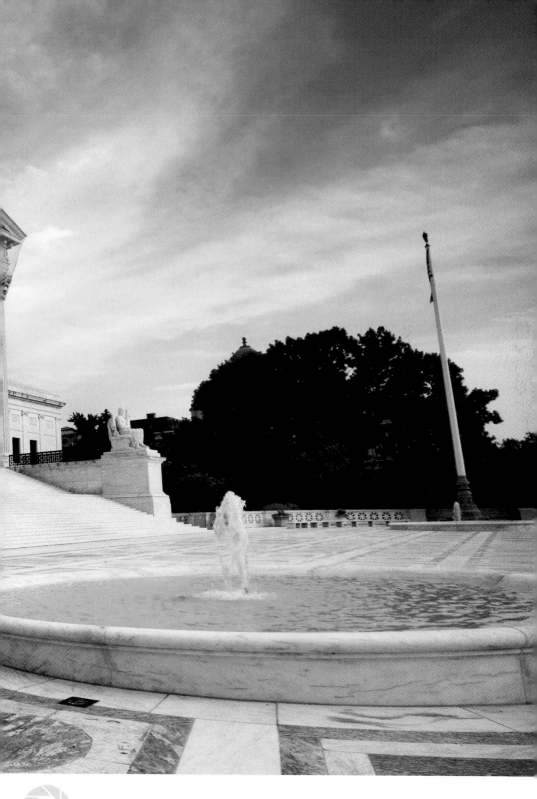

17 The Supreme Court of the United States

Why It's Worth a Photograph

The Supreme Court of the United States presides over all federal and state courts and bears the ultimate authority for the interpretation of the Constitution of the United States of America.

The U.S. Supreme Court was 146 years old before it finally got its own building in 1935. Prior to that, the Court's judges met over the years in a series of rooms within the U.S. Capitol until Chief Justice William Howard Taft (the former President of the United States) persuaded Congress to give the Supreme Court a building of its own.

Where Can I Get the Best Shot?

The front of the Supreme Court Building faces west. Its 16 marble columns, grand steps, and pediment that reads "Equal Justice Under Law" are all at once imposing

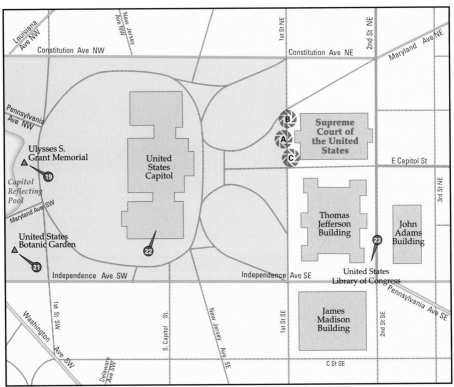

The best locations from which to photograph the Supreme Court of the United States: (A) west exterior facing east, (B) main steps, and (C) marble columns at west entrance. Nearby photo ops: (19) Ulysses S. Grant Memorial, (21) United States Botanic Garden, (22) United States Capitol, and (23) United States Library of Congress.

and monumental. It's a beautiful sight that even the most jaded Washingtonian can't pass without taking a second glance.

West exterior facing east

When photographing the west exterior of the Supreme Court Building, the late afternoon is your best bet for it being awash in golden sunlight (see figure 17.1). You can use many different ways to photograph from here, but one that works especially well is to add foreground subjects to the image.

Such subjects can be the candelabra on either side of the first, low set of steps, flowers that surround the building, or the pools of water and seating areas to either side of the main steps. People who are coming and going add a great sense of scale to the building as well.

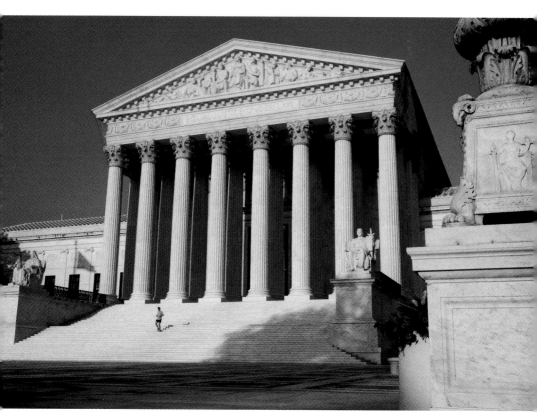

17.1 The west side of the United States Supreme Court Building (see A on the map). Taken at ISO 100, f/13, 1/125 second with a 40mm lens.

Main steps

Sculptor James Earl Fraser's marble figures grace either side of the main steps of the Supreme Court Building. On the left is a female figure, the *Contemplation of Justice*; to the right the *Guardian or Authority of Law* (see figure 17.2).

If you get to a spot below these figures, you can photograph them with the columns and pediment in the background, which makes for a wonderful photograph, especially with the late evening sun casting across both. You can also photograph them without the building in the background, which is a nice shot when the evening sky is a deep blue (see figure 17.3).

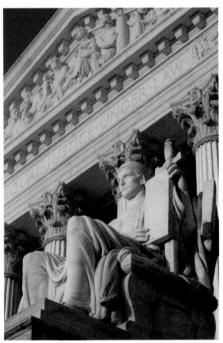

17.2 The Guardian or Authority of Law marble figure at the U.S. Supreme Court Building (see B on the map). Taken at ISO 200, f/6.3, 1/800 second with a 90mm lens.

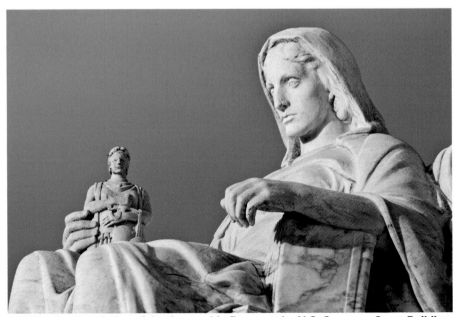

17.3 The Contemplation of Justice marble figure at the U.S. Supreme Court Building (see B on the map). Taken at ISO 200, f/6.3, 1/500 second with a 250mm lens.

Marble columns at west entrance

If you want to photograph beautiful columns, those at the Supreme Court Building are some of the best you'll find in D.C. (see figure 17.4).

17.4 The columns on the west side of the U.S. Supreme Court Building (see C on the map). Taken at ISO 400, f/16, 1/100 second with a 50mm lens.

How Can I Get the Best Shot?

The Supreme Court is one of the most beautiful buildings in Washington, D.C., although in 2006, a net was fastened to the west side's pediment after marble fell from the structure. Therefore, close-up photos of the pediment are less than optimal.

Equipment

Photography at the Supreme Court Building requires some wide and long lenses and some extra careful attention to composition.

Lenses

The Supreme Court Building is dauntingly large, and when you are up close to it, the vastness is striking. Moderately wide to normal lenses of between 35-50mm are good for shots from the lower stairs. When you get closer, you need a wide-angle lens of around 17-30mm, depending on how you are composing your shot.

Detail shots of the marble figures on either side of the main steps require a lens from 100-200mm.

Filters

If you are shooting in the evening light and composing a shot that is perpendicular to the sun, a polarizing filter can make the sky a deep blue and enhance the contrast with the clouds. But, if you are shooting along the same axis as the sun, a polarizer's effect will be minimized — it is most effective when used perpendicular to the direction of the light.

Extras

If you want to keep the angles correct on the Supreme Court, you can use a tilt-shift lens. Using this lens allows you to correct the distortion that occurs when you point your camera up from a low position when photographing buildings; this distortion is known as converging lines. These highly specialized lenses are used by architectural photographers to keep the angles of buildings correct, despite a less-than-optimal shooting position. These lenses are quite expensive but are often stocked by rental dealers.

Camera settings

When photographing the front of the Supreme Court Building lit by the sun, the building will be very bright and your camera may underexpose the scene if you are using an automatic exposure mode. Use your camera's exposure compensation function to increase its exposure, or take a look at what exposure settings it is automatically setting in an automatic mode, then switch to Manual and slow down the shutter speed and/or open the aperture to increase the exposure.

Get a handle on what a good overall exposure looks like and then start shooting photos, because the exposure will likely not vary significantly. If you are using a camera that lacks manual functionality, you may try its Snow or Beach mode — both are designed for overly bright scenes.

To get the warm glow of the sun setting into the building (refer to figure 17.1), set your color balance to its Sun mode and experiment with the other settings, such as the Shade mode to enhance the effect. During the day, the building can look clean and white while during the evening, it can glow orange in the final few minutes of sunlight. Choose your white balance based on your artistic preferences.

If you are photographing with something in the foreground, such as the candelabras, you will want to focus on those and set a fairly high aperture like f/11 to make sure that you get both the foreground elements and the background in focus, unless your artistic preferences say otherwise.

Exposure

The Supreme Court Building is striking no matter what the time or the weather, but by using the setting sun, your photo becomes spectacular.

Ideal time to shoot

Because the building faces west, the afternoon and evening are nice times to photograph here. But don't discount early mornings or even midafternoon. An early-morning, colorful sky can be a great backdrop, and the minimalism of clean, overhead light can make for a stark, contrast-filled shot.

When the court is in session, the public can view oral arguments. During these times, lines will form early in the morning for the more prominent cases, which isn't the best time to visit and take photographs.

 See the Court's Web site (www.supremecourtus.gov) for more information about these and other details about visiting.

Working around the weather

Overcast skies produce soft shadows and even lighting, which are easy to work with here, especially to make black-and-white photos. If it's raining, umbrellas and the people under them can add a colorful and different look to an otherwise monochromatic scene here.

Low-light and night options

At night, the interior area behind the columns is illuminated, which offers more possibilities.

Getting creative

Like many of the other landmarks in D.C., the Supreme Court building has countless details here that can make for great photos. The massive doors of the west side of the building are ripe for macro shots, as are the intricate parts of the marble figures. Also, when you are at the top of the main stairs, the view through the columns to the Capitol can make for an interesting composition.

The Thomas Jefferson Memorial from across the Tidal Basin before sunrise. Taken at ISO 100, f/11, 30 seconds with a tripod.

18 Thomas Jefferson Memorial

Why It's Worth a Photograph

The Thomas Jefferson Memorial honors the primary author of the Declaration of Independence and the third president of the United States. A lifelong student of philosophy, his eloquent prose articulated the principles of freedom for man as the basis for the British colonies' independence, and thus for the citizens of the future United States. In drafting the Declaration of Independence, his words helped form the philosophical foundation for the American-style of democratic government.

The Neoclassical monument, designed by John Russell Pope, was built in a style that Thomas Jefferson himself brought to U.S. shores with his design for the University of Virginia's rotunda. Likewise, the Jefferson Memorial's rotunda was built with 26 Ionic columns and contains a 19-foot tall statue of Jefferson inside (by Rudolph Evans), and within its walls are quotes by Jefferson throughout his career.

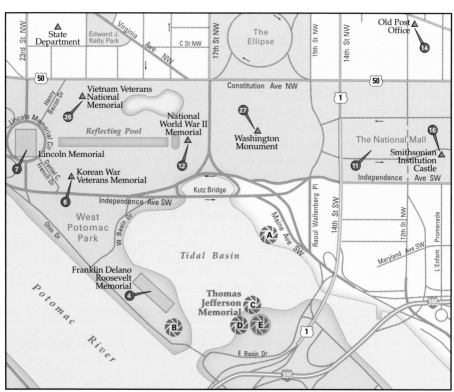

The best locations from which to photograph the Thomas Jefferson Memorial: (A) the northeast side of the Tidal Basin, (B) the southwest side of the Tidal Basin, (C) the Thomas Jefferson Memorial steps, (D) the westside outer walkway, and (E) the interior of the Memorial. Nearby photo ops: (7) Lincoln Memorial, (11) National Mall, (12) National World War II Memorial, (14) Old Post Office, (16) Smithsonian Institution Castle (26) Vietnam Veterans National Memorial, and (27) Washington Monument.

Where Can I Get the Best Shot?

The Jefferson Memorial is a little bit of a hike from the Mall and there are no Metro stops nearby, but it is well worth the trip. It's considered by many Washington D.C. locals as one of the prettiest and most relaxing spots of the city's many popular monuments.

Northeast side of the Tidal Basin

Definitely the iconic Jefferson Memorial image, figure 18.1 uses the waters of the Tidal Basin to reflect the memorial, and it allows you to see the statue of Jefferson within the memorial.

Southwest side of the Tidal Basin

There are several locations along the Tidal Basin from where you can photograph the Jefferson Memorial, and figure 18.2 takes advantage of a clean foreground and its west-facing side. With a setting sun (and in this case a rising moon), it's a nice vantage point to capture the Ionic columns, its dome, and still get the silhouette of Jefferson's statue.

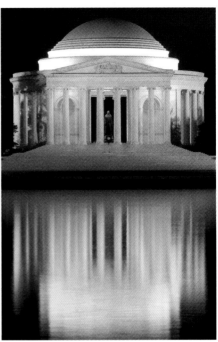

18.1 Viewing the Thomas Jefferson Memorial from its northeast side (see A on the map) early in the morning. Taken at ISO 100, f/11, 30 seconds with a 150mm lens and a tripod.

Thomas Jefferson Memorial steps

Close in, the steps of the Jefferson Memorial make a nice vantage point to capture the memorial's architecture as well as the sky beyond it (see figure 18.3). These steps often get crowded during the spring and summer, so you either have to use that to your creative advantage or try to get here at a time before other visitors show up (arriving before 9 a.m. is a good idea).

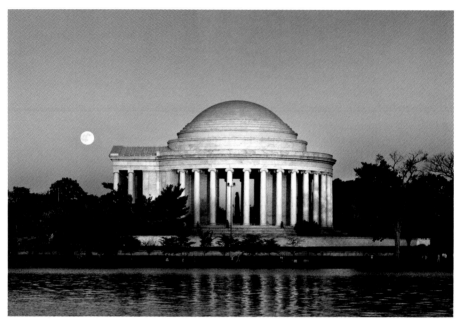

18.2 The sun sets over the Jefferson Memorial's west side (see B on the map). Taken at ISO 400, f/4, 1/320 second with a 120mm lens.

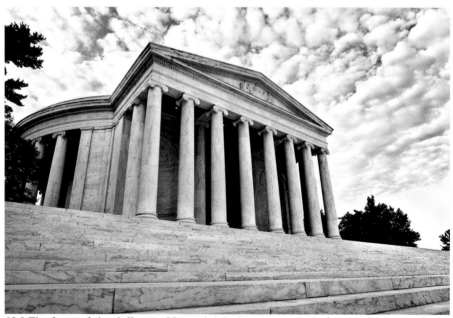

18.3 The front of the Jefferson Memorial during the morning (see C on the map). Taken at ISO 320, f/4, 1/640 second with a 24mm lens.

Westside outer walkway of the memorial

There are a variety of ways to photograph this side of the memorial. The east side could have the same possibilities, except there is a light post that gets in the way.

There are two walkways around the memorial, an outer one and an inner. The outer one lets you shoot from a vantage point that's less under the memorial, and, therefore, you get a cleaner line, and you use a longer lens which limits any distortion that a wide-angle lens used closer-in would create (see figure 18.4). You can make interesting pictures from both vantage points.

Interior of the memorial

The interior of the memorial is beautiful, with graceful curves and light that bounces all around that creates a peaceful glow by day (see figure 18.5).

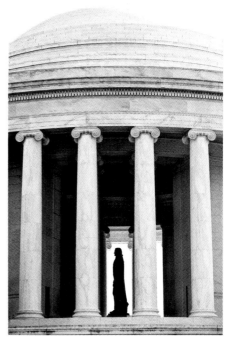

18.4 The Jefferson Memorial photographed from its westside outer walkway late in the morning (see D on the map). Taken at ISO 400, f/4, 1/1000 second with a 105mm lens.

The interior can be photographed at almost anytime during the day because of the abundant amount of light entering from all sides. However, crowds can become an issue, so getting here early in the morning is your best bet to keep your photos clear of other visitors — although other people in the frame do help to give a feeling of the sheer size of the Memorial. If there are a lot of people, you can move in towards the statue and shoot upwards.

How Can I Get the Best Shot?

The Jefferson Memorial can be photographed from a number of locations with a variety of lens options.

Equipment

Like the Lincoln Memorial and Washington Monument, tripods are not allowed within the marble areas of the Jefferson Memorial, but are usually allowed in other areas.

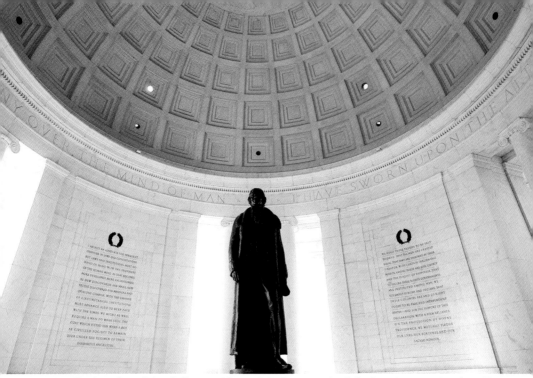

18.5 The interior of the Jefferson Memorial photographed during the morning (see E on the map). Taken at ISO 400, f/4, 1/125 second with a 20mm lens.

Lenses

A photograph from the northeast side of the Tidal Basin can be shot with anything from a 35mm lens on up, but to get the classic shot you need something in the vicinity of 90-150mm, depending on your composition.

The other images require fairly standard focal lengths between 100-150mm. When photographing from up close to the memorial as well as inside it, you need wider lenses of around 24mm and 20mm. Keep in mind that the wider the lens, the more distortion of architectural features.

Filters

Using a polarizer for any shots with lots of sky in them helps increase contrast and deepen a blue sky. A graduated neutral density filter can also help tone down the sky and clouds above the memorial.

Extras

A long shutter speed greatly emphasizes the reflection of the Jefferson Memorial on the water of the Tidal Basin, especially when the water is a bit rough. This requires a tripod so you can keep your camera perfectly still during the exposure.

Camera settings

For images from the northeast area of the Tidal Basin, exposure is key. I recommend that you take multiple, *bracketed* exposures, meaning ones with more and less exposure over what you think (or your camera thinks) is the proper exposure. You can bracket your exposure by using either your camera's exposure compensation feature, using your camera's automatic bracketing function (if it has one), or by dialing them in manually.

Note that making bracketed exposures isn't the same thing as simply changing your aperture or shutter speed when using an automatic exposure setting.

For example, if you are using Aperture Priority mode and your camera says a scene is metering at 1/500 second at f/8 and you change your aperture to f/11, your camera will slow its shutter speed down to 1/250 second to keep the exposure consistent. The amount of light entering the camera is the same for each setting. However, if you take the original settings (1/500 second at f/8) and add 1 stop of exposure using your camera's exposure compensation dial, the camera will change the shutter speed while keeping the aperture the same (because you are using Aperture Priority mode), so the new exposure will be 1/250 second at f/8 — or 1 stop more exposure.

Similarly, if you are photographing at a shutter speed of 10 seconds at f/11 and want to keep the same shutter speed (let's say because the reflection of the Jefferson Memorial looks the best at that setting), you want to change the aperture to bracket your shot. So a shot with 1-stop more exposure would be set to 10 seconds at f/8, and a shot with 1-stop less exposure would be set to 10 seconds at f/16. Many photographers also do several brackets in 1/2-stop increments to make sure they get the perfect exposure. This, however, requires a camera to be capable of making half stop increments with either shutter speed or f/stop.

The standard method when bracketing is to change the value that makes the least difference to the image. You can bracket with ISO, although doing so changes your image quality. And you can bracket with aperture, but doing so changes your depth of field (and potentially your focus), and often you don't want to risk having the correct exposure but losing focus. So the shutter speed is the appropriate value to bracket with here. If, however, you were concerned about movement in the frame (such as with a flag or water), you could bracket with aperture, ISO, or even a combination of the three.

If you want to create black-and-white photographs (see figure 18.6), the general rule of thumb is to shoot them in color and then convert them using software.

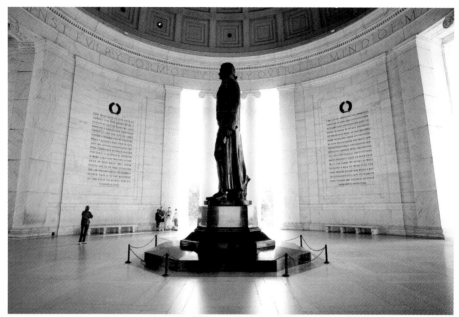

18.6 Another view of the Jefferson Memorial during the morning (see E on the map). Taken at ISO 400, f/5, 1/80 second with a 20mm lens.

Many cameras have black-and-white settings, and while these make the whole process very simple, they are also limiting you to whatever the camera *thinks* is the best settings for black and white. Although it may be right sometimes, you can't go back and add color to a black-and-white photo easily, whereas you can quite easily convert a color photo to a black-and-white photo.

Exposure

Like all buildings that are outdoors, the time you decide to photograph the Jefferson Memorial makes a big difference to your image. However, because there are interior images here and it faces north, there's some more leeway.

Ideal time to shoot

The classic Tidal Basin shots are definitely best done when the light is low, such as dusk, dawn, or at night to get the most reflection. For the frontal shots of the Jefferson Memorial, late morning to afternoon actually works well because it faces north — the more even the light the easier it is to get a clean front shot of the memorial. The same goes for the interior: Clean, evenly illuminated shots are

pretty easy to get during midday here, although when it's late or early in the day, the long shadows within the memorial can be quite nice. When shooting from the west, it's definitely best to use the setting sun, although very early morning here can look glorious as well.

Working around the weather

The Jefferson Memorial is a good one to go to if the weather isn't working out. Cloudy days help to evenly light the inside of the memorial, and if you're shooting the exterior of the building, the even, shadowless light of overcast weather works well.

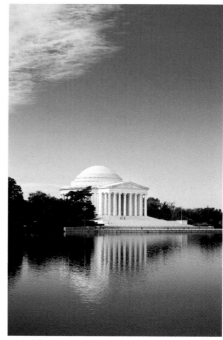

However, for images from the Tidal Basin where you're trying to get a good reflection (see figure 18.7), you want the water to be as still as possible — which means no wind, no rain, and not even any previous rains that could mean more movement of water within the basin. (The rougher the water, however, the longer a shutter speed you want to use to try to even it out when using a tripod.)

18.7 Viewing the Jefferson Memorial from the east side of the Tidal Basin in the morning (see A on the map). Taken at ISO 400, f/4, 1/400 second with a 70mm lens.

Because the Jefferson Memorial is largely surrounded by water, there are more opportunities to get fog in the shot. Fog can be tough to deal with: Too much and you can't see your subject, too little and the image will just look flat. Often the key to good fog images is to increase your exposure to deal with its brightness, although it's a very narrow exposure window you have to get it right. Remember to bracket!

The Jefferson Memorial is also out on its own, compared to all other memorials, and there are few places to seek refuge from the elements other than within the memorial itself.

If you happen to be in Washington, D.C. for the blossoming of the city's famous cherry trees (usually around early April; check www.nps.gov/cherry for information on peak bloom dates), there are a few tricks that will enable you to make the most of photographing these spectacular blooms.

Recommended vantage points are along the Tidal Basin (where you can see either the Jefferson Memorial, as shown in figure 18.8, or the Washington Monument) and the area adjacent to the Washington Monument. East Potomac Park's Ohio Drive SW is lined with them but doesn't offer views of the monuments or memorials.

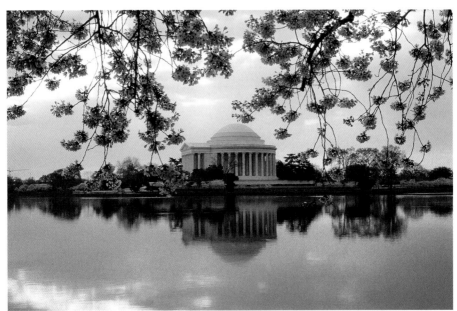

18.8 An early morning view of the Jefferson Memorial surrounded by cherry blossoms (see E on the map). Taken at ISO 200, f/22, 1/4 second with an 85mm lens and a tripod.

If you're going for close-up photos of the blossoms, use your camera's Macro function if it has one (often it's the Flower setting). If not, set your camera's zoom to its middle range and experiment with how close you can get to the flowers. Also try shooting through many of them, keeping only a few in focus and filling the entire frame with their color.

Try a trick of the trade: Photograph the flowers lit from the back, rather than the front. When lit from behind, the flowers glow with brilliant, saturated colors.

Because the cherry blossoms usually reflect a lot of light and can be very bright, some cameras will be thrown off and your photos may come out too dark. Try bracketing your exposures either manually, by using exposure compensation when using automatic or priority modes, or by using your camera's automatic bracketing feature, if it has one (of course this can also be done using a manual mode and adjusting your shutter speed or f-stop accordingly). Usually increasing exposure by 1/2 to 1 stop can help brightly lit photos have better color and brightness.

Low-light and night options

Night is a great time to come to the Jefferson because there are fewer people, although during the spring and summer the front may still be quite crowded even at 10 p.m. The water is often more calm at night as well, so reflections from the Tidal Basin can be better.

At night and low-light times your camera's white balance will have a big impact to the overall image. Rather than rely on its Auto white balance, it's a good idea to set either Daylight or another setting that won't try to constantly color balance a beautiful sunset or a colorful sunrise.

Getting creative

The unique rotunda and pillars make for interesting compositions, whether you photograph just the pillars (see figure 18.9) or use them with the statue inside.

The idea of doing tighter shots of Jefferson's statue head is perhaps worth trying, but he seems to be always covered in cobwebs and other detritus.

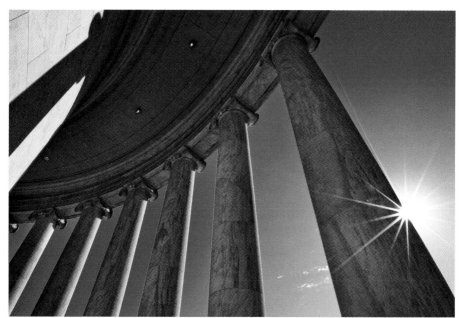

18.9 A detail view of the Jefferson Memorial's Ionic columns in the morning (see E on the map). Taken at ISO 100, f/22, 1/50 second with a 20mm lens.

A silhouette of The Artillery Group, one of the statues of the Ulysses S. Grant Memorial. Taken at ISO 200, f/6.3, 1/500 second with a 130mm lens.

19 Ulysses S. Grant Memorial

Why It's Worth a Photograph

Before Ulysses S. Grant was the eighteenth president of the United States, he was the commander of the Union armies during the final years of the American Civil War. He is credited with the victory of the Union over the Confederacy.

The Ulysses S. Grant Memorial sits on the west side of the Capitol, and begins the west side of the National Mall. Grant is astride his favorite wartime horse, Cincinnati, and he looks out over the Mall to Abraham Lincoln, the president who sought Grant's tactical savvy and bravery to win the war over the Confederate Army. He is flanked by *The Cavalry Group,* in which he is a young commander leading a charge during the Civil War, and *The Artillery Group,* where soldiers are positioning for an impending battle.

Where Can I Get the Best Shot?

Access to the Ulysses S. Grant Memorial is easy, because there is ample room to walk around the large statues.

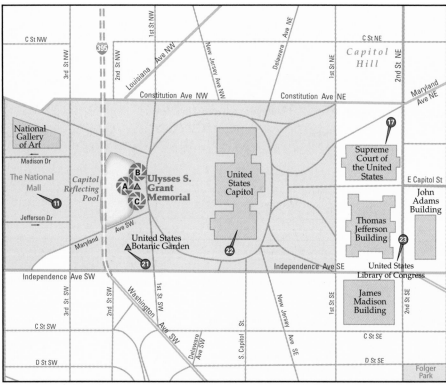

The best locations from which to photograph the Ulysses S. Grant Memorial: (A) Grant and his wartime horse Cincinnati, (B) The Cavalry Group, and (C) The Artillery Group. Nearby photo ops: (11) National Mall, (17) Supreme Court of the United States, (21) United States Botanic Garden, (22) United States Capitol, (23) United States Library of Congress.

Grant and his wartime horse Cincinnati

Grant and his horse can be photographed just next to the other statues, which allows you to use a longer lens and to use the sky behind the statue as a nice backdrop (see figure 19.1).

The Cavalry Group

Figure 19.2 can be done in a variety of ways; one method is to position yourself beneath the west side of the statue and shoot towards the sky. This simplifies the photo and gives the attention to the younger Grant, sword raised in the air, in command of his Union troops.

The Artillery Group

This statue, like *The Cavalry Group,* is full of amazing detail. Singling out a portion of the statue to photograph works well (see figure 19.3), and again you have plenty of space on either side of the statue to position for a shot.

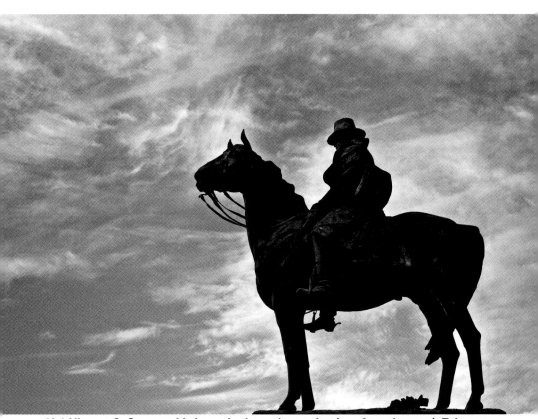

19.1 Ulysses S. Grant on his horse in the early evening (see A on the map). Taken at ISO 800, f/5, 1/320 second with a 90mm lens.

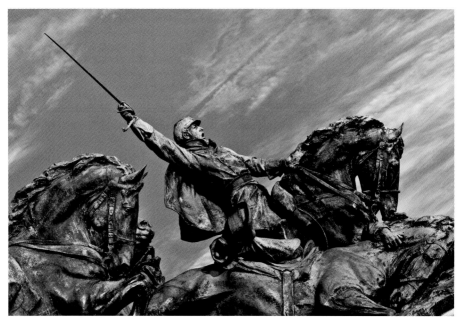

19.2 The Cavalry Group, viewed with the setting sun (see B on the map). Taken at ISO 800, f/8, 1/320 with a 90mm lens.

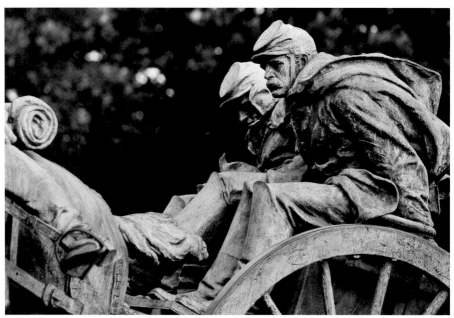

19.3 A detail of the The Artillery Group photographed in the evening light (see C on the map). Taken at ISO 1000, f/4, 1/160 second with a 230mm lens.

How Can I Get the Best Shot?

The light here is an important factor to getting a nice shot, but being prepared with the right gear always helps.

Equipment

Telephoto lenses and nice light together can make great images here.

Lenses

Keeping some distance between you and the statues here and using a longer lens helps to bring all the details of the statues together by compressing them — a trait of lenses 70mm and longer.

The first shot of Grant on his horse (refer to figure 19.1) uses a 90mm lens, as does the image of *The Calvary Group* (refer to figure 19.2). To get a clean perspective, *The Artillery Group* image was shot farther away and with a 230mm lens.

Filters

Using a polarizing filter when shooting perpendicular to the sun's light works well to darken blue skies and increase contrast between the clouds.

Extras

Unless you are photographing at night here, a tripod isn't necessary. It is, however, rather common to see tripods in use by photo enthusiasts in this area, especially on the west side of the Capitol Reflecting Pool for images of the U.S. Capitol at night and on the east side of the Ulysses S. Grant Memorial to get a photo of the Capitol. This specific area of the Capitol Reflecting Pool and Ulysses S. Grant Memorial is not managed by the U.S. Capitol Police, so within this area there's more leeway for tripods.

Camera settings

When photographing such statues, you definitely want to make sure that you have their essential elements in focus, but you also don't necessarily want the background in focus as well. So setting a reasonably low aperture value of between f/4 and f/8 helps to blur out the background while allowing enough light to enter your lens so that you can hand hold your camera without shaking it, which causes a blurry image. (Choose Aperture Priority mode to do so.) If you are photographing during normal light conditions, your camera's Automatic mode may work well, although you won't be able to necessarily control what the aperture is being set to.

Because the bronze of the statues has turned green, using a color balance that is too warm may mix with the green and blacks of the statues and create a warm, slightly muddy tone to the photo. If that is what you are seeing, try using the Daylight white balance, which is often cooler and reduces the yellows in the photo.

Also, adjusting your camera's exposure to compensate for either overly dark areas (by reducing exposure) or overly light areas (by increasing exposure) using your exposure compensation feature may be necessary, depending on your composition and the available light. If, for instance, you are doing a tight shot of *The Cavalry Group* and the dark, shaded trees are in the background, there's a good chance your image will come out overly bright and washed out because your camera's automatic exposure system thinks the scene is lighter than it really is. Reduce exposure by using the exposure compensation function to darken down your image. Very light scenes may come out too dark because the camera is trying to make them an average brightness. Increasing exposure helps those scenes retain the intended look.

Exposure

Be especially attuned to the lighting conditions. Having the correct lighting helps you capture the look of the statue and its background accurately. The bronze statues of *The Cavalry Group* and *The Artillery Group* have oxidized quite a bit and are largely green as a result, but the statue of Grant on his horse seems to have escaped this to a degree. These can be photographed in color but are also great candidates to be rendered in black and white, especially when given a slight warm tone.

Ideal time to shoot

The Grant Memorial faces west, so evening is a nice time to photograph it. Evening light has less contrast and can help fill the dark spots of the statues with light. After the sun goes down, a nice glow comes from the Capitol Reflecting Pool and the area surrounding it. If the sun is high in the sky or behind the statues, there will often be overwhelming amounts of contrast which won't help the image. However, nice silhouettes are possible from either the east or west when the sun is lower in the sky.

Working around the weather

Interesting cloud formations and skies work well for backgrounds to these statues. If it is foggy or raining, both can enhance the scene to a degree. Unique images have also been made when it's snowy — the abundant light reflecting from the ground helps to light the statues, and it also adds a feeling of intensity to the battle scenes.

Low-light and night options

There is little lighting at the Grant Memorial at night (usually just smaller lights near the statues on either side of Grant on his horse), although all sorts of indirect light come from areas just around it. It may require some experimentation, but night could work well to get some unique looks here.

Getting creative

In addition to trying black-and-white options, the green color of the bronze can be used to good effect with a nice blue sky. Also, you can experiment with compositions that layer different areas of the statues together as well as getting the Capitol or the Washington Monument in the shot.

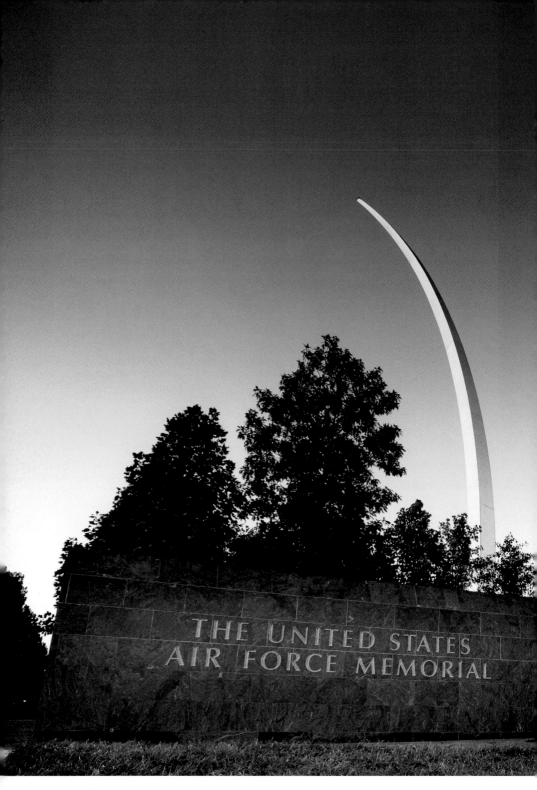

The entrance of the United States Air Force Memorial in the evening.
Taken at ISO 500, f/5, 1/100 second with a 20mm lens.

20 United States Air Force Memorial

Why It's Worth a Photograph

The United States Air Force Memorial honors the service and sacrifices of the men and women of the U.S. Air Force and the organizations related to it.

The newest of the major memorials in the Washington, D.C. area (it was dedicated in 2006), it is also one of the most dynamic and contemporary. The 270-foot tall stainless steel structure evokes the Air Force Thunderbird's contrails as they perform their bomb-burst maneuver, and the three arcs represent the three core values of the Air Force — integrity first, service before self, and excellence in all that is done. They are also meant to represent the three branches of the Air Force: active, guard, and reserve.

Where Can I Get the Best Shot?

Because of the minimal design of this memorial, the best pictures often come from within the memorial's walkway and the road next to it.

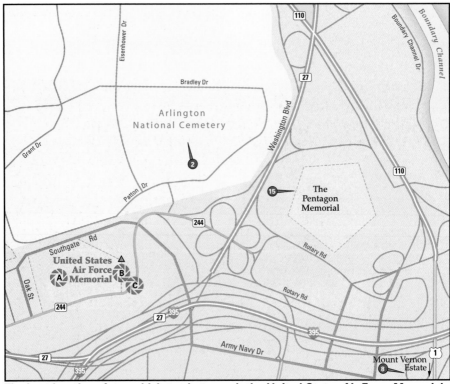

The best locations from which to photograph the United States Air Force Memorial: (A) facing east from the memorial, (B) at the memorial's base, and (C) S. Columbia Pike. Nearby photo ops: (2) Arlington National Cemetery, (8) Mount Vernon Estate (13 miles south), and (15) Pentagon Memorial.

Facing east from the memorial

If you stand on the first set of steps to your left after you enter the memorial from its main entrance, you see an unobstructed view of the stainless steel arcs, and there is enough space to capture their vast 270-foot height in the frame (see figure 20.1). It's a lovely place from which to view the arcs, and you will get a bit of a glow from Washington, D.C. in the background.

At the base of the memorial

A more unconventional but definitely interesting way to photograph the arcs is to view them from directly underneath (see figure 20.2). You can compose a shot a number of ways here.

20.1 Looking east from within the memorial grounds (see A on the map). Taken at ISO 400, f/6.3, 30 seconds with a 16mm lens and a tripod.

20.2 Looking straight up at the stainless steel arcs of the Air Force Memorial at night (see B on the map). Taken at ISO 400, f/8, 30 seconds with a 16mm lens and a tripod.

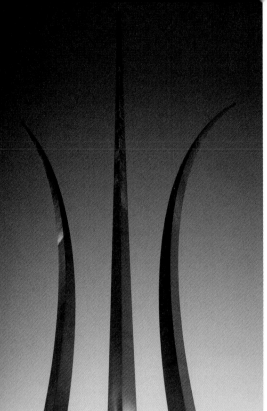

S. Columbia Pike

Another location from which you can photograph the memorial is along S. Columbia Pike, the road that winds its way along the south and east sides of the memorial. On the east side of the memorial along S. Columbia Pike, you can photograph it from this vantage point (see figure 20.3).

How Can I Get the Best Shot?

The Air Force Memorial is fun to photograph, and you can create colorful, vibrant images of it by using a variety of methods.

20.3 The Air Force Memorial photographed from its east side along S. Columbia Pike (see C on the map). Taken at ISO 1000, f/5.6, 1/30 second with a 35mm lens.

Equipment

Bringing the correct gear enables you to create a variety of interesting compositions.

Lenses

For the shot looking east (refer to figure 20.1), wide lenses on the order of 16-20mm are necessary, but it's always possible to get around this by cropping off the bottom of the memorial. Wide lenses are the rule for the images from within the memorial itself (refer to figure 20.2), although like any rule there are exceptions. The advantage of shooting from S. Columbia Pike (refer to figure 20.3) is that you can photograph the entire memorial by using a common 35mm focal length.

Filters

For daytime images, try a polarizing filter to enhance the contrast between clouds and the sky, or to just darken an already blue sky.

Extras

Tripods are allowed here, but of course use common sense when doing so. Using a tripod during crowded times causes problems for you, and other visitors and photographers who will visit in the future. A small table-top tripod works quite well.

Camera settings

Long-exposure night shots are great to get here, but the same compositions can be done during conditions with more light by handholding your camera.

If you are handholding, you want to focus on foreground elements in the photo and use a larger aperture value, such as f/11, to get the bulk of the monument in focus; if you focus on the far elements, the foreground portions of your photo may not be in focus, which is distracting. Using your Aperture Priority mode is a good option here, so you have some direct control. Finally, use your exposure compensation feature to fine-tune the exposure so that the sky and the memorial are well exposed.

As for white balance, during the day you will most likely want to use your Daylight setting because a large part of your image will be the sky. At night, the Daylight setting works well too, because the lights on the memorial are a similar color to daylight, so you can start there and change it to see how it affects your image.

Exposure

The Air Force Memorial is a beautiful structure that is the subject of thousands of beautiful photographs. Time, weather, and creativity will all be up to your interpretation in creating a unique image.

Ideal time to shoot

As I stated previously concerning white balance, there is an abundant sky shown in most photos of the Air Force Memorial, so shooting while the sky is interesting is key here. Sunrise and sunset are both great photographic opportunities, and the memorial also will have fewer visitors.

Working around the weather

Because the memorial is relatively new, there are still lots of pictures out there that have yet to be shot of it. Uncommon weather would help to create a unique photo here. If the weather is foggy, remember to increase your exposure to deal with the brightness of the fog (the same goes for bright, snowy conditions).

Low-light and night options

Night is a great time to shoot here, and the memorial is open late enough that there are plenty of opportunities to do so. The memorial is open every day of the year with hours from 8 a.m. to 11 p.m. from April 1 through September 30, and 8 a.m. to 9 p.m. from October 1 through March 31.

For night photography, use a tripod and long shutter speeds as a different way to shoot and to get very creative results. Long shutter speeds will blur out passing clouds above while allowing you to use a lower ISO for the best image quality. A tripod also lets you carefully compose your image as well.

The first thing to do is to figure out the right exposure. The simplest way to do this will be to use your camera's Night mode, but this will have different results based on how your camera chooses to interpret the scene. If you are using an automatic exposure mode, select Aperture Priority and set a higher aperture such as f/11 or f/16. This will force your camera to use a long shutter speed. Your camera has a maximum shutter speed, however, so keep this in mind as you are dialing in set- tings — you may have to raise your ISO to keep at or below its maximum shutter speed setting. Set your camera on its self-timer mode to let it start the exposure without any movement.

If your camera has a Bulb setting, this will let you use a cable release to keep the shutter open for any amount of time you wish to properly expose the scene. For example, if you find a good exposure at f/5.6, 30 seconds at ISO 400 using Aperture Priority, you could increase the exposure to f/11, 2 minutes at ISO 400 and get quite a different effect with the clouds and light surrounding the memorial. Depending on the type of camera you have, you can use much longer exposures as well.

Getting creative

Besides the ways I describe in this chapter, you also don't necessarily have to show each entire arc in your photo. Experiment with compositions that exclude only one or two arcs rather than all three — showing only one or two complete arcs can be enough to interpret the scene in a more creative way. Additionally, you can use the bronze Honor Guard statues in the foreground to compose a photo.

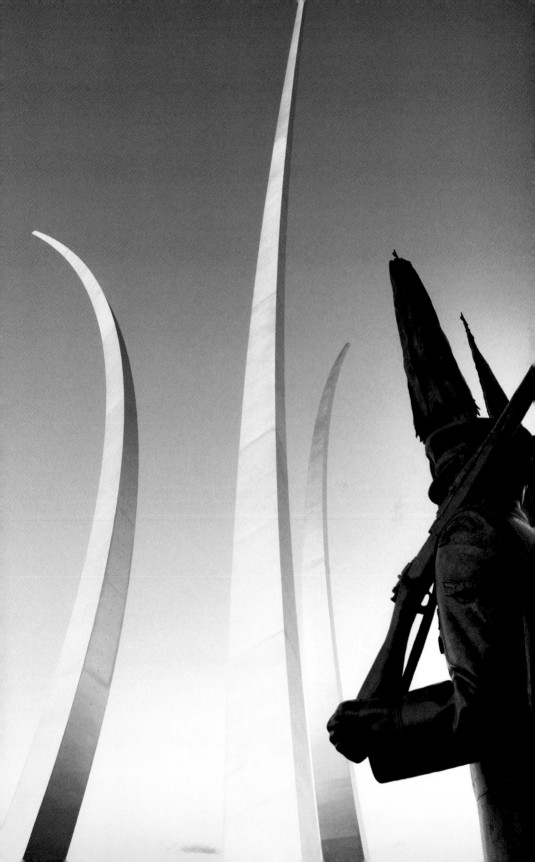

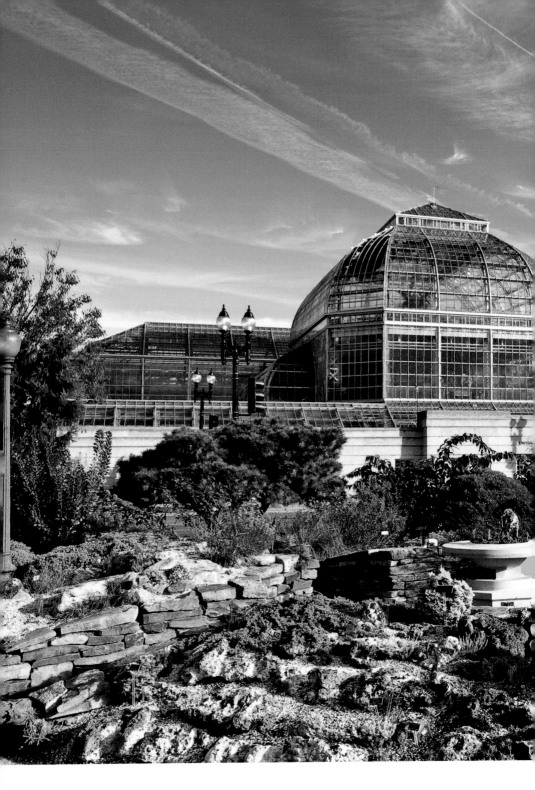

The United States Botanic Garden Conservatory seen from across Independence Ave. SW in Bartholdi Park. Taken at ISO 100, f/8, 1/100 second with a 28mm lens.

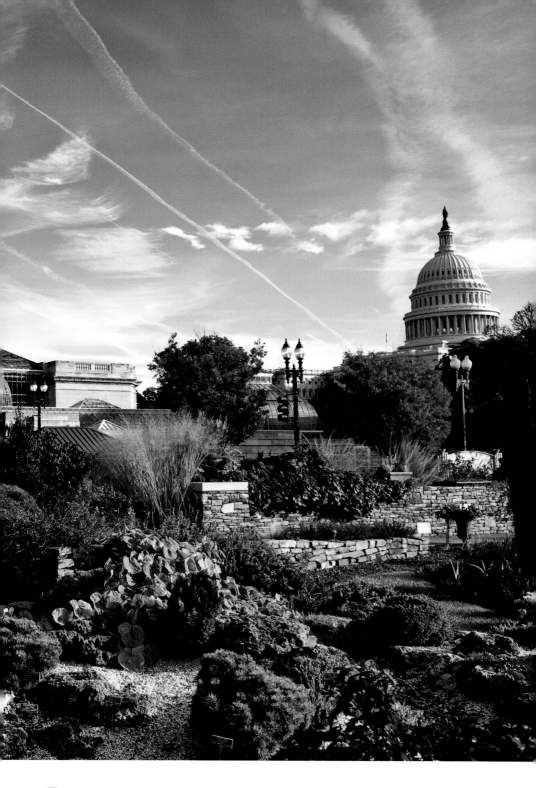

21 United States Botanic Garden

Why It's Worth a Photograph

Amidst the often crowded and busy National Mall sits the United States Botanic Garden, a tranquil oasis filled with over 4,000 plants. The Botanic Garden is comprised of the Conservatory, the National Garden, and across Independence Avenue, Bartholdi Park. It is the oldest continually operating botanic garden in the U.S., having been open to the public beginning in 1850.

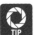 Check the Botanic Garden's Web site for details as to what is in bloom currently (www.usbg.gov).

The National Garden has a Butterfly Garden, First Ladies Water Garden (dedicated to the service performed by all the nation's first ladies), a regional garden showcasing plants native to the mid-Atlantic region, a small amphitheatre (which offers great views of the Capitol dome), and finally a Rose Garden. Across the street is Bartholdi Park, an area not visited by most tourists that showcases innovative gardening techniques and combinations of plants.

The best locations from which to photograph the United States Botanic Garden: (A) the Conservatory and (B) the National Garden. Nearby photo ops: (11) National Mall, (17) Supreme Court of the United States, (19) Ulysses S. Grant Memorial, (22) United States Capitol, and (23) United States Library of Congress.

Where Can I Get the Best Shot?

The Botanic Garden gives you a rare opportunity to photograph all sorts of plants in a single place. There are continually changing exhibits and always something in bloom. Below are some highlights for getting some great images. You will definitely find some of your own as well.

Conservatory

Within the Conservatory, you find permanent as well as changing exhibits and always something beautiful to learn about and photograph. You are greeted inside the Conservatory by the Garden Court, which is extraordinary.

While here, explore many exhibits including Orchids (see figure 21.1), Plant Exploration, Rare and Endangered, and of course the Canopy Walk (a raised walkway that allows you to take a bird's-eye view of the entire Jungle Room).

National Garden

The National Garden's five areas were opened in 2006 and "provide living laboratories for environmental, horticultural, and botanical education," according to the U.S. Botanic Garden.

The National Garden and Bartholdi Park are filled with opportunities to make close-up shots (see figure 21.2) as well as overall images of the gardens. It's a gorgeous setting for a stroll and to capture some spectacular gardens.

21.1 A miltassia orchid in the Orchid Room of the Conservatory (see A on the map). Taken at ISO 500, f/5, 1/60 second with a 24mm lens.

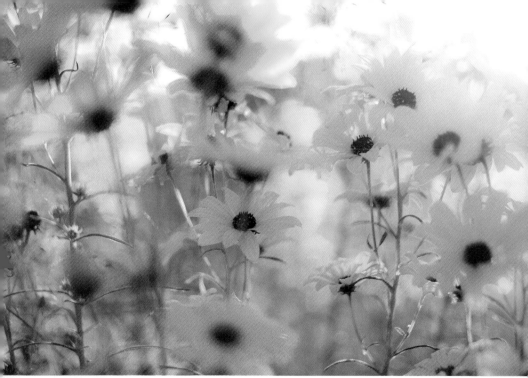

21.2 A walk through the National Garden's Regional Garden on a fall morning reveals many splendid colors (see B on the map). Taken at ISO 100, f/2, 1/1000 second using a 45mm lens.

How Can I Get the Best Shot?

You can find hundreds if not thousands of potential "best shots" at the Botanic Garden. Where will yours be?

Equipment

Often less is more with regards to camera equipment, and at the U.S. Botanic Garden traveling light is a great idea. Tripods are not allowed unless you get a permit first, but there is so much natural light that it's not necessary to use one. Because the walking paths are often rather narrow, especially within the Conservatory, it's requested that photographers be especially courteous to those walking around them while they take pictures.

 To request a tripod permit and for more information, call the U.S. Botanic Garden at 202-225-8333.

Lenses

Exploring the plants with a simple setup of a camera with a fixed (or prime) lens is an elemental way in which to photograph here. A simple camera, beautiful light, and beautiful plants make for some great photos. A 35mm or 50mm lens is good here (see figure 21.3), and these often have closer focusing distances as compared to their longer brethren.

If you are using a zoom lens, practice keeping its zoom at one setting and move yourself to compose the image. Keeping to one zoom level helps to simplify the process of composing a photo and lets you concentrate on subtleties within the photo such as elements in the foreground and background. Of course more experienced photographers may be comfortable using both at the same time as they compose an image.

21.3 A blue tango, part of the bromeliad family, taken in a temporary exhibit of bromeliads in the Conservatory's south lobby (see A on the map). Taken at ISO 200, f/2, 1/500 second with a 50mm lens.

Also, note that all lenses have a minimum focusing distance — if you are too close, the lens won't be able to focus. One way that's easy to focus at the closest point is to set your lens to its closest focusing distance, turn off the autofocus (if possible) and then while looking through the viewfinder, move your head slightly backward and forward to focus the image, rather than using the lens's focusing mechanism. This simplifies the process by limiting the variables affecting focus to one.

 If your camera is autofocusing and you are moving a little as well, it adds a certain degree of difficulty to getting an image focused accurately.

If you want to get close-up shots and you have a few different lenses, you may want to figure out the minimum focus distance for each lens (it's often printed on the lens, or you can look it up online) and compare that to its maximum focal length. This can give you an idea of how close you'll be able to get to a subject with a given lens — the longer the focal length and the closer the minimum focusing distance, the closer to the subject you can get. Some camera manufacturers also give the *reproduction ratio* of a lens. This is the subject's actual size shown divided by its size as rendered by the lens. A true macro lens renders subjects at a reproduction ratio of 1X, while a common 50mm lens will render them at .15X.

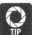 As you get closer, the depth of field for a given aperture value is reduced so focus becomes even more critical.

Filters

For overall shots of the inside of the Conservatory and in the outdoor gardens, you may want to use either a polarizing filter to enhance a blue sky or a graduated neutral density filter to darken down the sky, but otherwise they aren't necessary.

Macro Lenses

Special macro (sometimes referred to as micro as well) photography lenses and accessories such as lens extension tubes are designed to focus close enough to render the object at or close to a true 1:1 scale. Manufacturers have taken abundant leeway with this term, however. The word "macro" marked on a lens body often denotes a closer-than-normal focusing distance rather than true macro capability. A lens with "macro" in its official name usually does offer a true macro function.

Extras

Carrying a small one-foot round reflector can work well to fill in the shadows of flowers and also to reflect light on them (having a helper here can work wonders). Also a small diffusion reflector can soften hard light hitting a plant which reduces the contrast and makes for more pleasant lighting.

Camera settings

When photographing flowers, you can use a variety of creative approaches. With low aperture values such as f/2 to f/4, you get little in focus and, depending on the type of lens you are using, beautiful out-of-focus areas (see figure 21.4). But doing so requires great attention to the exact focus point. In general, the main point of the photo should be in sharp focus, although it may be a small sliver of the subject that is in focus.

21.4 Bird of Paradise, from the Plant Exploration Room of the Conservatory (see A on the map). Taken at ISO 100, f/2, 1/125 second with a 65mm lens.

Another approach is to use larger aperture values to ensure that you get the entirety of the flower in focus. To try this, use apertures such as f/5.6-f/11, depending on how close you are to the subject and how large the subject is.

If you are using an Automatic mode, try using your camera's macro function. Many point-and-shoot cameras feature a macro function, which is commonly shown as a flower on a camera's dial or mode buttons. This function usually selects a small aperture value to blur out the background, and it may also set the autofocus on the closest subject it encounters.

Depth of field is a big factor in determining the look of plant and flower images, so using Aperture Priority will allow you to dial in an aperture to get a lot (a higher aperture value) or a little depth (a lower aperture value).

Note that your camera may be thrown off if it tries to use its Auto White Balance for these images due to an abundance of one color, such as green or yellow. Using the Sun or Daylight setting can work well to keep the colors looking natural, but each camera will require a little experimentation.

If you aren't adept at using flash, you generally want to avoid using it here (especially on-camera flash) and instead concentrate on taking advantage of where the nice light is. Using advanced flash methods such as off-camera flash and fill flash can be used to create light where it's needed as well. If you want to experiment without extra gear, try setting your camera to its Fill flash mode or setting your flash exposure manually (try turning its power all the way down to start).

Exposure

The Botanic Garden changes with the seasons, but because there are indoor and outdoor areas, you can always find a beautiful exhibit to photograph here.

Ideal time to shoot

Both the Conservatory and the National Garden are open 10 a.m to 5 p.m. daily. Although photographing at the Conservatory early or late will let you use the beautiful morning or evening light, depending on the time of the year, it will also tend to limit the number of plants you will be able to photograph because the light will be hitting fewer of them. Therefore, going during bright daylight hours is a good idea.

The National Garden and Bartholdi Park are definitely lovely at all times, but when the sun is sweeping across its various gardens in the morning and evening, those areas are glorious.

Working around the weather

You can photograph the Botanic Garden no matter what the weather because its outdoor and indoor areas offer the best of both worlds (see figure 21.5). Overcast days are also a good option, because the entire sky will act as a soft box above the plants, inside and out.

Low-light and night options

Due to the hours of the Botanic Garden, you have few options here for night or low-light photography.

21.5 An interior view of the beautiful conservatory of the United States Botanic Garden. Taken at ISO 800, f/8, 1/60 second.

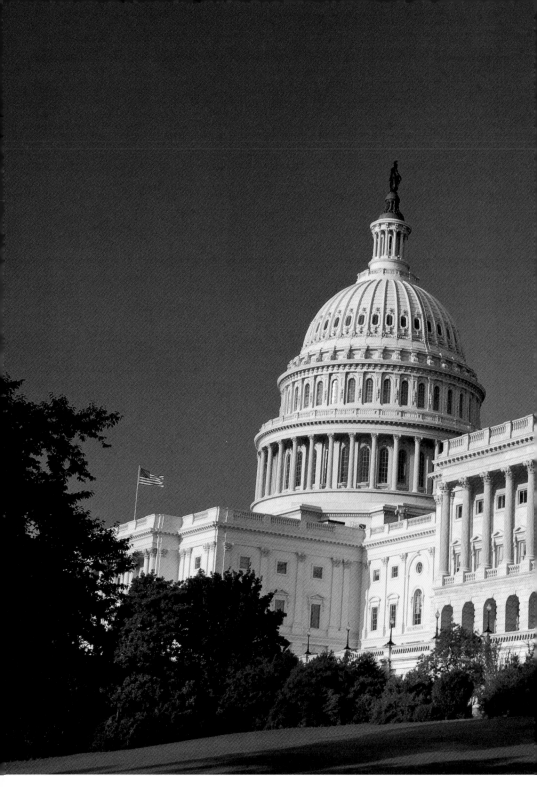

Looking northeast at the Capitol on an early summer evening. Taken at ISO 100, f/5, 1/200 second with a 45mm lens.

22 United States Capitol

Why It's Worth a Photograph

The most important building to the government of the United States is the Capitol. Beneath its massive dome, the United States Congress presides over the nation based on the powers given to it by the United States Constitution.

Public tours are relatively easy to join but proceed rather quickly, and for security reasons, the guides request that you stick near the main group at all times. Private tours, which U.S. residents can request from their Congressperson, usually require weeks, if not months, of advance planning but allow you more access and more time to photograph.

Where Can I Get the Best Shot?

A photographer could literally spend weeks capturing the Capitol in all its glory. The suggestions in the next sections are some locations where you can begin your photographic tour. You will undoubtedly find some spots of your own as well.

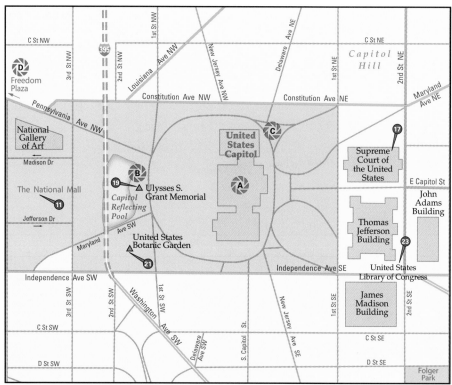

The best locations from which to photograph the Capitol: (A) the interior of the Rotunda, (B) the Capitol Reflecting Pool, (C) the northeast corner, and (D) Freedom Plaza (1.5 miles northwest). Nearby photo ops: (11) the National Mall, (17) Supreme Court of the United States, (19) Ulysses S. Grant Memorial, (21) United States Botanic Garden, and (23) United States Library of Congress.

 Cameras are allowed in the main areas of the Capitol that you can visit, but if you are intending to visit the Galleries of the Senate and House, almost nothing is allowed to be carried into them.

The interior of the Rotunda

Standing beneath the Capitol Dome is one of the best experiences a visitor can have when coming to Washington, D.C., and you may even consider booking a couple of tours to take it all in.

It's not easy to capture the grandeur of the Rotunda in a photograph. But one way to do so is to take a wide photo that features the swirling Rotunda with one of the statues in the foreground as shown in figure 22.1. Because the Rotunda is so bright at the top, you can partially silhouette the statue below. The contrast of light and dark, along with the textures and colors creates a striking image.

Another good shot is to walk to the centermost area of the Rotunda (or as close as you can get given the crowds) and to photograph the dome on its own. The combination of light pouring through the windows along with the layered architectural and art details makes a photo that you'll just want to stare at for a while to take in. You can do this shot wide — capturing as much of the circular area as possible — or you can zoom in and focus on the details.

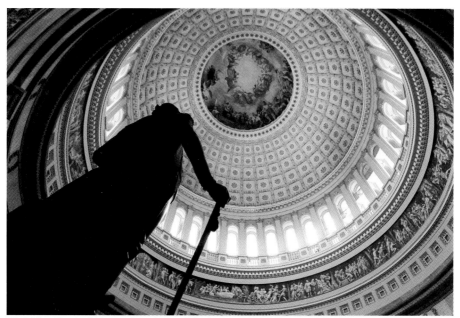

22.1 The Capitol Rotunda taken with the statue of George Washington in the foreground (see A on the map). Taken at ISO 400, f/5.6, 1/80 second with a 22mm lens.

Capitol Reflecting Pool

One of the coolest ways to photograph the Capitol is with its reflection in the Capitol Reflecting Pool on the building's west side during the evening or at night (see figure 22.2). It's a popular spot and one that other tripod-toting photographers are seeking to get too.

Figure 22.2 was made by using a small table-top tripod sitting on the lip of the reflecting pool, which makes for an interesting, low vantage point. Small table-top tripods are a great idea as they don't attract attention and are easy to carry. Also note that if the wind is low, the reflection will be clearer.

The northeast corner

Personally, this view is one of my favorite views of the Capitol, especially in black and white as in figure 22.3. It's majestic and full of patterns, textures, light, and shadow. This view reveals the intricate and stately manner of the Capitol.

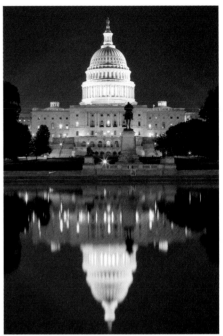

22.2 The U.S. Capitol with its reflection in the Capitol Reflecting Pool (see B on the map). Taken at ISO 200, f/14, 25 seconds with a 65mm lens and a table-top tripod.

Freedom Plaza

An interesting shot that captures more of a city feel can be made from Freedom Plaza, just north of Pennsylvania Avenue downtown (see figure 22.4). Actually, if Pennsylvania Avenue continued uninterrupted, it would go straight through the plaza, so here you have the nice opportunity of being in the middle of the road while not having to deal with any traffic. It's a nice view down a historic avenue, and it's a great view at night.

Tripods at the Capitol

Remember that tripods are not allowed on the grounds of the Capitol unless you have a permit from the U.S. Capitol Police. The Capitol grounds include the U.S. Capitol and many surrounding buildings and streets. The Capitol Reflecting Pool and Ulysses S. Grant Memorial are not part of these grounds. To understand more about using tripods in Washington, D.C., see this book's Introduction.

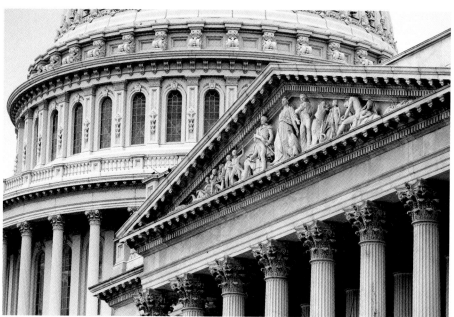

22.3 The east side of the Capitol, looking from its north end (see C on the map). Taken on an early, overcast morning at ISO 500, f/4, 1/200 second with a 150mm lens.

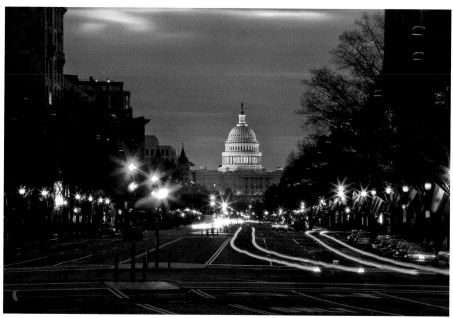

22.4 The view down Pennsylvania Avenue NW towards the Capitol (see D on the map). Taken at ISO 100, f/32, 20 seconds with a 170mm lens and a tripod.

How Can I Get the Best Shot?

These photos of the Capitol require a variety of techniques, but from all these vantage points the shots can be made as simple or as technical as you want.

Equipment

Because you may be packing lightly to enter the Capitol and take the tour, these shots can all be made with equipment that can fit into a bag sized at the requirements mandated by Capitol security.

Lenses

For Rotunda images (refer to figure 22.1), you need wide lenses — the wider, the better. At minimum, you will need something between 20-24mm, but anything wider works well, too. For detail shots of the Rotunda, a lens between 60-70mm is a good choice. And of course you can use a longer focal length if you want to get very specific shots of some of the details.

The night shot with the Capitol Reflecting Pool (refer to figure 22.2) can be made with a 65mm lens, but you can also shoot it wider or tighter depending on your preferences. Also, a vertical shot works as well, shooting tight in on the Capitol and its reflection.

The photo from the northeast corner of the Capitol (refer to 22.3) can be done in a variety of ways, but using a longer lens will compress the details of the building, leading to a layering effect. Using a wide-angle lens and getting closer often results in unpleasant distortion of the elements that make up the photograph.

For the shot looking down Pennsylvania Avenue shown in figure 22.4, a 170mm lens or similar should work, but again this can be shot tighter if you choose to go for a different look.

Filters

For the northeast corner shot (refer to figure 22.3), a graduated neutral density filter either on the camera or added in a photo-editing program (if your exposure is close) works. And if you have nice clouds and a blue sky, a polarizer will sharpen up the contrast of the sky nicely.

Extras

The key element of the many night shots is a table-top tripod. You can certainly use a standard-size tripod as well, but lugging one around can be a real pain and figuring out where you can and where you can't use a tripod is not all that easy. The table-top one goes basically unnoticed and is easy to take around; you can also use it to snap pictures of yourself or those traveling with you. Use your camera's self-timer to trip the shutter without causing camera shake or use a cable release.

Camera settings

When photographing the Rotunda, there's a good chance that the bright light of the windows will throw off your camera's exposure. Be prepared to increase the exposure by using your camera's exposure compensation function (if using an automatic mode) or, if using Manual mode, let the exposure meter go about 1/2 to 3/4 of a stop over normal. Doing so compensates for the brightness of the windows. Despite their brightness, it is still relatively dark here. Set your ISO between 400-800, depending on the amount of light at the time you are visiting.

The northeast corner photo is a pretty standard shot requiring no special settings. You can use Aperture Priority mode and adjust the aperture to f/5.6 or so to keep your subject in focus. (Remember that you get more depth of field farther from your focus point, so you want to focus on something closer to you rather than something that is farther away in the frame.) If the sun is shining directly, there is a chance that you'll need to add some exposure to the scene because the Capitol is white and some cameras might underexpose this scene.

If you are using Shutter Priority or Aperture Priority modes, you will have to test how well your camera will expose the night scenes — some will do this better than others. If you are using a tripod, you can go ahead and set a high f-stop value, such as f/16 or higher to ensure that everything is in focus. Cameras have different maximum exposure times though, so you may have to adjust your ISO or aperture to compensate for yours.

Exposure

At the Capitol, no matter what time it is or where you are, you can take a good photo.

Ideal time to shoot

For shooting the Rotunda (refer to figure 22.1), visiting during midday helps ensure that all the windows will be evenly illuminated. However, don't rule out afternoon or mornings — the transitioning light can work well to create something a little different.

The shot from the northeast (refer to figure 22.3) is best done before noon, when the sun is on the east side of the building, but a backlit Capitol Building may offer a unique image as well.

22.5 The Capitol dome photographed from the east at sunset. Taken at ISO 400, f/4, 1/800 second with a 150mm lens.

Working around the weather

Bad weather can be a great thing for photographs of the Capitol, especially during times when it's foggy or snowy. Rainy days can also make an atmospheric shot, so if your only time to shoot is during inclement weather, look at it as a good thing. Far fewer shots are made during this time, so you may be getting something very unique.

Low-light and night options

The Capitol dome glows brilliantly in low light (see figure 22.5), and it stands out from amongst everything else, so at dusk and night there are many possibilities for great images.

If you are hand-holding night shots, try Shutter Priority mode and set a shutter speed that you can hand-hold without shaking your camera to avoid blurring the photo. Start off at 1/60 second and try a few photos at slower shutter speeds as well, going down to 1/15 second or even slower. Also, be sure to turn your flash off.

Getting creative

Inside the Capitol Visitor Center, you have the opportunity to photograph the model statue of the *Statue of Freedom*. Try doing so from the steps of the entrance area, using a longer lens. You can also do some tight portrait shots from next to her.

If you like photographing people, statues are actually good practice. You can find plenty of them in the Capitol Visitors Center.

Finally, the Capitol is set on many acres of land, and within those are trees, plants, and flowers that all can be nicely used as foreground elements in your photographs (see figure 22.6). The west side in the spring and summer is especially good for such photographs.

22.6 The Capitol from Garfield Circle. Taken at ISO 320, f/13, 1/100 second with a 35mm lens.

A detail of the exterior of the Thomas Jefferson Building of the Library of Congress showing the busts of Johann Wolfgang von Goethe, Benjamin Franklin, and Thomas Babington Macaulay. Taken at ISO 100, f/8, 1/250 second with a 35mm lens.

23 **The United States Library of Congress**

Why It's Worth a Photograph

The Library of Congress is the largest library in the world, and it serves as the research arm for members of the United States Congress. After a fire destroyed the original collection in 1814, Thomas Jefferson sold his personal library to the institution, thus starting the incredible collection that the Library offers today. Also under the Library is the Copyright Office, which provides the essential infrastructure for the nation's copyright system.

The Thomas Jefferson Building is the showpiece of the Library's three buildings. Its Great Hall is considered one of the most beautiful public buildings in the United States. Within the Thomas Jefferson Building are some of the most valued documents the Library possesses: drafts of the Declaration of Independence, George Washington's copy of the Constitution, Thomas Jefferson's original library, and a Gutenberg Bible.

Where Can I Get the Best Shot?

Photographs are allowed to be taken inside The Great Hall, but photographs of its documents and within the Reading Room are prohibited. The best pictures are therefore the exterior of the Thomas Jefferson Building as well as the interior of The Great Hall.

1st St. SE

The main entrance of the Italian Renaissance-styled Thomas Jefferson Building is on its west side on 1st St. SE, just north of its intersection with Independence SE. This is the grand entrance of the building and the side worth beginning your photography thanks to its many intricate details and lovely appearance.

The building features 33 *ethnological heads* which are featured as ornaments on all the keystones of the first-story windows. They are meant to show the physical characteristics of different human races from Arab through Zulu and are based on models from the collection of the Smithsonian Institution. The 23-carat gold-plated flame of the Torch of Learning sits atop the building. The building (shown in figure 23.1) was inspired by the Paris Opera House and was designed to eclipse the European libraries with both its size and its collections.

Nine historically significant busts are featured across the front entrance of the building, which include Emerson, Irving, Goethe, and Dante, among others. In front of the building is a fountain containing King Neptune, Roman god of the sea.

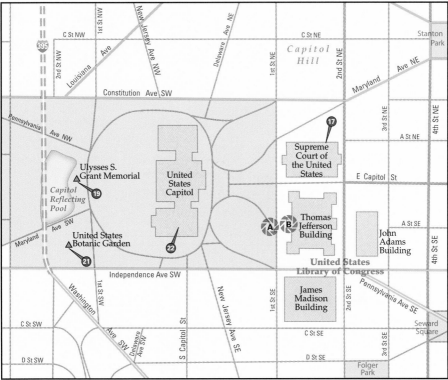

The best locations from which to photograph the Thomas Jefferson Building of the Library of Congress: (A) 1st St. SE and (B) inside the Great Hall. Nearby photo ops: (17) Supreme Court of the United States, (19) Ulysses S. Grant Memorial, (21) United States Botanic Garden, (22) United States Capitol.

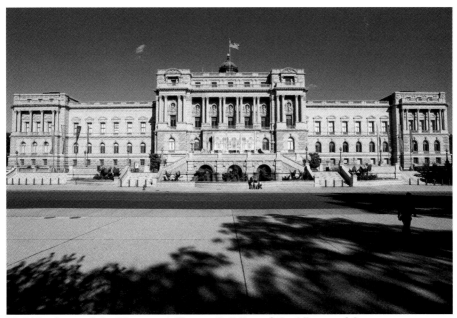

23.1 The front of the Thomas Jefferson Building of the Library of Congress seen from east of 1st St. SE (see A on the map). Taken at ISO 100, f/8, 1/250 second with a 20mm lens.

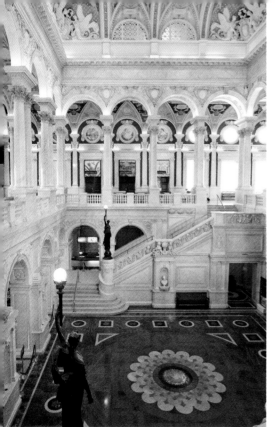

23.2 The Great Hall of The Library of Congress Thomas Jefferson Building photographed from the top of one of the two staircases (see B on the map). Taken at ISO 2000, f/4, 1/50 second with a 25mm lens.

Inside the Great Hall

The entrance here leads into The Great Hall, an extraordinary display of both art and architecture that overall represents the achievements and knowledge of mankind. Over 40 American painters and sculptors created the artwork inside over a period of eight years. All told, it is a vibrant and majestic scene to witness and therefore an excellent photo opportunity.

The depth and breadth of the artwork here requires a fair amount of study to properly understand it, and the interactive kiosks provide a great insight into its significance.

During the day there is just enough light that if your camera is able to use higher ISO values and maintain its quality, you can carefully hand hold your camera inside. The Library does not allow the use of any artificial light sources. But most any on-camera flash system is ineffective in such a large space, not to mention the generally ugly light it would provide compared to the already present natural light.

You can study the building in an intimate manner (see figure 23.2), as detail shots within the Great Hall are plentiful (see figure 23.3).

How Can I Get the Best Shot?

Visiting the Thomas Jefferson Building is an awe-inspiring trip, and you may want to take it all in before beginning to photograph it by following a guided tour.

Equipment

The exterior of the Thomas Jefferson Building is rather straightforward, but the interior requires both some technique as well as modern gear to achieve the best results.

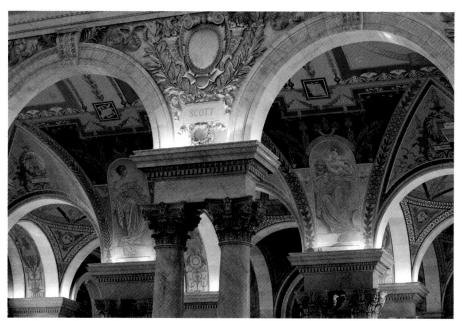

23.3 Detail of the ceiling within The Great Hall of The Library of Congress Thomas Jefferson Building (see B on the map). Taken at ISO 3200, f/4.5, 1/160 second with a 90mm lens.

Lenses

For exterior images such as figure 23.1, a wide-angle lens of 20mm may be used to capture the entire building. You can compose the shot in a traditional, horizontal manner or in a vertical way for something a little different. Of course some distortion occurs due to using the wide-angle lens and pointing your camera up to take the photo, but it still makes a nice image.

To minimize distortion, stay as far away from the building as possible to use the longest focal length lens possible, and keep your camera as level to the ground as your composition permits. There are, however, plenty of trees that can get in the way if you go much farther west than the western side of 1st St. SE, and if you compose the image with a perfectly level camera, the composition will involve a lot of the road and sidewalk in front of you. Although distortion may annoy some, it can also be used to artful effect if you choose to.

Inside, fast lenses with apertures of f/4 and below are almost essential because the light is so low. Also, a stabilized lens, which can negate movement of the camera at slow shutter speeds, is worth its price here.

Filters

For exterior images, a graduated neutral density filter can help deepen a blue sky. If you are shooting the exterior with the sun at your back, a polarizer will not be very effective, because it works best 90 degrees to the sun.

Extras

You must acquire a permit to use a tripod here. (To do so, visit the Public Affairs Office, Room LM105, in the Madison Building.) If you don't want the hassle of carrying a tripod, getting creative with stabilizing your camera can help. Use a friend's shoulder or brace yourself against part of the building to hold your camera still. Also, hold your camera at either end to keep it as still as possible: Rest the very end of the lens on your fingers and then hold the body of the camera. Doing this minimizes its movement. Another option is a lightweight, telescoping monopod — but this method still requires a lot of precision to keep the image from being blurry and may be met with mixed results.

Camera settings

When the sun is shining strongly against the west façade of the building, you may want to add some exposure to compensate for the brightness of the building. Whatever mode you are most comfortable with, whether it be Aperture Priority or Full Auto, will likely work out fine because of the relatively normal lighting conditions here. If the sun is shining strongly against the west façade of the building, you could experiment by adding some exposure (via exposure compensation or dialing it in using Manual mode) to adjust for the brightness of the building. Keep in mind that in order to use exposure compensation you usually have to use Program or one of the priority mode settings.

Inside requires more technique because of the low levels of light. You want to set a high ISO value, such as 2000-3200 and you then need to use a slower shutter speed. Remember the relationship between focal length and shutter speed: You always want to keep your shutter speed fast enough that any slight amount of camera shake is minimized by using a shutter speed that is fast enough to negate it. The rule is based on a simple concept: As your focal length gets longer, it becomes easier to shake the lens due to its physical length and zoom.

The traditional rule, a stalwart of the 35mm film days, is known as the *one over focal length* or *inverse focal length* rule. The rule stipulates that by using a shutter speed with your focal length as its denominator, your chances of having camera-shake induced blur is minimized. So if you are using a 50mm lens, you would simply use 50mm as the denominator of your shutter speed; your minimum shutter speed would thus be 1/50 second. If you have a stabilized lens or camera, you can go a little slower than this rule by perhaps one or two stops, because the stabilization feature reduces the apparent shaking of the camera.

Many digital cameras change the apparent focal length of a lens by anything from 30 to 100 percent due to its crop factor, so to use this rule with your specific camera you'll want to first determine your crop factor and always multiply that by your focal length. For example, if you are using a camera that has a crop factor of 1.6X, and your zoom lens is set to 30mm, you would multiply your crop factor (1.6) by the lens focal length (30mm) which equals 48mm. Thus to be safe you'd want to keep your shutter speed above 1/50 second. Many cameras, when set to automatic exposure modes, will take into account your focal length and set an appropriate shutter speed. They may also blink your shutter speed or otherwise alert you that your shutter speed is slow compared to your focal length.

If this sounds like too much math to do while you are just wanting to take photos, keep this simple guideline in mind: Avoid shutter speeds below 1/30 second with wide lenses, 1/125 second when using normal length lenses, and 1/500 second when using longer lenses (above 100mm). This is a conservative guideline, but it also takes into account all the variance in digital cameras and also other factors that can cause camera shake, such as wind, shooting from a moving vehicle (such as a tour bus), and taking a quick, impromptu shot where you don't have time to completely steady yourself.

If your camera has a short timer delay of, say, 2 seconds, you can use it while holding your camera to reduce camera shake. This gives you time to press the shutter and rest your hand on your camera body, all before the camera takes the shot.

Setting a smaller aperture value also helps indoors when there is less light (refer to figures 23.2 and 23.3), but remember you'll get less depth of field when doing so. However, a wide-angle lens's optics are much more tolerant of smaller aperture values with respect to depth of field, so if you are using a lens of 35mm or less, you can often get away with apertures of f/5.6 and below more easily than if you are using a lens of over 50mm. No matter what the lens, you get less depth of field in front of your focus point and more behind it, so it helps to focus on an object slightly more in the foreground to maintain sharp focus throughout the picture.

Exposure

Having more light always helps with a photograph, and at this location that is especially true.

Ideal time to shoot

The exterior photographs of the Thomas Jefferson Building are great when in the afternoon and late evening, when the sun is setting and brightly illuminating the west façade of the building. Black-and-white images lit with strong sunlight have great contrast and are vibrant with detail. If the light drops too low, though, the trees on the west side if 1st St. SE will cast shadows on the building.

Inside, shooting at times that offer lots of bright light is key: The brighter it is inside, the easier it is to get good photos. Days that have heavy overcast make getting good inside shots tough.

Working around the weather

If the weather isn't optimal for shooting overall exterior images of the building, you can try for detail shots that don't rely so much on nice weather to work. The many details of the building can be photographed in a way that one would not have any idea that it's not optimal weather outside. If it's raining, the opposite can sometimes be true: While shooting a wide scene, you may not even realize it is raining.

If it is dark outside, the interior images will be tougher to capture because there won't be very much ambient light. You'll have to use slower shutter speeds, wider apertures, and higher ISO values. One way you can get around this is to concentrate on areas that are lit well, such as corners that are full of windows where detail shots can be taken. Follow the light for the best photos if there is little light otherwise.

Low-light and night options

Great night shots can be made of the Neptune Fountain at the front of the building, and once the sun has set you don't have to worry about shadows from the trees on the building.

Getting creative

The Italian Renaissance-styled exterior of the Thomas Jefferson Building is great for black-and-white photos (see figure 23.4). Start off with the more formal shots showing the arches and stairs, but also try shots of the exterior that incorporate vignettes of artwork, which cover the building's façade. Experiment with angles and compositions that use layer textures and design elements together to create an interesting view.

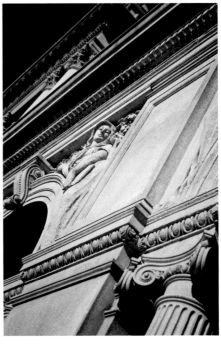

23.4 A detail shot of the exterior of the Thomas Jefferson Building of The Library of Congress (see A on the map). Taken at ISO 100, f/5, 1/800 second with a 65mm lens.

Inside, you can discover many ways to get creative. Similar to the exterior, try working with various methods of composition with the layered arches, columns, and artwork.

Inside you have more opportunities to use depth and color. Studying the interior with your camera lens lends itself to discovering the intricate artwork as well as coming up with unique images of it all.

Try to get out of the habit of standing in the usual locations or using the same angles. Try looking straight up, or tilt your camera to compose elements to fill the entire frame in a way that isn't just at 90-degree angles (see figure 23.5).

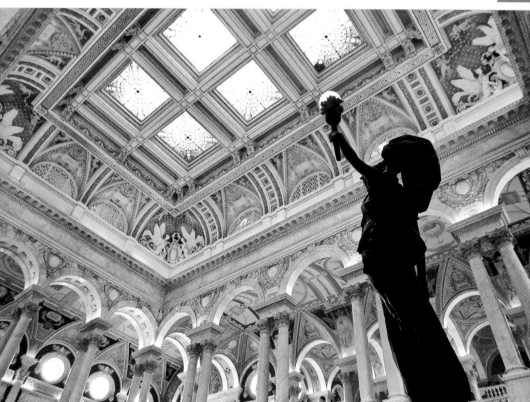

23.5 An interior view of The Great Hall (see B on the map). Taken at ISO 1000, f/4, 1/50 second with a 25mm lens.

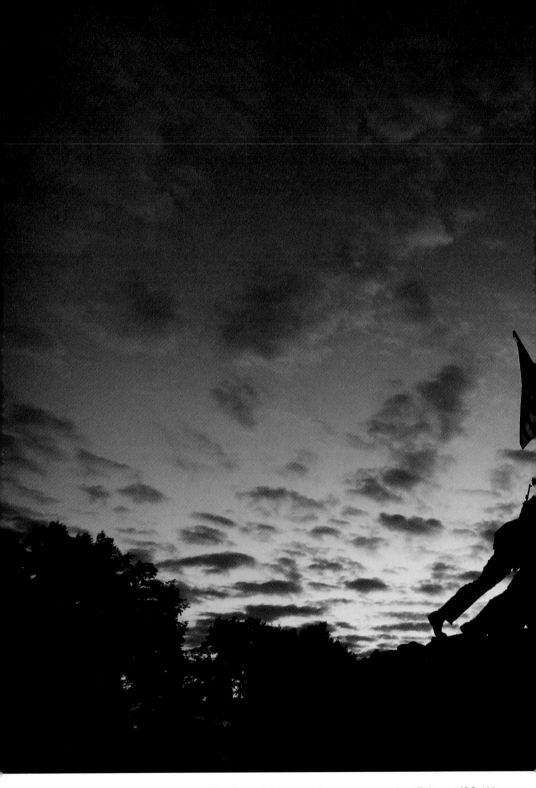

The United States Marine Corps War Memorial on an early summer morning. Taken at ISO 400, f/4, 1/50 second with a 16mm lens.

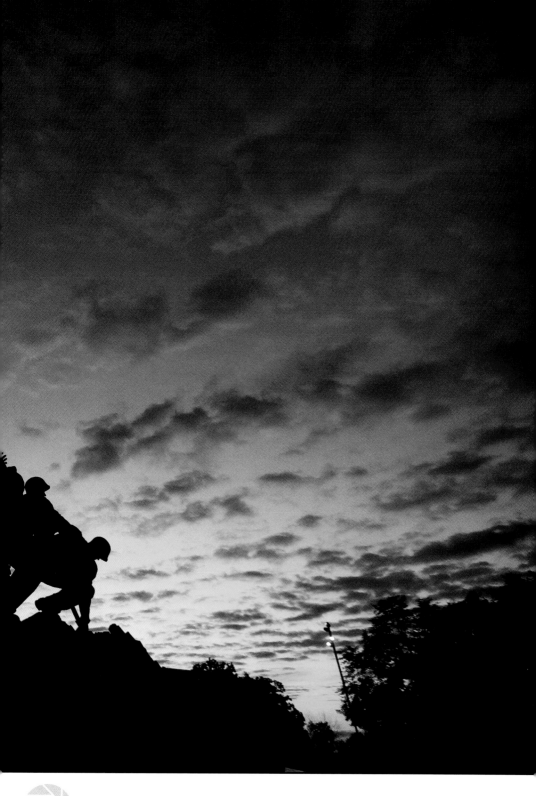

24 **The United States Marine Corps War Memorial**

Why It's Worth a Photograph

The United States Marine Corps War Memorial, often referred to by the scene it depicts from the Battle of Iwo Jima during World War II, honors fallen Marines. Its base is inscribed with the many battles in which Marines have fought.

The bronze statue depicts the Pulitzer-prize winning photograph *Raising the Flag on Iwo Jima* by the late Associated Press photographer Joe Rosenthal. The 33-year-old Rosenthal shot the photo using the press camera of the period, a large format Speed Graphic (1/400 second at f/11), on February 23, 1945.

Where Can I Get the Best Shot?

An image of the U.S. Marine Corps War Memorial is another one of the most recognizable photographs of sights around the D.C. area.

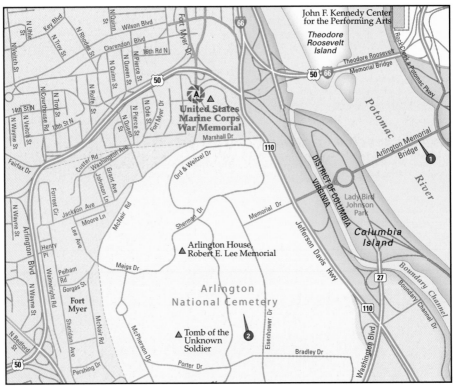

The best location from which to photograph the United States Marine Corps War Memorial: (A) west of the memorial. Nearby photo ops: (1) Arlington Memorial Bridge and (2) Arlington National Cemetery.

West of the memorial

The iconic shot of the U.S. Marine Corps War Memorial can be taken just west of the memorial. Two locations here work well and are just feet from each other. First, you can shoot from within the trees that form the west border with U.S. Marine Memorial Circle. Here you get a little more elevation on the statue, and you can line up the U.S. Capitol, Washington Monument and, especially in the winter (when the trees are bare), the Lincoln Memorial behind the statue (see figure 24.1).

Second, if you walk down the small hill here, you can pick a variety of spots to shoot from as well (see figure 24.2). From the west side, you are also viewing the statue as Joe Rosenthal viewed the actual soldiers when he made his photograph during the Battle of Iwo Jima.

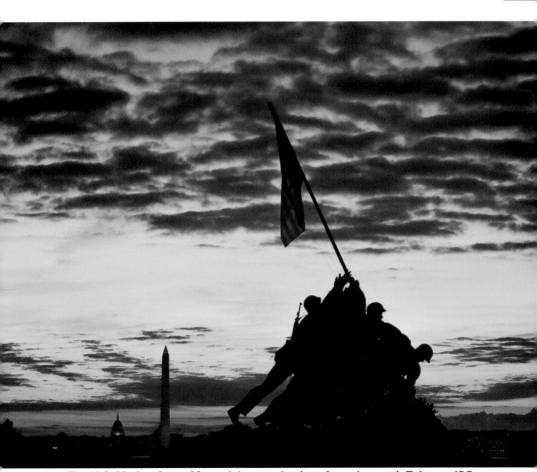

24.1 The U.S. Marine Corps Memorial at sunrise (see A on the map). Taken at ISO 100, f/16, 4 seconds with a 100mm lens mounted on a tripod.

How Can I Get the Best Shot?

The 7.5 acres that surround the memorial are a pleasant place to photograph and give you an opportunity to walk around the statue to see it from all angles.

Equipment

The gear requirements here are quite straightforward and don't require much out of the norm.

Lenses

To emulate figure 24.1 where you have the Capitol, Washington Monument, and other areas of Washington, D.C. in the shot, you need a lens of between 100 and 150mm. If you shoot horizontally, you can use the wider lens, whereas a vertical photo allows you to use a longer lens. When closer to the memorial, you can use a variety of wider lenses, from 16-24mm.

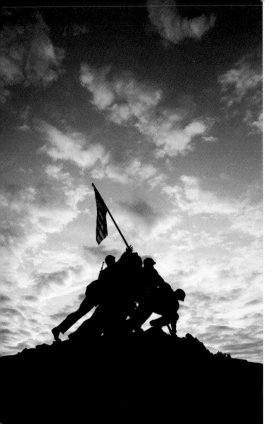

24.2 Another angle of the U.S. Marine Corps War Memorial at sunrise, this time from closer to the memorial and with a wider lens (see A on the map). Taken at ISO 200, f/5.6, 1/500 second with a 25mm lens.

Filters

Because the sun will be either in front or behind you for many of these images, polarizing filters will have less effect (they work best at 90-degree angles to the sun). A graduated neutral density filter could be used to good effect depending on how bright the sky is.

Extras

A tripod is very helpful for any low-light shots, especially the first shot amongst the trees using a longer lens in lower light. Because this is an area that doesn't have much pedestrian traffic other than photographers usually, tripods are okay here. However, the closer you get to the memorial and the more crowded it is, the more likely it is that a tripod may be a safety issue for other visitors.

Camera settings

Most cameras set to an automatic exposure mode tend to overexpose low-light scenes, so you'll have to adjust your camera to render these correctly. This is why many cameras have a night setting, so the camera knows to adjust its exposure for a predominantly dark scene. Another way to expose a dark scene correctly is to use your camera's exposure compensation feature and reduce the exposure if your camera is rendering it too brightly.

Determining how you shoot this will be based on whether you are handholding your camera or using a tripod, and time of day. If handholding in low light, try using Shutter Priority and set a shutter speed of 1/60 second (this is a speed at which most people can hand hold their camera and not get any camera-shake blur). Be sure to focus on the memorial carefully because your camera will likely set a low aperture value, which means that the margin of error for focusing is much lower.

If your sky is looking too washed out, try using exposure compensation and reducing the exposure by one stop to start. Another option is to note what the settings are when using Shutter Priority mode, and switch to Manual and dial in these settings. By switching to Manual mode, you can start at the exposure the camera set, but then you can adjust your shutter speed to a higher value to reduce exposure, or increase your aperture value to do the same.

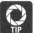 Some photographers can hand hold a shot down to 1/15 of a second or even slower, but getting a sharp image at such slow shutter speeds can be very difficult because of camera-shake induced blurring.

If you are using a tripod, then you can use Aperture Priority mode and let the camera set whatever shutter speed it wants. In this case, using a higher aperture value causes the camera to let in less light and sets a longer shutter speed. Using longer shutter speeds can make great effects with passing clouds and if the flag of the memorial is fluttering in the wind, getting a little motion in the Stars and Stripes.

Finally, setting a white balance other than auto can help your sunsets come out with their true colors. If you are shooting early or late in the day, try using the Sun setting, which will let the colors be warmer and give a truer feel of a sunset or sunrise photo.

Exposure

You can take good shots here at most times of the day, but the most provocative time is early morning and late evening.

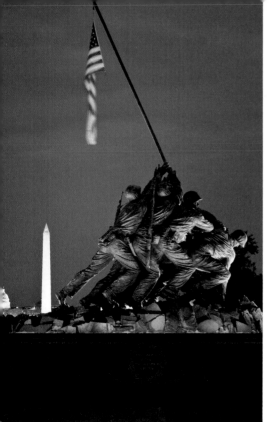

Ideal time to shoot

Early morning is definitely a great time to shoot here. If you arrive before the sun comes up, you have time to compose a shot and then watch as the colors and clouds interact to change the picture every second. During the day though, the same photos can be taken, just with less dramatic light. (If you are at the memorial during midday, you may try using the sun to silhouette the statue.)

In the evening and at dusk, the statue will most likely be lit with bright flood lights. Try to balance the exposure of the statue with the ambient light (see figure 24.3). If the sky goes too dark, it will quickly turn black when the memorial is exposed correctly.

24.3 A view of the U.S. Marine Corps War Memorial on a cloudy evening (see A on the map). Taken at ISO 320, f/18, 30 seconds with a 150mm lens mounted on a tripod.

Working around the weather

Stark photos of the memorial can be made during heavy snows, fog, and even possibly rain. You won't find many areas here to shield yourself from the weather unless you drove, so be prepared if it does begin to rain. Finally, keep an eye on the wind. A little wind fluttering can really help the photo by giving the flag some form.

Low-light and night options

At night, you can shoot interesting images of the memorial, with the landmarks behind when facing east, as well as detail shots of the statue (see figure 24.4). Also, more options are available at night facing west, since the buildings that surround the statue are less noticeable.

Getting creative

Besides the iconic shots looking east, some other vantage points can make for good views of the memorial, especially in the winter when the trees have lost their leaves. Next, try rotating your camera with detail shots to compose the photograph in a way that is compelling, rather than always keeping your camera either exactly horizontal or vertical. Finally, shooting other variants of the above photos can make for some great images, too.

TIP The United States Marine Corps War Memorial was created by sculptor Felix de Weldon, www.felixdeweldon.com, and is copyrighted. The original photograph shot by Joe Rosenthal, as well as others he made at the scene, can be viewed at the Associated Press Web site, www.apimages.com.

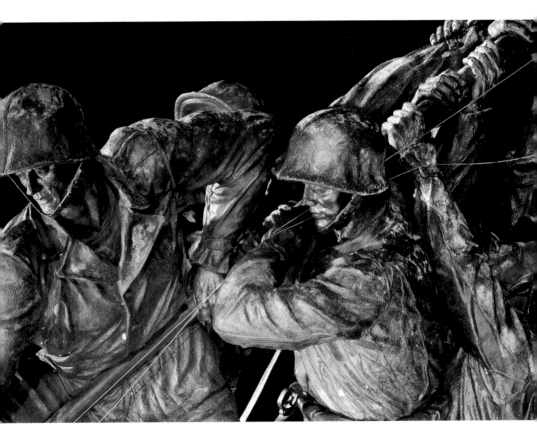

24.4 A detail of the U.S. Marine Corps War Memorial at night (see A on the map). Taken at ISO 400, f/11, 8 seconds with a 160mm lens mounted on a tripod.

Fall begins at the United States National Arboretum. Taken at ISO 100, f/4, 1/400 second with a 90mm lens.

United States National Arboretum

Why It's Worth a Photograph

The United States National Arboretum is a living museum of some 400 acres filled with woodlands, meadows, unique plant collections, and research areas. The museum offers the largest designed herb garden in the U.S., and it houses the National Bonsai and Penjing Museum, a showcase of the Asian art of miniature trees.

The arboretum has one of the more unique sights in Washington, D.C.: the National Capitol Columns. These Corinthian columns were part of the Capitol's east portico prior to the installation of the massive dome. The dome was quite larger than the original designs had specified, and these columns appeared too small and out of balance with the structure. In 1958, the Capitol's east side received a makeover, and the columns were removed and marble reproductions were put in their place. Today, 22 of the 24 columns sit atop a meadow within the National Arboretum. It's a beautiful, tranquil place to both visit and photograph.

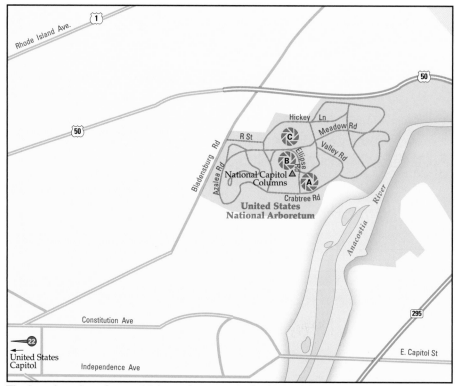

The best locations from which to photograph the United States National Arboretum: (A) the Capitol Columns from the southeast intersection of Ellipse Rd. NE and Beechwood Rd, (B) Capitol Columns, and (C) the administration building.

Where Can I Get the Best Shot?

Images of the National Capitol Columns along with many others of flowers, exotic plants, trees, and gardens are possible at the arboretum. Nine miles of roads connect the various areas, so a car or a bike is quite useful when visiting. Private and public tram tours are also available.

Capitol Columns from the southeast intersection of Ellipse Rd. NE and Beechwood Rd

During the summer when the wildflowers are blooming at the southeast corner of this intersection, it's a beautifully surreal scene at the Capitol Columns (see figure 25.1).

Capitol Columns

When next to the Capitol Columns there are many ways they can be photographed, whether you use the reflecting pool as part of the composition or not (see figure 25.2).

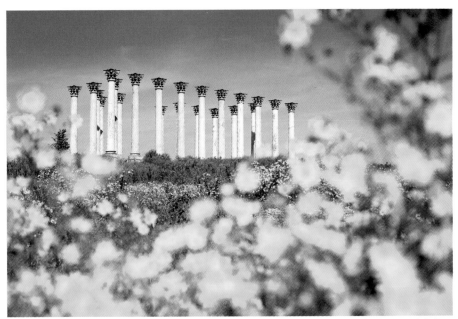

25.1 The National Capitol Columns framed by wildflowers at the U.S. National Arboretum (see A on the map). Taken at ISO 100, f/2.8, 1/2000 second with a 65mm lens.

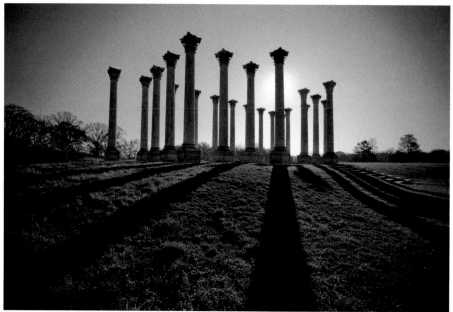

25.2 Standing next to the National Capitol Columns (see B on the map) during late morning. Taken at ISO 100, f/8, 1/400 second with a 20mm lens.

25.3 Agave attenuata photographed near the entrance of the National Arboretum's Administration Building (see C on the map). Taken at ISO 100, f/22, 1/6 second with a 50mm lens mounted on a tripod.

The administration building

Around the arboretum, you can find diverse collections of flora and fauna (see figure 25.3). Whether your desires are roses, lilac, or simple switchgrass, you can find lovely examples of many types of plants close by the administration building. Japanese koi swim in pools at the Aquatic Garden, surrounded by a vast variety of greenery.

The other gardens next to the building feature plants developed through research and breeding by Arboretum scientists and are a kaleidoscope of color and form. Also nearby are many other gardens, such as the Historic Rose Garden and Herb Garden.

How Can I Get the Best Shot?

The National Arboretum has a variety of areas to shoot, and it's a very peaceful setting. Be sure to be mindful of other visitors and not block their way with equipment and, most importantly, do not tamper with the plants.

Equipment

Great shots can be taken here with everything from a point-and-shoot camera to a high-end dSLR.

Lenses

The photograph of the National Capitol Columns (refer to figure 25.2) can be shot with a 100-150mm lens, depending on how you want to compose it. Lenses with larger apertures allow you to blur out the foreground more, but this is a style preference. The picture could be equally interesting shot at higher aperture values of f/11, for example. If you are shooting next to the columns, you'll need a wide lens in the range of 16-24mm. Or you can walk away from them and use a more standard lens of 35mm or 50mm, but a wide lens adds a vast feeling that you don't really get with standard-length lenses.

When working from the Capitol Column reflecting pool, you can use a lens between 20mm and 35mm if you are right at the base of the pool.

For close-up images near the administration building (see figure 25.4), regular lenses of between 35mm and 50mm are great. Some lenses allow you to focus closer than others, however, so you may want to experiment beforehand with your lens' minimum focusing distance. You can also use macro (sometimes referred to as *micro*) lenses here. (See chapter 21 for more information about macro photography.)

Filters

Images of the Capitol Columns may be significantly enhanced with both a polarizing filter and a graduated neutral density filter. The polarizer darkens a blue sky and increases contrast with the clouds, while the neutral density can help to equalize the exposure between the ground and the sky.

Extras

A tripod is a great help when photographing flowers and other plants, because you won't have to hold your camera steady constantly when composing your shot. However, bear in mind that photographing flowers with long shutter speeds requires a completely windless day, as any movement will blur them in the photo.

25.4 Panicum virgatum (switchgrass) photographed next to the National Arboretum's Aquatic Garden, on the grounds of the Administration Building (see C on the map). Taken at ISO 100, f/2, 1/250 second with a 50mm lens.

Camera settings

Using a camera's Auto white balance when photographing flowers can throw off the natural colors significantly. Cameras often base their white balance off of what colors are predominant in the photo, and if your subject is predominantly yellow or green, the camera may correct for this. Try out other settings to see what works best for reproducing the colors faithfully. Often the Daylight setting is a good starting point.

For the images from the wildflowers of the Capitol Columns, using Aperture Priority mode allows you to set a lower aperture value to blur out the foreground — or you can set a higher aperture value to keep everything in focus. But be sure to keep an eye on what corresponding shutter speed your camera is setting when handholding your camera.

You should keep your shutter speed set fast enough to avoid camera-shake induced blurring using the rule of *one over your focal length*. For example, using a focal length of 150mm means you want to select a shutter speed that is at or

above 1/150 second to avoid a blurry image from shaking your camera. Because this falls between the common shutter speeds of 1/125 second and 1/250 second, you want to select the faster of the two. This rule gets more important as focal length gets longer (above 70mm in general), as it's harder to keep a longer focal length lens steady.

If you are photographing the columns from a low vantage point, try intentionally underexposing the scene so that the sky goes very blue and the columns are silhouetted. You can do this either with your camera's exposure compensation function (by setting it to a lower or negative setting) or by manually setting it to a value below what your camera's meter is telling you is a normal exposure.

Exposure

The time of day may determine where you should photograph at the arboretum. The good news is that there is an abundance of areas you can choose from for any time of day and type of light.

Ideal time to shoot

Of all the places in Washington, D.C., the arboretum varies most with the seasons. Doing some upfront research can help you plan where to go. Spring and summer are obviously the best times for abundant and varied color; fall is a beautiful time to see the changing leaves; and winter has its beauty with both snow and conifers. You can also find year-round exhibits, such as the Asian Valley, Friendship Garden, National Bonsai and Penjing Museum, and the Holly and Magnolia collections.

Check the arboretum's Web site to find out what exhibits will be at their peak during your visit: www.usna.usda.gov.

Working around the weather

Surprisingly a bright, sunny day can be great for some photos but not for others. And what some may see as a dreary, overcast day can actually be wonderful light for photographing flowers. The light is very soft with diffused shadows, which create graceful lines and colors. Here, you can choose the subjects to photograph based on what the conditions are: A bright, sunny day could mean great backlit shots of sunflowers, while an overcast day may mean catching the subtle color gradations of Shortwood Phlox (see figure 25.5).

When photographing from the reflecting pool of the Capitol Columns, a windless day gives you a better reflection here. Also, the clouds in the sky influence how the light bounces off the water here: A blue sky gives you more clean reflections, while a cloudy day makes the image in the water vary more.

Low-light and night options

The arboretum is open daily from 8 a.m. to 5 p.m. every day of the year except December 25. Therefore, low-light options are generally limited to the winter after daylight savings time ends on the first Sunday in November.

25.5 Shortwood Phlox photographed on an overcast day. Taken at ISO 100, f/4, 1/100 second with a 50mm lens.

Getting creative

The National Arboretum is a grand test of one's creative thinking, and in every garden a wonderful photograph could be waiting to be shot. Don't discount the less elegant subjects, either. Switchgrass may not sound elegant, but when photographed creatively, it can be supremely so. Creativity always involves exploration; at the arboretum, you can wander around its grounds to find something unexpected.

Be sure to experiment with not only the safer ways of photographing, such as front-lit subjects, but also with more difficult methods, such as using light behind the subject, which creates a terrific glow (you'll often have to increase your exposure when doing so by using exposure compensation). And trying color and black-and-white options can really open up the possibilities.

> The National Arboretum is federally funded but also relies on private funds for some of its most popular attractions, such as the placement of the National Capitol Columns on its grounds. If you enjoyed your visit, consider a small donation on your way out or online.

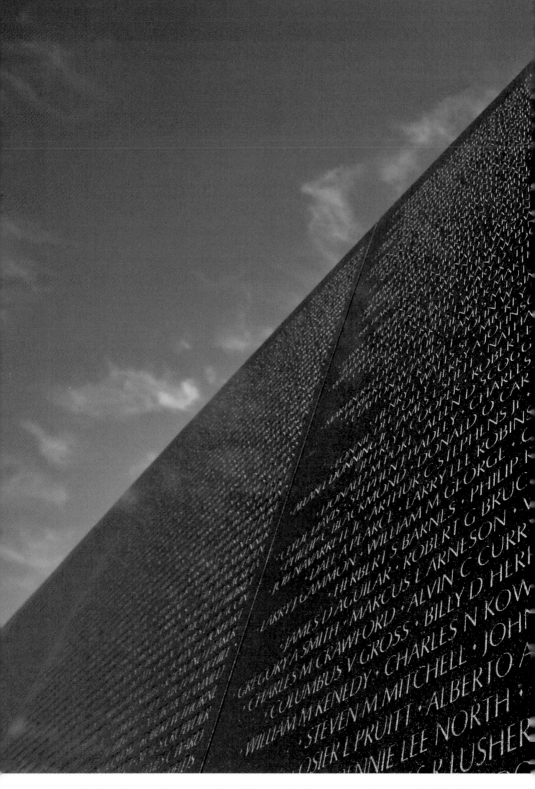

A detail of the Vietnam Veterans National Memorial in the morning. Taken at ISO 500, f/10, 1/250 second with a 20mm lens.

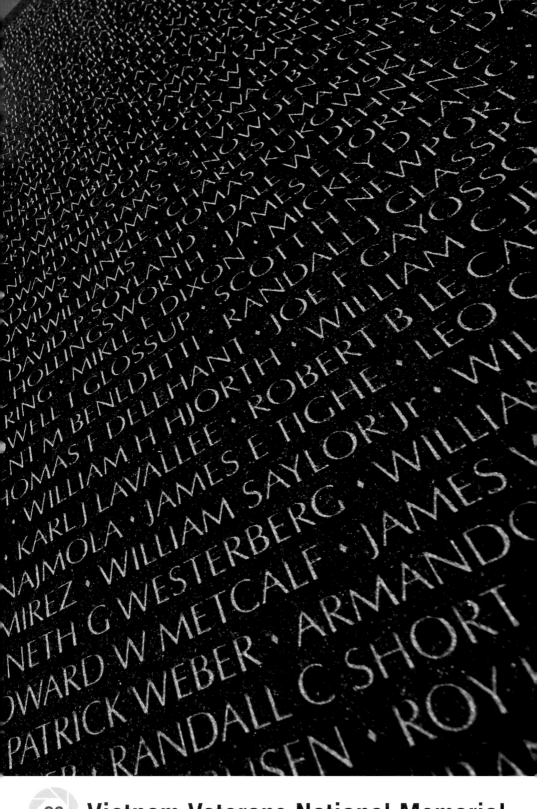

Why It's Worth a Photograph

The Vietnam Veterans National Memorial honors members of the U.S. armed forces who died in the Vietnam War. The memorial is at the western end of the National Mall and is a black granite wall that makes a wide V-shape. It is inscribed with the names of over 58,000 men and women who were killed or designated as missing in action.

It has become a tradition that visitors to the memorial will often leave small mementos to those who are remembered on the wall. These items are collected each day by National Park Service Rangers and, if possible, added to an archive kept by the Smithsonian Institution.

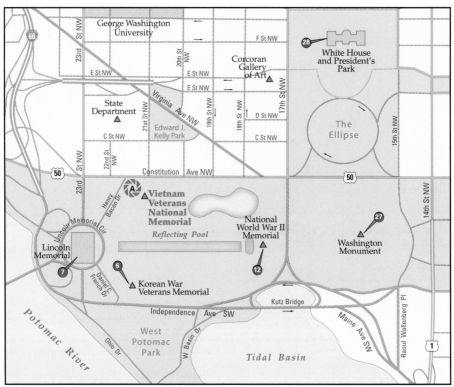

The best location from which to photograph the Vietnam Veterans National Memorial: (A) the memorial's walkway. Nearby photo ops: (7) Lincoln Memorial, (12) National World War II Memorial, (27) Washington Monument, and (28) White House and President's Park.

Where Can I Get the Best Shot?

Because of the minimal design of this memorial, the best pictures often come from within the memorial's walkway.

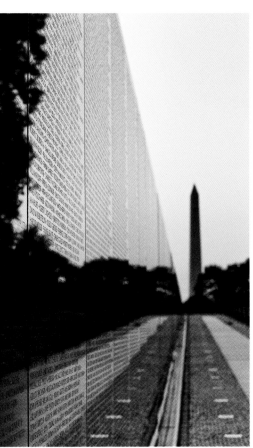

26.1 Looking east towards the Washington Monument before sunrise (see A on the map). Taken at ISO 400, f/8, 1/640 second with a 90mm lens.

Along the memorial's walkway

At first glance, the walkway of the memorial doesn't seem to offer many photo opportunities — its stark design is brutally simple and is wholly different from many other areas along the Mall. Look carefully though, and you'll find several interesting ways to photograph it.

One of the classic images of the Vietnam Veterans Memorial (and indeed one that the artist Maya Lin sketched on her original proposal for the memorial) is a shot looking along its east wall towards the Washington Monument (see figure 26.1).

The black granite surface reflects light in many different ways during the day, and these reflections can make interesting ways to view the memorial. One of the popular shots is to stand just west of the middle of the memorial and look straight in at the west wall (see figure 26.2). You can see the Washington Monument reflected in the wall with hundreds of names surrounding it.

National Park Service volunteers are well-versed in the good locations to photograph the memorial and can help you find these spots. They are also full of great facts and stories about the memorial and are well-worth a listen.

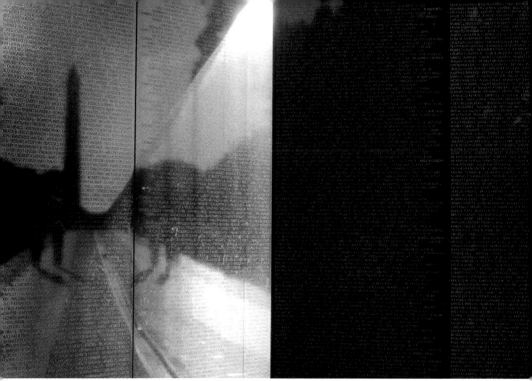

26.2 Viewing the intersection of the east and west walls of the memorial in the morning (see A on the map). Taken at ISO 400, f/11, 1/125 second with a 65mm lens.

By the end of the day, there are often many flowers and other objects left at the base of the memorial. These small objects can be interesting detail shots whether they are flowers, Vietnam era helmets, flags, or photographs (see figure 26.3).

How Can I Get the Best Shot?

Good photographs here require some concentration and exploration of the memorial.

Equipment

Great shots can be made here with a minimum of equipment. Note that tripods are not allowed within the walkway area that borders the memorial wall.

Lenses

For images looking along the east wall (refer to figure 26.1), focal lengths from about 50-125mm work well, depending on your composition.

When shooting into the wall with the reflection of the Washington Monument and the east wall of the statue (refer to figure 26.2), wider lenses such as 50, 35, and 24mm work better because they do not compress the scene as much and thus render the reflections a little more clearly.

Finally, tight detail shots that include the items left by visitors along with the names engraved on the walls can be done with longer focal length lenses (refer to figure 26.3). Something between 70 and 100mm works well for such images (or even longer) depending on how you compose your shot.

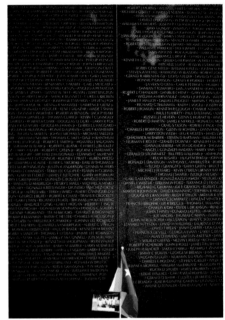

26.3 A Texas flag and a photograph left at the wall of the memorial (see A on the map). Taken at ISO 160, f/7.1, 1/125 second with a 65mm lens.

Filters

If you have a polarizing filter with you, try to see how using it changes the reflections on the wall. These filters work best at a 90-degree angle to the reflected light, so when using them to minimize reflections, a little experimentation will be necessary to get the right angle.

Extras

Wear dark clothing to the memorial — it's rather easy to get your own reflection in the wall when shooting directly into it, and somber colors help prevent this.

Camera settings

The dark wall will almost undoubtedly confuse your camera's automatic exposure. Because it is so dark, most cameras end up overexposing the scene and create washed out images. The reason is because the dark granite is so much darker than the average brightness that a camera expects. You can try to use your camera's night scene if it has one (although this may result in your flash being used, which you don't want). Otherwise, when using an automatic mode, dial down the exposure by using your exposure compensation feature, or by setting the exposure yourself in manual mode. On average, it will be about one to one and a half stops less exposure — this will depend on how much light the glossy wall is reflecting, however.

Next, you may want to experiment with different white balances to create the cleanest-looking image you can based on the lighting at the time. Different white balances affect the contrast of the image and thus how you see the engraved names against the black wall.

Exposure

The good thing at this memorial is that it can be photographed at almost any time during the day.

Ideal time to shoot

In the early morning, before the sun has risen, there will be nice light on the wall, but after the sun comes out, very strong reflections appear along the wall of both the sun and Washington Monument. Later in the morning and afternoon the reflections are easier to manage, but there are often many more people at the memorial who will be in the reflections. This, however, can be used as a creative opportunity if you wish.

There are times during the year, notably Veterans Day and the Fourth of July, when the memorial will have more activity around it. You have many opportunities to photograph here during this time, but the crowds are large, too.

Working around the weather

Anything in the sky can be reflected in the walls of the memorial. Clear skies make it easier to discern names on the walls, but different cloud formations may offer an opportunity for different kinds of images. Many of the reflection images can be taken in a variety of weather as well. As is expected, unique weather can make any picture even better, too.

Low-light and night options

Nighttime is a great time to shoot here as well. The image looking down the east wall with the Washington Monument works well at night, although because tripods aren't allowed, you must hand hold the camera. The tripod rule is enforced no matter whether or not there is a crowd there at that time.

Getting creative

If you are here during the winter, images of the memorial surrounded by snow can be beautiful.

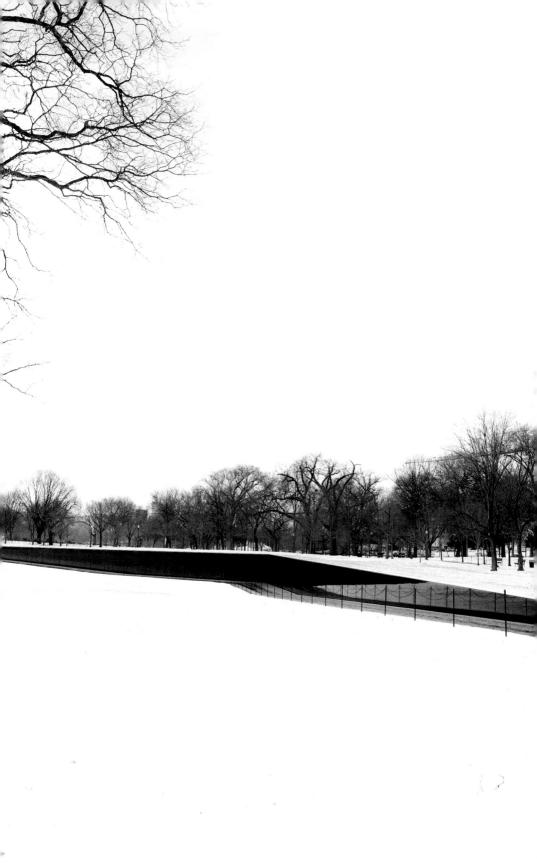

The Washington Monument from the northeast side of the Tidal Basin with the National Park Service's tulip library in the foreground (annuals are planted in place of the tulips after their season passes). Taken at ISO 400, f/20, 1/60 second.

27 The Washington Monument

Why It's Worth a Photograph

At just over 555 feet high, the Washington Monument was built to commemorate George Washington, the first president of the United States. This monument is the tallest structure in Washington, D.C., and for a short time the world's tallest structure until the Eiffel Tower was completed in Paris, France in 1889.

When the engineers began work after a hiatus due to the American Civil War, they were faced with a dilemma: There was no more marble that matched the marble used to build the first 150-odd feet some 20 years prior. They contracted with a company to provide similar marble from Sheffield, Massachusetts, but they immediately ran into quality and delivery problems. Eventually, the monument was

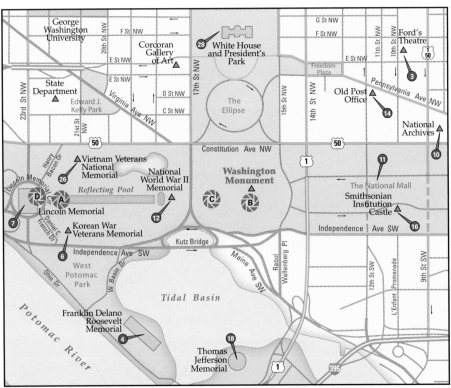

The best locations from which to photograph the Washington Monument: (A) the west end of the Lincoln Reflecting Pool, (B) the inner circle of the Washington Monument, (C) the park area just west of the monument, and (D) the Lincoln Memorial. Nearby photo ops: (3) Ford's Theatre, (4) Franklin Delano Roosevelt Memorial, (6) Korean War Veterans Memorial, (7) Lincoln Memorial, (10) National Archives, (11) National Mall, (12) National World War II Memorial, (14) Old Post Office, (16) Smithsonian Institution Castle, (18) Thomas Jefferson Memorial, (26) Vietnam Veterans National Memorial, (28) White House and President's Park.

finished with marble from nearby Cockeysville, Maryland. Today, you can see the three different colors of the marble used in the monument: the first area of marble from the original construction, four rows of the Sheffield, Massachusetts, marble, and the rest from Cockeysville.

Where Can I Get the Best Shot?

The Washington Monument can be photographed from all over the city, but several iconic views stand out as the very best.

The west end of the Lincoln Reflecting Pool

Figure 27.1 shows one of the photographs that you almost can't leave Washington, D.C., without making: the Washington Monument seen from the west end of the Lincoln Reflecting Pool. Here, you see the monument's slender lines elegantly reflected in the wide pool of water that forms a line between the Lincoln Memorial, the World War II Memorial, the Washington Monument, and the Capitol.

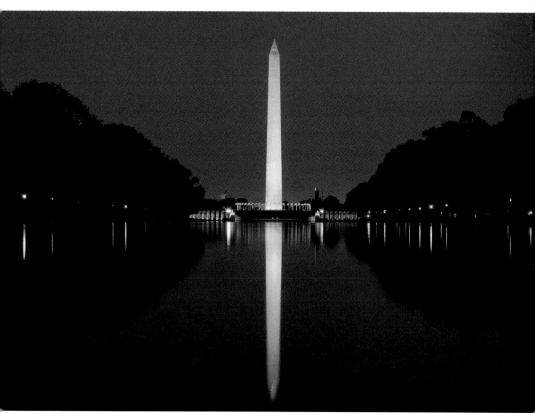

27.1 The Washington Monument from the west end of the Lincoln Reflecting Pool (see A on the map). Taken at ISO 200, f/22, 13 seconds with a 65mm lens and a tripod.

The inner circle of the Washington Monument

When you are right next to the monument, its 555-foot statue is breathtaking. Here, there are 50 flags that represent the 50 U.S. states, and capturing an image of the breeze flowing through the flags along with the top of the monument is a great sight (see figure 27.2). There are a few different ways to make this shot. You can include one or many flags, and try experimenting with tilting your camera to let the flags and monument sweep through the frame.

The park area west of the Washington Monument

In the park just east of 17th Street SW, you can get a clean view of the Washington Monument (see figure 27.3). The monument's inner circle is gradually uphill from the western area of the park where you will be shooting from. For this reason, trees and other buildings can be hidden from view. Also, you can avoid seeing the entrance area, which isn't exactly a becoming part of the structure.

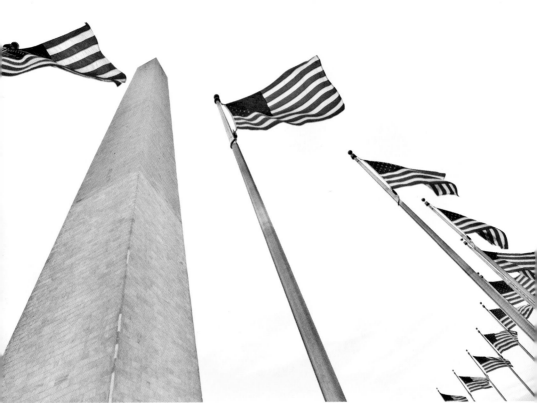

27.2 Looking up at the Washington Monument from its inner circle (see B on the map). Taken at ISO 800, f/4, 1/320 second using a 20mm lens.

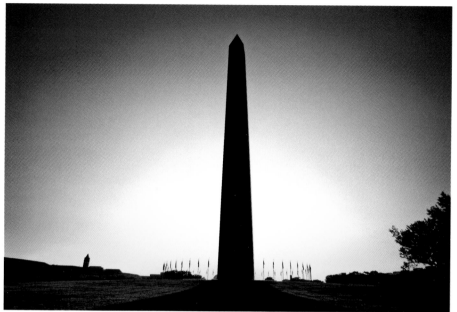

27.3 The Washington Monument before the sun rises (see C on the map). Taken at ISO 100, f/16, 1/80 second with a 22mm lens.

The Lincoln Memorial

The top of the steps of the Lincoln Memorial is another great vantage point from which to photograph the monument. Here, you can do two different types of photos: one where you shoot with a wide-angle lens and include the columns in the frame (see figure 27.4), and another where you can shoot an overall composition of the Reflecting Pool with the monument in the distance (see figure 27.5).

How Can I Get the Best Shot?

For all the Washington Monument's 555-plus feet, you can probably photograph it from an equal number of locations. Keep an eye out as you are driving, walking, or riding, and you may discover a great one yourself.

Equipment

Because there are so many views of the Washington Monument, there are quite a variety of equipment and methods you can use to get many different images.

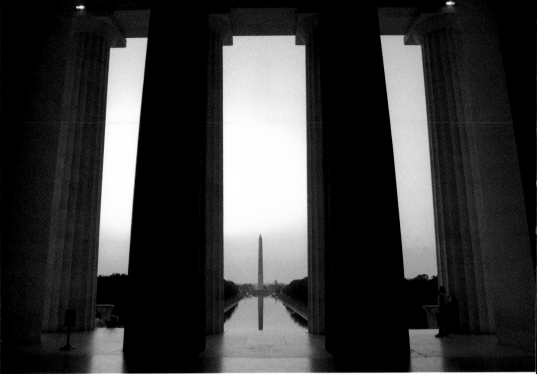

27.4 Looking east from within the Lincoln Memorial to the Washington Monument in the morning (see D on the map). Taken at ISO 640, f/8, 1/60 second with a 20mm lens.

Lenses

For the shot from the Lincoln Reflecting Pool at night (refer to figure 27.1), you need a tripod and, depending on the type of composition you are going for, a lens of between 35-70mm.

From the inner circle of the Washington Monument (refer to figure 27.2), a 50mm lens works well if you are shooting a tighter shot of just a flag with the monument in the background. Here, you can also shoot with a very wide lens (such as a 17mm) if you want to get many flags in the frame.

Images taken in the park area west of the monument (refer to figure 27.3) require a rather wide lens of between 17-24mm, depending on whether you shoot horizontally or vertically.

The image from the Lincoln Memorial requires a lens of about 20-24mm for the shot that has the memorial's columns in the foreground (refer to figure 27.4). A 50mm lens works for the shot at the top of the steps here (refer to figure 27.5).

Filters

Using a polarizing filter is a great idea when heading out to the Washington Monument, because most photos will have a large amount of sky as part of the composition. A polarizer adds intensity to a blue sky and enhances the contrast with any clouds.

Remember that polarizing filters cut about one to one and a half stops of light off the exposure (more important if you are already shooting in low light), and that they work best at 90-degree angles to the sun.

Extras

A tripod is generally tolerated by National Park Rangers as long as you do not use it within the inner circle of the Washington Monument or on the steps or within the Lincoln National Memorial. At these two locations, tripods are strictly forbidden.

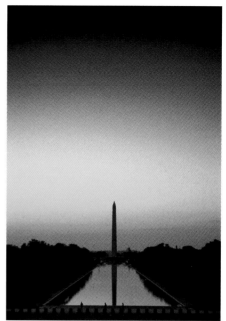

27.5 Looking east from the steps of the Lincoln National Memorial to the Washington Monument in the morning (see D on the map). Taken at ISO 400, f/10, 1/100 second with a 50mm lens.

You may see other photographers using one, but unless they have a permit from the National Park Service, they aren't allowed to do so. A small, table-top tripod can be used quite effectively for the photo of the Washington Monument at the west end of the Lincoln Reflecting Pool.

Camera settings

When shooting from the west end of the reflecting pool using a tripod at night or in low light (refer to figure 27.1), you need to set your camera to either manual mode or Shutter Priority to use long shutter speeds. While this isn't necessary if you have a camera that has quality high ISO settings, long shutter speeds make it possible to shoot at lower ISO values for better quality photos. In addition, passing clouds become painterly in nature.

When using a long shutter speed, it doesn't hurt to set a higher aperture value to make sure that everything is tack sharp. Use your camera's self-timer or, if you have one, a cable release, to trip the shutter. If you are using a more advanced camera, you can also enable its Mirror Lockup function to reduce any camera vibration from the mirror swinging up and out of the way of the digital sensor.

You want to begin somewhere around 12 seconds at f/22 at ISO 200 — and you can vary this exposure as well. But keep in mind that if you want to get several different shots within a short time period (when the sun is setting, for example), using a higher ISO value can give you more time to shoot by shortening your shutter speeds. And nowadays the quality difference between ISO 100 and ISO 200 is hardly noticeable with modern cameras.

A higher aperture value not only keeps everything in focus because of its increased depth of field, but it also uses the central area of the lens, which is generally the sharpest area of any lens.

From the inner circle of the Washington Monument (refer to figure 27.2), you can use your camera's Aperture Priority function to set a lower aperture value of, say, f/4 or f/5.6 so that you only get the flag in focus. Doing so leaves a little to the imagination, instead of having a straight everything-in-focus shot. Because the images here involve a lot of sky, images during the daylight hours may require adding some exposure by using your camera's exposure compensation feature or by dialing it in manually.

An easy way to do this is to set your camera to an automatic mode (for example, Program mode), note what its auto settings are when you compose your shot, switch to manual and set those same settings, and then increase the exposure by increasing the shutter speed by about one stop. Many cameras may think the bright sky and monument need to be darker than they really should be.

Finally, shots from the top of the steps at Lincoln Memorial (refer to figures 27.4 and 27.5) are a little harder because tripods aren't allowed here. If you get here well after the sun has set, you'll have to shoot with a very high ISO value, so try to get here when you can work with the light.

You'll likely need a fairly slow shutter speed, so be sure to stabilize your camera well to avoid camera-shake, which leads to fuzzy, unsharp images. Using a friend's shoulder works well for doing this. Either rest it on top or press it against the side of their shoulder while they stand still. This is where a smaller camera has more of an advantage, because it will be easier to hold still than a hulking dSLR with a big zoom lens.

Exposure

Timing is rather important for getting great shots of the monument because the sky is a big part of the composition.

Ideal time to shoot

The Reflecting Pool shot (refer to figure 27.1) can be done at pretty much anytime of the day, but the most evocative time is after the sun has gone down in the evening. With a glow still in the sky, you can capture the Washington Monument fully lit along with the National World War II Memorial circling it. Early morning is good too, because the monument will be silhouetted by the rising sun.

While at the inner circle of the monument (refer to figure 27.2), it's very nice to have the sun come across the flags and monument at an acute angle. What's good about this shot is that you can go to whatever side has the best lighting, because it's the same for all 360 degrees. That said, a more minimalist style of photo could be had during midday when the sun is more overhead.

In the park just west of the monument (refer to figure 27.3), a morning shot is a bit more technically hard to pull off because it is backlit by the morning sun, but when metered correctly it works out quite well (try using exposure compensation to increase the exposure when using a Priority Setting). The more traditional time to shoot here is at sunset, when the monument is lit by the warm evening sun. But even a nice, blue sky day works well here. During winter months when the sun is lower on the horizon, this shot would work during the day as well.

The view from the Lincoln Memorial is best in the early morning and early to late evening. In the morning, light fills the interior of the Lincoln's columns, while in the evening, there will be more contrast as the monument is lit more but less light is entering the interior of the Lincoln Memorial.

Working around the weather

Because photographing the monument usually involves a lot of sky, the weather makes a huge impact to a photo. Whether it's a cloudy evening when the sun is weaving through the sky or when giant cumulonimbus clouds are towering over Washington, D.C., most all of the areas can be enhanced with interesting weather.

If it's raining, look for interesting reflections on the sidewalks or puddles. If the light is muddy and flat, concentrate on the flags and monument from the inner circle, and overexpose it a little bit to turn the sky white and create a stark, minimalist photo. If it's pouring rain, what happens if you shoot through your car or bus window? The goal is to capture a mood, and weather can help you out a lot here. There's a great photo to be made no matter what the weather, that is for sure.

Low-light and night options

All the aforementioned shots can be taken at night as well, with perhaps the exception of the photos from the Lincoln Memorial (refer to figures 27.4 and 27.5) because using a tripod here isn't allowed. You can take a great night shot from the northwest end of the Lincoln Reflecting Pool (see figure 27.6). Here, you can shoot along this end of the pool and get the National World War II Memorial, the Washington Monument, and the Capitol all in one shot.

The Washington Monument is covered in light at night, but the light pollution from the city makes a difference to how it looks against the sky. Low clouds on an overcast night can mean the orange glow of the sodium-vapor street lights will illuminate the night, which can give the scene quite a surreal look.

27.6 Looking east from the northwest end of the Lincoln Reflecting Pool (see A on the map). Taken at ISO 400, f/29, 30 seconds with a 365mm lens and a tripod.

Also at night, the silhouettes of people against the base of the monument are fantastic with the flags in the photo.

Getting creative

In addition to the monument, the flags that surround it are very photographable (see figure 27.7). People are always milling about here, whether they are tourists gazing in awe at the structure or locals out on a run. Stand farther away from them and use a longer lens, such as a 150mm or 200mm, to compress all elements of the scene together.

Also, by using a wide lens at the base of the monument, you can get some rather wild-looking shots. They don't look too much like the typical Washington Monument shots, but they can be very graphic and striking. Remember that Washington, D.C. is incomparable during cherry blossom season. Opportunities for gorgeous photos abound at the monument, as in other areas around the city (see figure 27.8).

27.7 The flags surrounding the Washington Monument as seen facing west and just north of the Washington Monument Lodge (see B on the map). Taken at ISO 100, f/4.5, 1/1250 second with a 260mm lens.

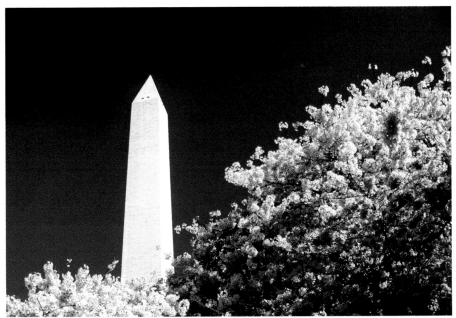

27.8 The area around the Washington Monument is vibrant during the cherry blossom season (see C on the map). Taken at ISO 100, f/8, 1/500 second with a 70mm lens.

271

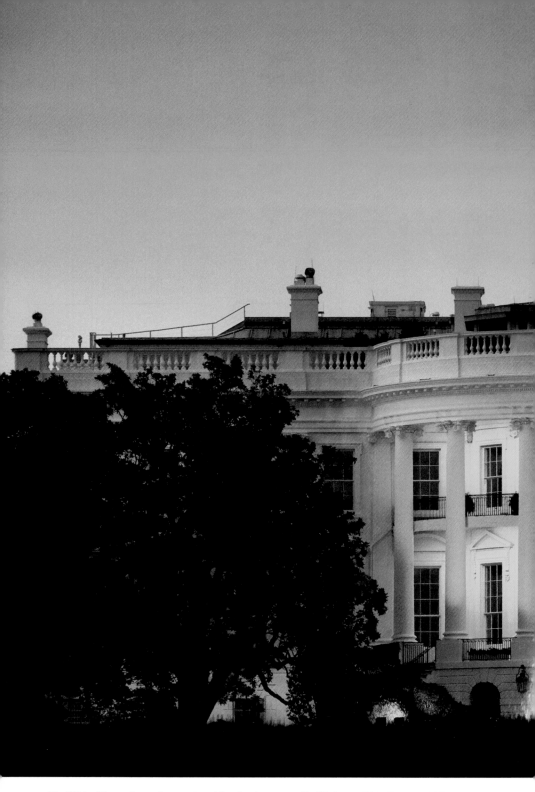

The White House from the south public viewing area off of E Street NW. Taken at ISO 1600, f/4, 1/80 second with a 160mm lens.

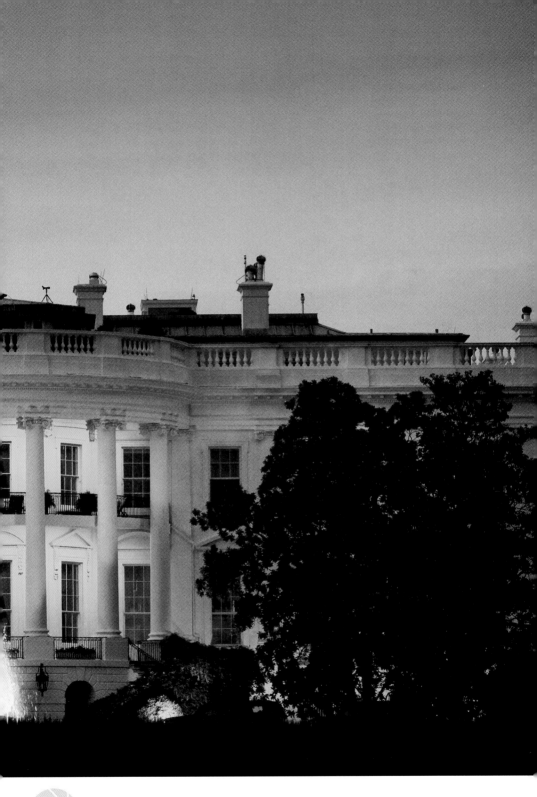

28 **The White House and President's Park**

Why It's Worth a Photograph

It's known as the most recognized address in the United States — 1600 Pennsylvania Avenue NW, Washington, D.C. The White House is the official residence and office of the President of the United States.

Following in the tradition of the White House being open to the public (it is the only private residence for a head of state in the world that is), tours of its interior are available to U.S. citizens by contacting their member of Congress. Non-U.S. citizens may arrange a tour through their embassy in Washington, D.C. However, essentially nothing is allowed to come with you after you enter the White House, including cameras.

President's Park encompasses the White House as well as the areas just around it: the White House Visitor's Center, Lafayette Park (to the north) and President's Park South, known as The Ellipse.

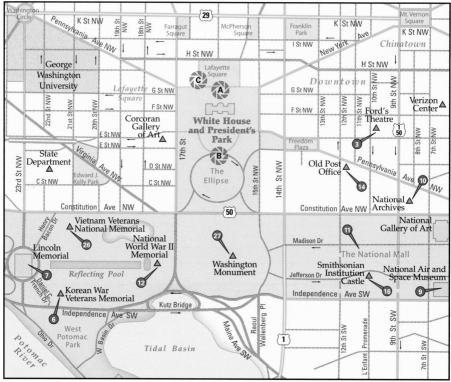

The best locations from which to photograph the White House and President's Park: (A) the sidewalk at 1600 Pennsylvania Avenue NW, (B) E Street NW, and (C) General Jackson statue in Lafayette Park. Nearby photo ops: (3) Ford's Theatre, (7) Lincoln Memorial, (9) National Air and Space Museum, (10) National Archives, (11) National Mall, (12) National World War II Memorial, (14) Old Post Office, (16) Smithsonian Institution Castle, (26) Vietnam Veterans National Memorial, and (27) Washington Monument.

Where Can I Get the Best Shot?

The White House grounds are easily accessible on foot, and you can take pictures from either the north or south sides. Access to other views is limited. You have to photograph it through the metal fence that surrounds each side.

The sidewalk at 1600 Pennsylvania Avenue NW

The north side along Pennsylvania Avenue is the closest view you can get of the White House. Although still a great view (see figure 28.1), this side is less of an iconic view than the rounded South Portico. However, because of the wide-open sidewalk and the closed-to-traffic stretch of Pennsylvania Avenue, it can be less crowded and therefore easier to get a good view.

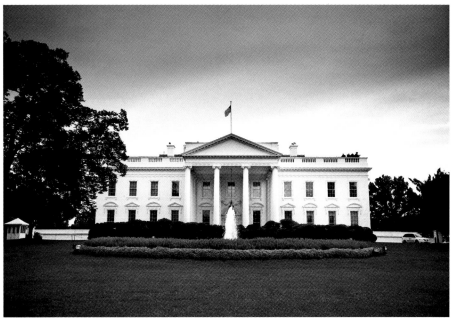

28.1 The White House seen from its north side along Pennsylvania Avenue (see A on the map). Taken at ISO 100, f/5.6, 1/160 second with a 50mm lens.

E Street NW

The South Portico is often seen when the press covers the President arriving or departing by helicopter, and when he and the first lady are greeting dignitaries. The vast south lawn gives the view here a more regal feel, as does the elegantly rounded portico (see figure 28.2).

It's also usually more crowded — there's less space because the sidewalk is narrower and because E Street NW is closed to both pedestrian and auto traffic. Like the north side, a metal fence blocks the view here, but you can position your camera between the bars to keep it out of the picture. The police may close either side at any time and at a moment's notice for any reason, although typically it is the south side that gets closed more often.

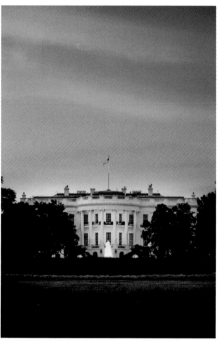

28.2 The White House seen from its south sidewalk off of E Street NW (see B on the map). Taken at ISO 800, f/4, 1/60 second with a 90mm lens.

General Jackson Statue in Lafayette Park

Just across from 1600 Pennsylvania Avenue NW is Lafayette Park, named for the first foreign guest to stay at the White House, General Marquis de Lafayette.

The General Jackson Statue (see figure 28.3) shows Major General Andrew Jackson reviewing his troops at the Battle of New Orleans, Louisiana, in 1815. The 15-ton statue is made from the melted British cannons captured by Jackson at the historic battle.

28.3 The General Jackson Statue in Lafayette Park, across from the north side of the White House (see C on the map). Taken at ISO 250, f/5.6, 1/125 second with a 220mm lens.

How Can I Get the Best Shot?

Visiting the White House is the highlight of most visits to Washington, D.C. It's fairly easy to photograph well.

Equipment

Photographing the White House doesn't require any special gear; in fact, most cameras with standard zoom lenses work well. It does help to have a more modern camera that has higher ISO settings while still maintaining quality for evening or dusk shots, but during the day most any camera will do well.

Lenses

On the north side (refer to figure 28.1), a 35mm lens works well when photographing from the metal gate. From the south side (refer to figure 28.2), you'll be much farther away, which gives you more options for creativity. A lens of around 85mm is a good start. With it, you can capture some environment around the White House, including some sky.

Beginning at about 150mm, you can fill a horizontal frame with the White House from the south sidewalk. If you are photographing from the field farther south of E Street NW, you'll need a lens of over 200mm to fill the frame, and at that point the *compression effect* of a lens that long begins to make the White House look somewhat flat and lacking dimension.

Filters

Because the White House faces north and south, a polarizing filter can work well to enhance a blue sky and clouds. (A polarizer works best 90 degrees to the direction of the sun.) And either a graduated neutral density filter on your camera or within a software application can help even out the exposure of the sky. Be sure if you are choosing the software option to expose carefully, because you have less latitude for correction than you do when physically using a filter.

The Compression Effect

A long lens, which generally refers to a lens over 200mm in length, creates an effect of bringing background and foreground elements closer together, referred to as compression. It looks as if all the elements in a scene were moved closer to each other. This can be used as a trick to make something look closer to something else than it really is. It can also degrade an image somewhat by causing it to look less three-dimensional and more two-dimensional.

Extras

Tripods are not allowed on the sidewalks on either the north or south sides of the White House. On the north side, the police officers allow them to be used off the sidewalk on Pennsylvania Avenue, but there's not much point because you will most likely have the metal fence squarely in your shot. On the south side, officers generally allow their use on the sidewalk south of E Street NW and in the grass area here. You can get a cleaner photo here with a tripod than on the north side, but you'll just barely be over the heads of all the visitors (unless you want to compose them in your shot, which is another option).

If you wish to briefly use a tripod, it's recommended that you ask a nearby police officer by saying hello and explaining what you want to do — a little traditional courtesy can go a long way.

 See this book's Introduction for a more thorough look at Washington, D.C. dos and don'ts for tripods.

Camera settings

Using Shutter Priority or Aperture Priority on your camera should get good results here, assuming that the building and sky are roughly at the same exposure (such as during midday). If it is early morning or late evening, you can avoid camera shake by using shutter-speed priority and setting it at 1/60 second, although you can try to go as low as 1/15 or 1/10 if you are careful to hold your camera very still. Because you'll be photographing through the bars of the gate surrounding the White House, you can rest your camera against these bars and use a much slower shutter speed than by just handholding your camera.

Notice that in figure 28.2, the standard shutter speed rule of *one over your focal length* was broken: The shot was made with a 90mm lens at a shutter speed of 1/60 second. Normally, you would want to keep your camera set at 1/125 in a situation like that to avoid camera shake. But because the bars allow you to rest your camera against them and effectively stabilize the lens, you can slow down your shutter speed. If you have a newer, high-end camera that has ISO speeds higher than 3200, you don't necessarily need to concern yourself with this.

Exposure

You can get a good photo of the White House at most any time. Of course, having nice light never hurts a photo.

Ideal time to shoot

The White House, perhaps because it is inherently beautiful and because it is facing north-south, can be photographed at almost any time during the day and make a nice photograph. (Buildings that face east-west are inherently more problematic because of the sun being either directly behind or in front of them.)

However, as shown in the example photos, a colorful sky never hurts a photo. If you plan on visiting during the setting sun and are careful to hold your camera steady, you can get lovely images with colorful skies and the White House subtly lit without direct sunlight (refer to figure 28.2).

Working around the weather

A day of adverse weather could actually be great when photographing here because of the uniqueness of the photograph that you'll get. Whether it is snow, fog, or a brewing storm overhead, don't avoid taking a photo here if the weather is less than perfect. Rain may make the shot problematic, however. If rain begins to pour, you can take refuge in the nearby White House Visitor Center.

Low-light and night options

Nighttime is a tough time to photograph the White House. Using tripods in the good spots isn't allowed, so you have to use a high ISO because you'll be hand-holding your camera (even with it stabilized against the bars of the gate surrounding it). The most recent high-end digital cameras have ISO settings that are enabling photographers to shoot at ISO 3200 and well beyond. If you have one of these, the White House at dusk and night is a great use for it.

Most cameras' automatic modes will expose a night scene here reasonably well. If you want to try the more advanced way of using your camera's manual exposure settings, do what a professional would do if faced with a similar situation and no tripod — start shooting at an exposure that you feel you can reasonably handhold, such as 1/30 second at f/4 at an ISO of 1600.

Take a few shots and then slow down your shutter speed (you'll have to use Shutter-Speed Priority mode in combination with exposure compensation, or Manual mode), taking a few shots each time. Slow down your shutter speed to something that isn't routinely hand-holdable, such as 1/10 second or slower, and shoot several frames while stabilizing your camera against the bars of the gate as you do.

Changing your shutter speed only on an automatic mode, such as Shutter Priority, won't change the overall exposure. Of course, for newer cameras that have very good quality high ISO settings, such techniques are becoming less and less necessary.

Even though you would be holding your camera well below what the typical shutter speed guidelines suggest, it doesn't hurt to try. The goal is that you get one or two frames that are well-exposed and tack sharp using settings that are a little harder to hand hold, while you have a few with more "safe" settings as a backup. You could also set a lower ISO if you are getting good results to enhance the quality of your photo.

Getting creative

Because you are limited on locations to shoot from, there are fewer possibilities for compositional creativity. But still, you can shoot with wide or long lenses to create something different. Also, the crowds that are attracted here can be enormous, and that alone can be worthy of an alternative to the standard White House photo. And if you are lucky, you may able to watch the President land or take off in Marine One from the White House's South Lawn.

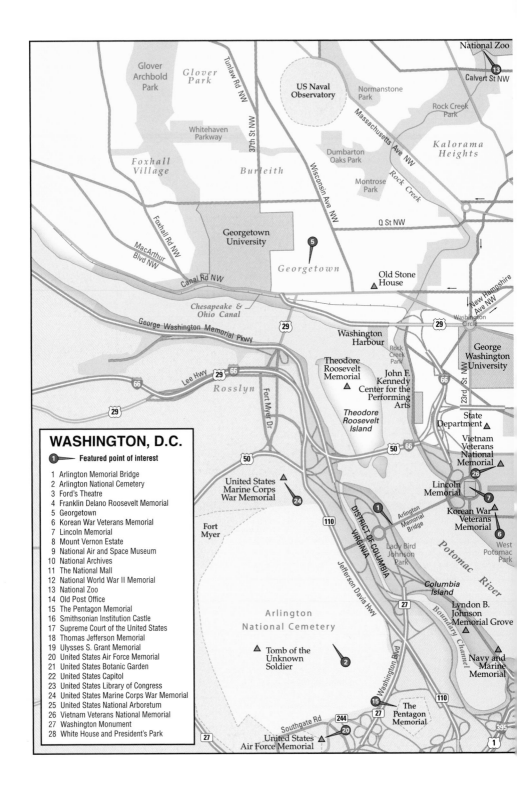

National Zoo
13
Calvert St NW
Glover
Archbold
Park
*Glover
Park*
Tunlaw Rd NW
37th St NW
US Naval
Observatory
Normanstone
Park
Rock Creek
Park
Massachusetts Ave NW
*Kalorama
Heights*
Whitehaven
Parkway
Dumbarton
Oaks Park
Wisconsin Ave NW
Rock Creek
*Foxhall
Village*
Burleith
Montrose
Park
Foxhall Rd NW
Q St NW
MacArthur
Blvd NW
Georgetown
University
5
New Hampshire Ave NW
Canal Rd NW
Georgetown
Old Stone
△ House
Washington
Circle
29
Chesapeake &
Ohio Canal
29
George Washington Memorial Pkwy
29
Washington
Harbour
Rock
Creek
Park
George
Washington
University
Lee Hwy
29
66
Theodore
Roosevelt
Memorial
John F.
△ Kennedy
Center for the
Performing
Arts
23rd St NW
66
66
Rosslyn
Fort Myer Dr
State
Department △
29
*Theodore
Roosevelt
Island*
50
66
Vietnam
Veterans
National
Memorial △
26
50

WASHINGTON, D.C.

1 ──── Featured point of interest

1 Arlington Memorial Bridge
2 Arlington National Cemetery
3 Ford's Theatre
4 Franklin Delano Roosevelt Memorial
5 Georgetown
6 Korean War Veterans Memorial
7 Lincoln Memorial
8 Mount Vernon Estate
9 National Air and Space Museum
10 National Archives
11 The National Mall
12 National World War II Memorial
13 National Zoo
14 Old Post Office
15 The Pentagon Memorial
16 Smithsonian Institution Castle
17 Supreme Court of the United States
18 Thomas Jefferson Memorial
19 Ulysses S. Grant Memorial
20 United States Air Force Memorial
21 United States Botanic Garden
22 United States Capitol
23 United States Library of Congress
24 United States Marine Corps War Memorial
25 United States National Arboretum
26 Vietnam Veterans National Memorial
27 Washington Monument
28 White House and President's Park

United States
Marine Corps △
War Memorial
24
Lincoln
Memorial
7
Korean War
△ Veterans
Memorial
6
West
Potomac
Park
Fort
Myer
110
DISTRICT OF COLUMBIA
1
Arlington
Memorial
Bridge
Potomac River
VIRGINIA
Lady Bird
Johnson
Park
*Columbia
Island*
27
Lyndon B.
Johnson
Memorial Grove
△
Boundary Channel
Jefferson Davis Hwy
*Arlington
National Cemetery*
Navy and
△ Marine
Memorial
△ Tomb of the
Unknown
Soldier
2
Washington Blvd
15
110
395
27
244
The
Pentagon
Memorial
27
Southgate Rd
20
United States △
Air Force Memorial
1

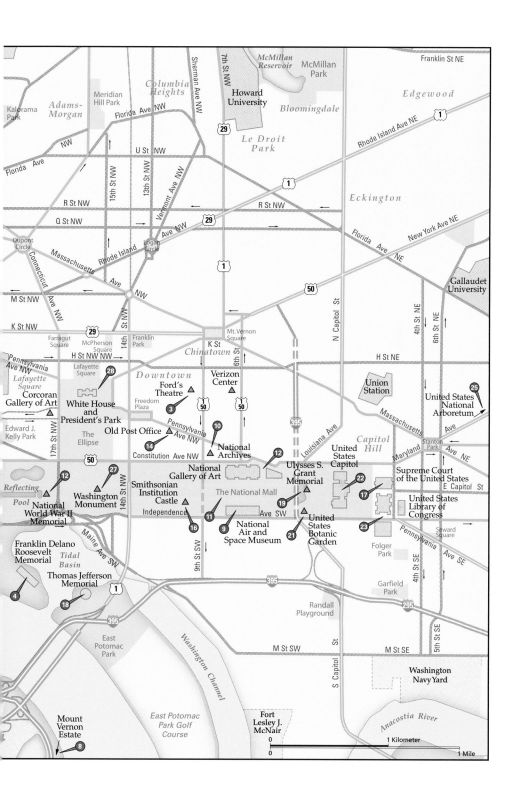

Index